COMPLETE
COLOR
HARMONY
Workbook

ROCKPORT

C O M P L E T E

COLOR
HARMONY
Workbook

A WORKBOOK AND GUIDE TO CREATIVE COLOR COMBINATIONS

GLOUCESTER MASSACHUSETTS

ROCKPORT
PUBLISHERS

© 2007 by Rockport Publishers, Inc.
This paperback edition first published in 2008

First published in the United States of America by
Rockport Publishers, a member of
Quayside Publishing Group
100 Cummings Center
Suite 406-L
Beverly, Massachusetts 01915-6101
Telephone: (978) 282-9590
Fax: (978) 283-2742
www.rockpub.com

Library of Congress Cataloging-in-Publication Data available

ISBN-13: 978-1-59253-501-9
ISBN-10: 1-59253-501-1

10 9 8 7 6 5 4 3 2 1

Text by Lesa Sawahata and Kiki Eldridge

Printed in Singapore

artist: Jane Maxwell

CONTENTS

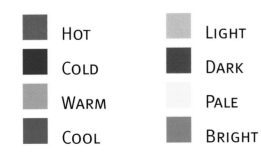

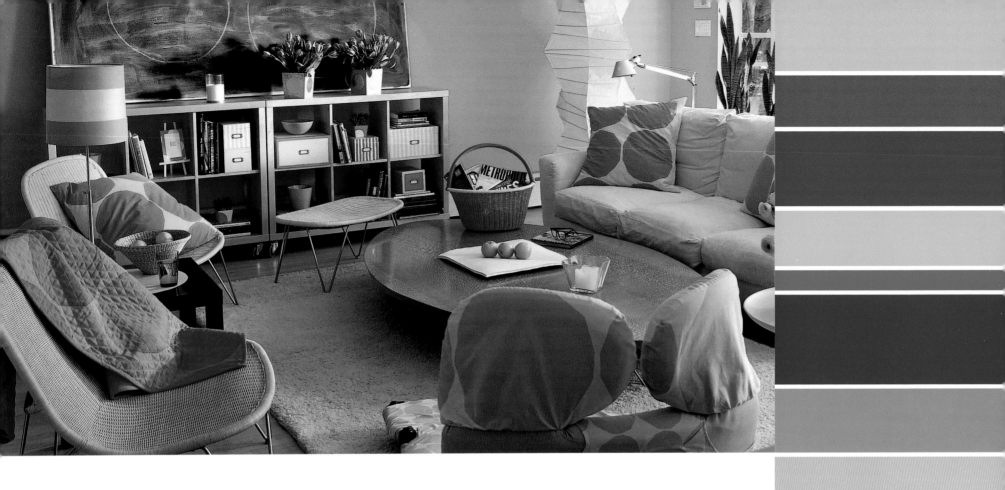

INTRODUCTION

In his seminal 1963 book *Interaction of Color*, the influential German artist
Josef Albers noted that while human auditory memory is excellent—a melody is often
repeatable after hearing it only once or twice—our visual memory, in particular the
memory of color, is quite poor. Ironically, those who have the most apparent skill
and experience with color—including artists and designers of every type—often find
themselves beset by this frustrating perceptual frailty. The fact is, especially for those
with a creative eye, color is layered with emotional, psychological, personal, and cultural
meaning that can obscure objective reality.

How to Use This Book

Enter *The Complete Color Harmony Workbook,* a tool designed to end this frustration and lend ongoing inspiration and support to anyone who needs a precise command of color in all its delicious variety and moods. *The Complete Color Harmony Workbook* includes:

- **Basic color information**
- **A color wheel**
- **Themed color schemes**
- **Color swatches for easy reference**

Armed with this information, color professionals (including graphic and interior designers, architects, artists, and craftspeople) can approach their particular project—whether a brochure, home interior, or painting—infused with new confidence and creativity.

The Process of Choosing Color

To begin:

- **DEFINE** the mood and goal of your project;

- **CHOOSE** the color you feel best expresses this mood;

- **PLAY** with the possibilities presented in the workbook's color themes, using swatches to match fabrics, paints, papers, inks, and so on.

- **REFINE** these color options down to the best possible color scheme.

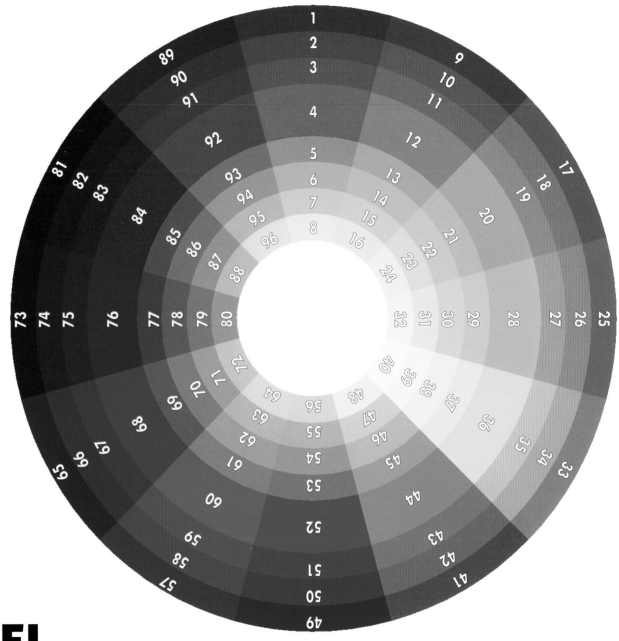

WORKING
WITH THE
COLOR WHEEL

While it may appear complex, the color wheel is simplicity itself.

Before discussing it, however, some basic color terminology is helpful. A hue is simply a pure color—any color except white or black. A tint is a hue mixed with white (red is a hue, pink is a tint). A shade is a hue mixed with black (maroon is a shade of red). A tone is a hue mixed with gray. The chroma is the intensity or saturation of a hue—red has a higher chroma than pink or maroon. The value describes the lightness and brightness of a color. Pink has a higher value than maroon; yellow has a higher value than blue.

The color wheel is composed of twelve basic hues: three primary, three secondary, and six tertiary. The colors in these families are found equidistant from one another on the color wheel.

Pure, high-chroma hues appear in the wide center band of the color wheel (look at numbers 4, 12, 20, 28, 36, 44, 52, 60, 68, 76, 84, and 92). Colors found in the four interior bands are tints, with various quantities of white added to the original hue; while the three outer bands are shades, with various amounts of black added to the original hue. The numbering system allows easy location of large swatches in the back of *Complete Color Harmony Workbook*.

PRIMARY hues are red, blue, and yellow—colors that cannot be made by mixing other colors.

SECONDARY hues (green, orange, violet) are made by mixing two primary colors—red and yellow, for example, create orange.

TERTIARY hues are made by mixing a primary with a secondary color— red-violet, yellow-orange, blue-green, blue-violet, yellow-green, and red-orange.

COMPLEMENTARY colors are opposite on the color wheel and, when mixed, will create a neutral.

THE FACETS OF COLOR

The emotional and psychological effects of color are undeniable, and it is in the facets of color that the feeling produced by color has its strongest impact. On a cold day, we long for the leaping red flames of a fire; in summer, the mere sight of a blue-green pool is refreshing. So we are constantly caught in the play of color and feeling, as outlined below.

HOT

Intense, fully saturated red is like the essence of fire—that's how to recognize a hot color. Red has been proven to stimulate the physical body, increasing the level of activity as well as body temperature; it also increases sexual desire. Hot colors are aggressive and attention-grabbing, making them a common choice in packaging and advertising design.

WARM

Warm colors are based in red. Unlike hot colors, warm colors are softened with the addition of yellow, which creates a heady array of red-orange, orange, and yellow-orange. These direct, emotionally touching colors seem to reach out to us—an inviting, comforting aspect of warm colors that makes them natural for home interiors.

COLD

To understand cold colors, think of ice, with its combined hues of blue, blue-green, and green. These colors have the mind/body effect of slowing metabolism—someone in a cold-colored room will literally "chill out." The effect of a fully saturated blue can be powerful, frigid, and austere; or it can be clean and fresh.

COOL

Cool colors are anchored in blue; unlike cold colors, however, they are blended with yellow and red, which creates a gorgeous range of colors from green through blue through violet. These colors are perceived as soothing, calming, meditative, and peaceful, like a slowly moving stream.

BRIGHT

Bright colors are clear, distinctive, high-chroma colors—pure hues without a noticeable addition of white or black. These intense colors actually seem to vibrate; they are a keynote of the Pop Art movement of the 1960s. Bright colors add dynamism and energy to graphic and advertising design, as well as fine and applied arts.

PALE

Pale colors are tints—that is, hues combined with a large amount of white. Found in the central rings of the color wheel, these soft, tender pastels evoke a feeling of youth, innocence, gentleness, and romance. These colors are considered to be "feminine" and are used frequently in cosmetic packaging.

LIGHT

Light colors are barely colors at all—only the faintest hint of a hue is perceptible in these sheer, translucent colors. Because they are mostly white, light colors reflect the light around them, making a room—or a painting—seem to glow with a subtle illumination. Light colors open up space, making it feel larger and airier.

DARK

Dark colors are strong, sober, and seem to diminish rather than expand space. They are often used in the fine arts, and interior and graphic design as a means of contrasting lighter colors, and can convey a variety of moods—from dignity, tradition, and restraint to melancholy.

BASIC COLOR SCHEMES

Basic color schemes concern the physical, objective reality of using and combining color. There's a mathematical perfection to these schemes; complementary colors, for example, will always be directly opposite each other on the color wheel, and will always seem to intensify each other. Each of these schemes creates a unique effect on the eye of the perceiver.

ACHROMATIC

Meaning "without color," an achromatic scheme consists of black and white, and the vast range of grays that can be mixed from them. Variation is possible—"warm" and "cool" achromatics are made by adding a hint of red, yellow, or blue.

ANALOGOUS

Any three hues that are adjacent to each other on the color wheel (including their tints and shades) are considered analogous. These hues have a harmonious, pleasing effect on the eye.

MONOCHROMATIC

This restrained, peaceful color scheme consists simply of a slice of the color wheel "pie"—a single hue combined with any of its tints or shades.

COMPLEMENTARY

This scheme involves using direct opposites on the color wheel—green/red, blue/orange, etc. These colors enhance one another, producing an almost vibratory visual sensation when seen side by side.

PRIMARY

The most basic of color schemes: the pure hues of red, yellow, and blue are combined. The elementary nature of this color scheme makes it a favorite for children's books, toys, and bedrooms. The purity of the primary scheme has made it an important palette for such artists as Piet Mondrian and Roy Lichtenstein.

SPLIT COMPLEMENTARY

The split complementary scheme is often more pleasing than a true complementary scheme. Choose a hue; the hues on either side of its complement create the split complementary scheme (orange with blue-green and blue-violet, for example).

CLASH

Clash color schemes have a brash, surprising effect. To create a clash color scheme, combine a hue with the color found on either side of its complement; blue with red-orange or orange-yellow, for example.

SECONDARY

The secondary color scheme combines the secondary hues of green, violet, and orange. It has a fresh, uplifting quality and can be made quite subtle by using tints and shades of the secondary hues.

TERTIARY TRIAD

There are two tertiary triad color schemes, which consist of three tertiary hues that are equidistant from each other on the color wheel. The two tertiary triad schemes are: Red-violet, yellow-orange, and blue-green; or red-orange, yellow-green, and blue-violet.

NEUTRAL

So soft that it seems almost invisible, a neutral color scheme consists of hues that have been neutralized by adding their complements. The further addition of black and white expands the neutral palette.

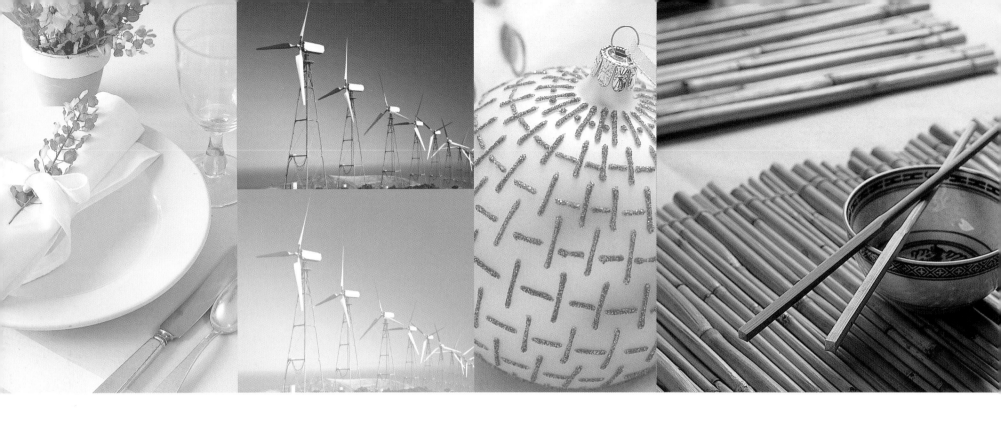

SPECIAL EFFECTS FOR COLOR

Necessity may be the mother of invention, but it is our continual quest for change that leads to innovation. This principle has governed color research over the ages.

In ancient Egypt, Cleopatra couldn't exactly send a slave to the local drugstore for a new lipstick. So the Queen of the Nile turned instead to her cosmetic wizards, who transformed flower blossoms and fine clay into a cornucopia of lip and cheek rouges, and crushed ant eggs to make eyeliner.

Artists spent centuries as veritable prisoners in their studios until the invention of pigment tubes, which finally allowed them to paint en plein air. The Impressionists' extraordinary marriage of color and light would have been impossible had they not taken their palettes and brushes outdoors.

Today's technological advances in printing have left no new colors to create, so where do we turn for the next wave in color innovation? Just as the ever-changing sunlight on a landscape inspired the Impressionist painters, metallic, opalescent, and fluorescent special effects can transform the way we perceive

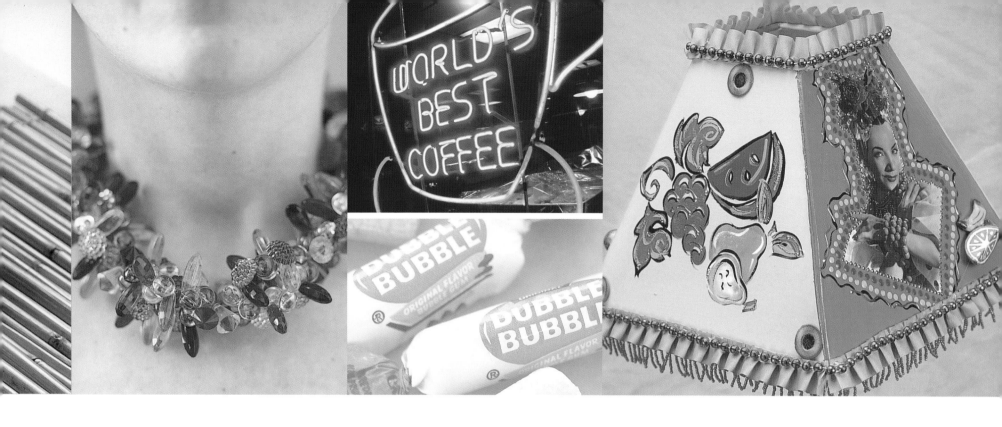

color. These shimmering finishes catch our eye in subtle or dramatic ways, capturing and reflecting light while adding surface interest and a fresh dimension to the spectrum.

The psychological implications of these special effects also offer designers a new avenue for reaching out to their target markets. Fluorescents pop with an energizing youth and vitality, while metallics and opalescents speak quietly of refined taste and exclusivity.

Do you want to imply affluence? From antique chalices and crowns to the cry of "Eureka!" in the gold rush days, shiny metallics have always held a special, moneyed allure, for both the obvious intrinsic value of the ore itself and its use as coin of the realm. Today, the very mention of the word gold or silver

conjures images of power and success. These colors adorn the best athletes in the world at the Olympic Games and are reserved for the most prestigious customers by credit card companies.

Interestingly, even though gold is the more precious of the two metals, silver has greater appeal to luxury car buyers in Asia, Europe, and the Americas, according to DuPont's annual Global Color Popularity Report. Since icy grays contain none of the warmth associated with gold tones, silver implies an aloofness that sets it apart from the mass market. After all, we say the rich are born with silver spoons in their mouths, not gold.

DuPont suggests that silver also offers "sophisticated automotive styling cues that express technology

driven lifestyles." The association of metallics and optical effects with the Computer Age adds to this message of state-of-the-art innovation.

In printing, "things that sparkle and shine tend to get noticed," affirms *Ink World* magazine. But unlike eye-catching reds or oranges, metallics connote money and currency, giving them an impression of extravagance. Silver or gold ink on wedding invitations speaks of ballrooms and chandeliers, while metallic wrapping paper suggests a precious gift inside.

Of course, all that glitters goes well beyond gold—or silver, for that matter. Metallic finishes can add depth to any hue in the spectrum.

Opalescents remind one of gemstones and lustrous pearls. Even the luminescent interior of an abalone or conch shell lying on the beach gives the impression of a buried treasure. In addition to pleasing the eye, opals and pearls can be either classic or unique, so those ethereal finishes appeal to a wide range of tastes.

Consider that style icons like Jacqueline Kennedy Onassis and Audrey Hepburn popularized wearing a single tasteful strand of pearls, always de rigueur in proper society. But at the same time, iconoclasts have given pearls a more unconventional twist, as exemplified by provocative dancer Josephine Baker, who wore ropes and ropes of pearls in her act, and not much else.

An attraction to opalescent finishes isn't exclusive to women. Lustrous sheens in products and packaging also appeal to men who want to express a sense of nonconformity without being overt. When men buy sun- or eyeglass frames, for example, they prefer interesting surface finishes that mottle the color, making it more distinctive.

And for that all-important automobile purchase, metallic or opalescent effects exude class and originality. Anyone can own a white car, the thinking goes, but one that has a pearlized cream finish that changes color depending on the time of day makes a statement in the driveway.

If you really want to catch your neighbor's eye, though, fluorescents are the way to go. No other colors command immediate attention as effectively.

Favored by children, playful designers, and athletic-wear manufacturers, fluorescent colors offer a kitschy, retro feeling reminiscent of neon signs and roadside diners. But there's a practical side as well. As the most conspicuous color effect, Day-Glo brights are ideal for running shoes and outdoor apparel to make athletes and children more noticeable at night.

That's why fluorescents are the finish of choice for emergency equipment and signs. Brilliant yellow road signs pop out against the pavement, rapidly alerting drivers to potential hazards, while high-intensity orange life preservers silently call out to rescue boats. Construction workers and crossing guards would be in greater danger if their bright orange vests didn't set them apart from oncoming traffic.

Lime green is the ideal choice for billboards or equipment that needs to be seen at night. Research has proven that reflective fluorescent lime is the most visible color in the dark, as well as in poor weather conditions such as fog.

In fact, safety-research studies of fire engines found that when they were painted lime green, the trucks were involved in half the number of traffic accidents, especially at night. So why aren't all fire trucks now painted lime? Because red proved too iconic with the public, which psychologically couldn't accept such a major color change.

That can be a great advantage of special-effects finishes: Applying them lets you change the look of an existing product without altering its accepted color.

A French rosary manufacturer did precisely that in the 1600s by artificially creating pearlescent pigments to give its beads a suitably ethereal presence. The desired effect was achieved by scraping the skin and scales of whitefish

Today, mica crystals, both natural and synthetic, produce light-reflecting iridescence. But as was true in the seventeenth century, the popularity of these finishes is due in part to our renewed spirituality in troubled times.

Luminosity is prized for more down-to-earth reasons as well, with mica being seen as an indispensable ingredient in cosmetic foundations that promise a "youthful glow."

Car finishes, however, need to last a lot longer than makeup applications. It took years of research for the automotive industry to develop pearlized effects that could pass the standard three-year durability test for heat stability and weather-fastness. Metallic car colors underwent their own ingredient makeover to guarantee longevity. The metal flakes used in the 1950s required so many clear top coats that the top coats often cracked and yellowed. Mylar-coated flakes are used today.

A leader in the science of color management, DuPont used the knowledge it accumulated while researching automotive finishes to make special-effects printing more predictable. The performance of metallic inks has also improved in recent years, resulting in substantial market growth.

METALLIC PALETTES

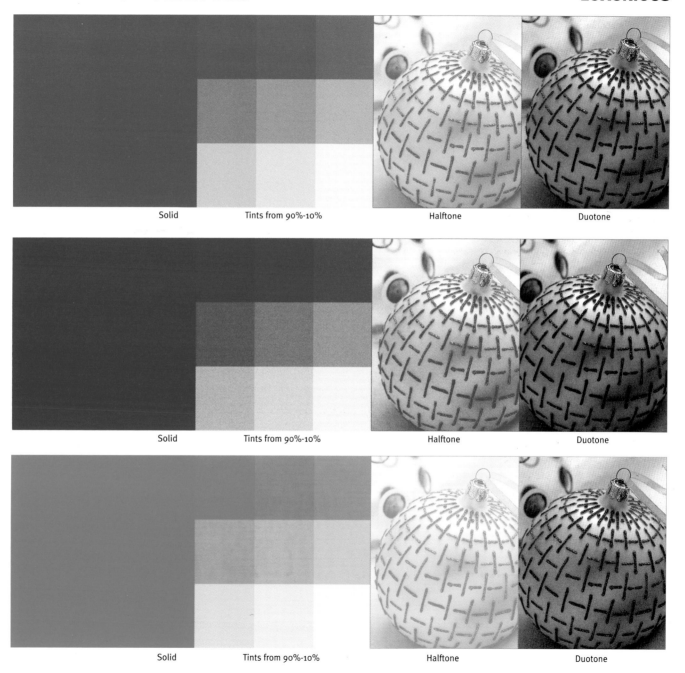

Solid Tints from 90%-10% Halftone Duotone

Solid Tints from 90%-10% Halftone Duotone

Solid Tints from 90%-10% Halftone Duotone

special effects for color

SOPHISTICATED

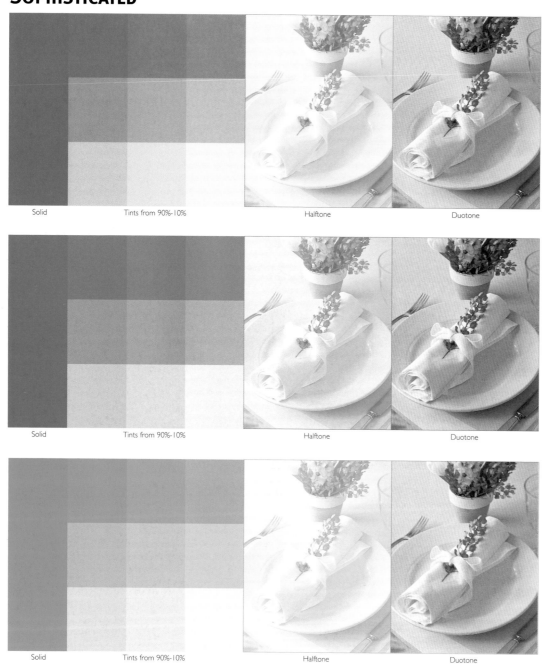

Solid Tints from 90%-10% Halftone Duotone

Solid Tints from 90%-10% Halftone Duotone

Solid Tints from 90%-10% Halftone Duotone

complete color harmony workbook

Solid Tints from 90%-10% Halftone Duotone

Solid Tints from 90%-10% Halftone Duotone

Solid Tints from 90%-10% Halftone Duotone

metallic palettes

CORPORATE

Solid Tints from 90%-10% Halftone Duotone

Solid Tints from 90%-10% Halftone Duotone

Solid Tints from 90%-10% Halftone Duotone

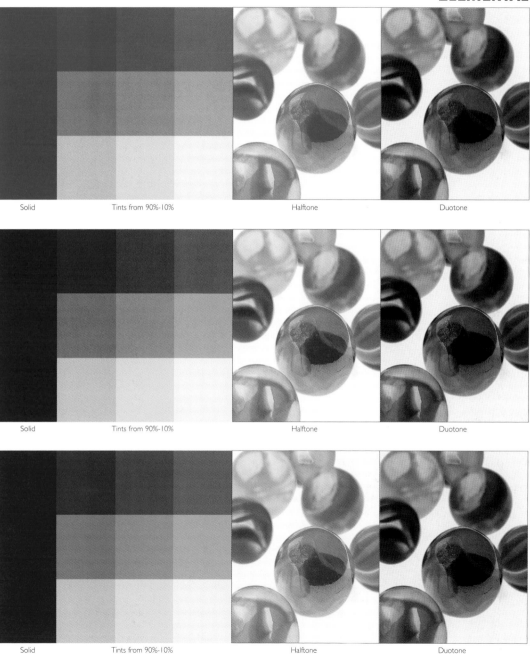

Solid Tints from 90%-10% Halftone Duotone

Solid Tints from 90%-10% Halftone Duotone

Solid Tints from 90%-10% Halftone Duotone

metallic palettes

Organic

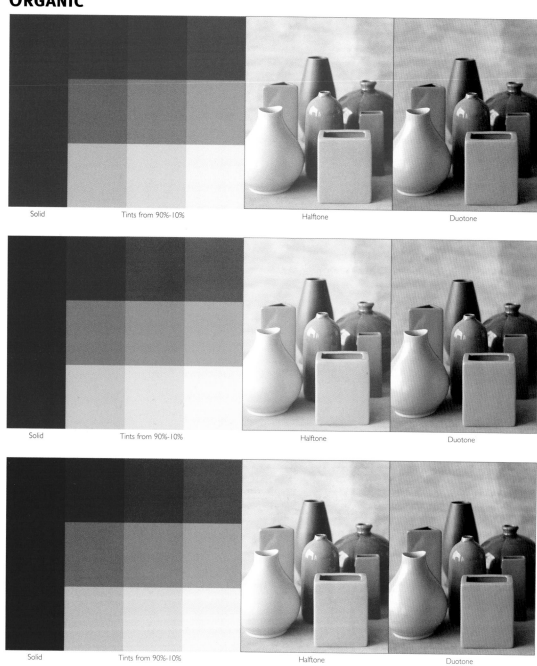

Solid Tints from 90%-10% Halftone Duotone

Solid Tints from 90%-10% Halftone Duotone

Solid Tints from 90%-10% Halftone Duotone

complete color harmony workbook

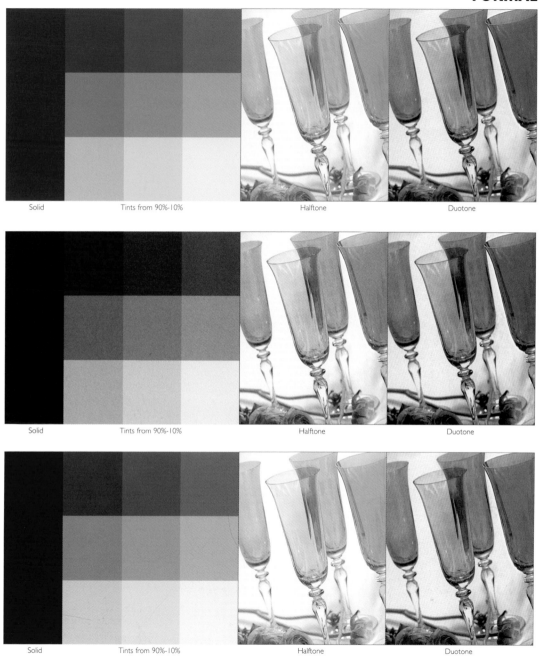

Solid Tints from 90%-10% Halftone Duotone

Solid Tints from 90%-10% Halftone Duotone

Solid Tints from 90%-10% Halftone Duotone

metallic palettes

FESTIVE

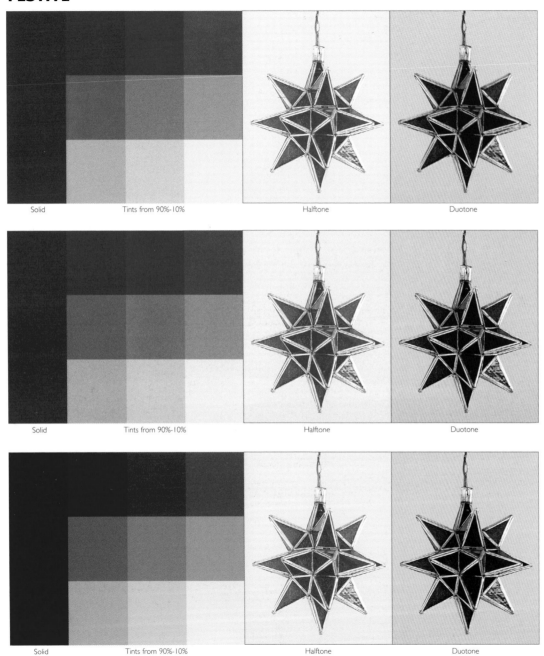

| Solid | Tints from 90%-10% | Halftone | Duotone |

| Solid | Tints from 90%-10% | Halftone | Duotone |

| Solid | Tints from 90%-10% | Halftone | Duotone |

complete color harmony workbook

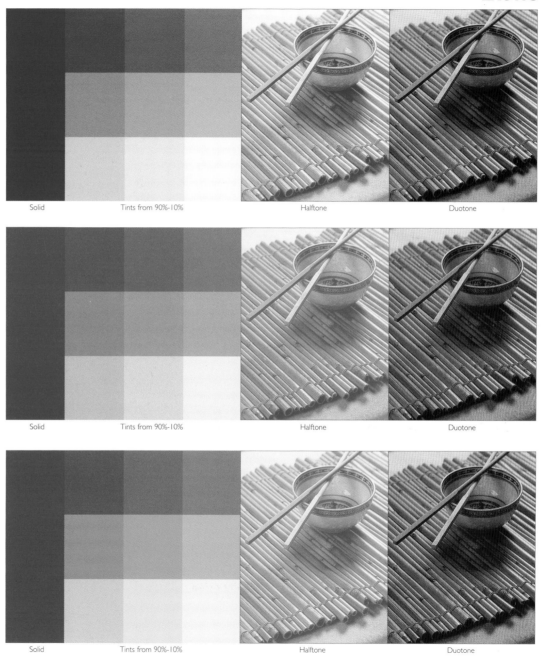

Solid Tints from 90%-10% Halftone Duotone

Solid Tints from 90%-10% Halftone Duotone

Solid Tints from 90%-10% Halftone Duotone

metallic palettes

FLUORESCENT PALETTES ### OLD-FASHIONED

Solid | Halftone | Duotone

RETRO

Solid | Halftone | Duotone

HAPPY

Solid | Halftone | Duotone

complete color harmony workbook

SAFETY

Solid Halftone Duotone

FUN AND WILD

Solid Halftone Duotone

SWEET

Solid Halftone Duotone

PRETTY

Solid Halftone Duotone

GIRLY

Solid Halftone Duotone

AND WHAT'S NEXT?

And what's next? The industry magazine
Ward's Auto World predicts that "effects such as matte and gloss, reflective and iridescent, and opaque and phosphorescent, are some of the new automotive coating trends expected to show up on dealer lots in the next few years." Holographic, refractive, and glow-in-the-dark color research is also underway, not only for use on cars, but in product packaging as well.

This means big business for many industries. When glow-in-the-dark material was first produced in children's sneakers, for example, the resulting effect proved irresistible to both boys and girls, greatly boosting sales.

Once the technology is perfected, the next step involves romancing the consumer. That's why color naming has become a science unto itself, with vivid monikers being coined.

The experts at the Color Marketing Group have always been inventive. Metallic names have included Shimma, "a shimmer, a shake, a little golden flake;"

Fortune Teller, "a deepened, metallic hue that looks into the future of gray and silver;" Champagne Bubble, "celebrating the marriage of Silver to Gold with Art Deco glamour;" and Root Beer, a copper-based rich brown with "pop."

From the Ralph Lauren paint line come Looking Glass Slipper, Ballroom Gold, and Oyster Pearl, all bringing to mind the elegant luster of Lauren's Duchesse Satin wall finish.

Feel the need for speed? Harley-Davidson can rev up your engine with the custom colors Sinister Blue Pearl or Arresting Red. And what child wouldn't be happy with a playroom painted fluorescent Saturn Yellow, Blaze Orange, or Rocket Red?

But whether tantalized by the name or the multicolored finish, "the human eye is always stimulated by novelty," according to the experts at Pantone. Technological advances in special-effects color finishes should keep delivering surprises for many years to come.

CREATIVE COLOR COMBINATIONS

Nassar Design

ICI Paints, maker of the Glidden brand

Ann Salisbury, *Inner Glow*

POWERFUL

A powerful color scheme is one that captures the viewer's attention and emotion. The surest means to this end? Use a potent red hue as part of a color scheme. Irrespective of the other hues used, one's eye will always gravitate to where the red is. This aggressive, dominant quality has long made red the color of choice for advertising, particularly packaging—it's natural to see a red soft drink can or cigarette pack before noticing products in more subtly hued packaging. It is interesting to note how many nation's flags include red, the color of strength.

The bold effect of a powerful color scheme may derive from playing red off of its complement or near complementaries. Green, blue-green and yellow-green enhance red hues and take on an increased vibrance in proximity to red. Analogous schemes that include tints or shades of red, red-orange and red-violet often have a warming, even royal effect. It may be more effective to allow a red hue to speak for itself, by combining it with tints and shades or setting it off with achromatics. In any case, a powerful color scheme is intrepid and full of drama.

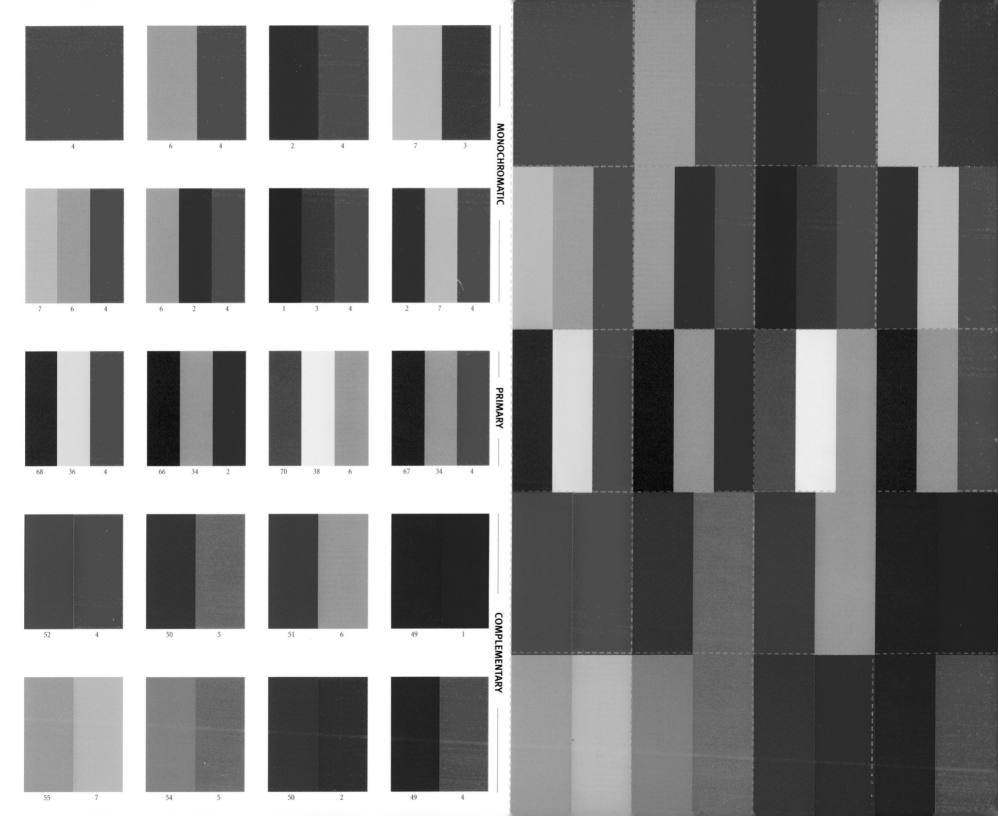

4

6 4

2 4

7 3

7 6 4

6 2 4

1 3 4

2 7 4

68 36 4

66 34 2

70 38 6

67 34 4

52 4

50 5

51 6

49 1

55 7

54 5

50 2

49 4

POWERFUL Monochromatic 7

POWERFUL Monochromatic 4

POWERFUL Monochromatic 2

POWERFUL Monochromatic 4

POWERFUL Monochromatic 6

POWERFUL Monochromatic 4

POWERFUL Monochromatic 4

POWERFUL Monochromatic 7

POWERFUL Monochromatic 2

POWERFUL Monochromatic 4

POWERFUL Monochromatic 3

POWERFUL Monochromatic 1

POWERFUL Monochromatic 4

POWERFUL Monochromatic 2

POWERFUL Monochromatic 6

POWERFUL Monochromatic 4

POWERFUL Monochromatic 6

POWERFUL Monochromatic 7

POWERFUL Primary 4

POWERFUL Primary 34

POWERFUL Primary 67

POWERFUL Primary 6

POWERFUL Primary 38

POWERFUL Primary 70

POWERFUL Primary 2

POWERFUL Primary 34

POWERFUL Primary 66

POWERFUL Primary 4

POWERFUL Primary 36

POWERFUL Primary 68

POWERFUL Complementary 1

POWERFUL Complementary 49

POWERFUL Complementary 6

POWERFUL Complementary 51

POWERFUL Complementary 5

POWERFUL Complementary 50

POWERFUL Complementary 4

POWERFUL Complementary 52

POWERFUL Complementary 4

POWERFUL Complementary 49

POWERFUL Complementary 2

POWERFUL Complementary 50

POWERFUL Complementary 5

POWERFUL Complementary 54

POWERFUL Complementary 7

POWERFUL Complementary 55

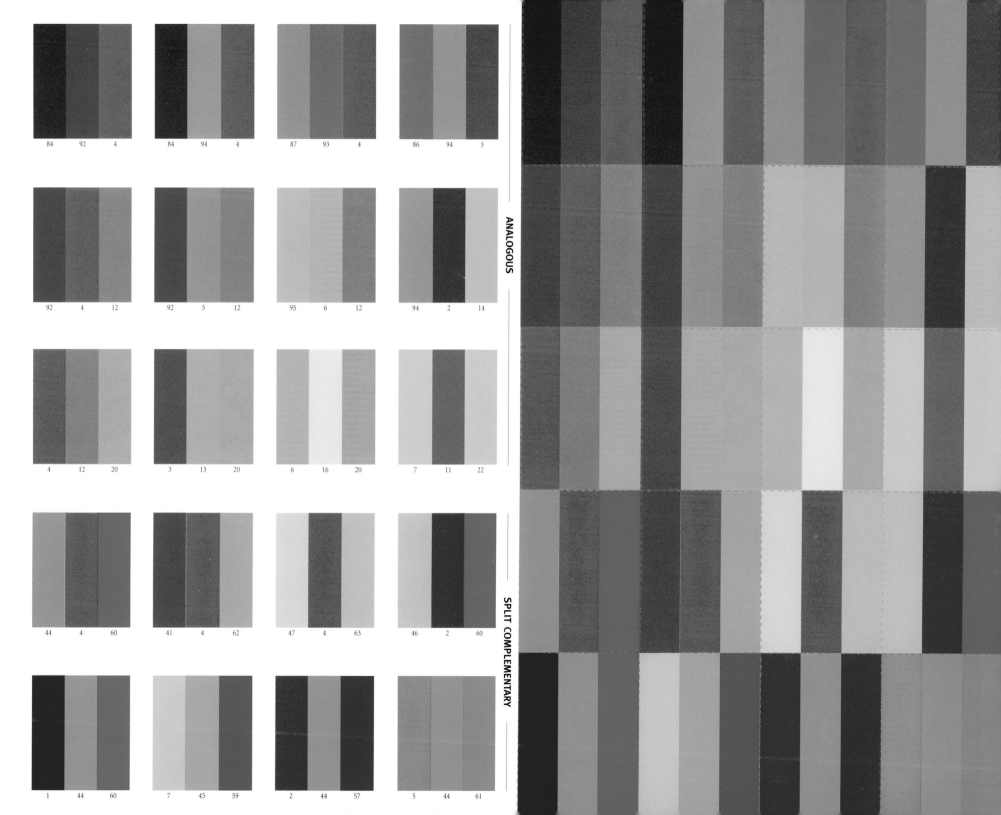

84 92 4

84 94 4

87 93 4

86 94 3

92 4 12

92 5 12

95 6 12

94 2 14

4 12 20

3 13 20

6 16 20

7 11 22

44 4 60

41 4 62

47 4 63

46 2 60

1 44 60

7 45 59

2 44 57

5 44 61

POWERFUL											
Analogous 3	Analogous 94	Analogous 86	Analogous 4	Analogous 93	Analogous 87	Analogous 4	Analogous 94	Analogous 84	Analogous 4	Analogous 92	Analogous 84
Analogous 14	Analogous 2	Analogous 94	Analogous 12	Analogous 6	Analogous 95	Analogous 12	Analogous 5	Analogous 92	Analogous 12	Analogous 4	Analogous 92
Analogous 22	Analogous 11	Analogous 7	Analogous 20	Analogous 16	Analogous 6	Analogous 20	Analogous 13	Analogous 3	Analogous 20	Analogous 12	Analogous 4
Split Complementary 60	Split Complementary 2	Split Complementary 46	Split Complementary 63	Split Complementary 4	Split Complementary 47	Split Complementary 62	Split Complementary 4	Split Complementary 41	Split Complementary 60	Split Complementary 4	Split Complementary 44
Split Complementary 61	Split Complementary 44	Split Complementary 5	Split Complementary 57	Split Complementary 44	Split Complementary 2	Split Complementary 59	Split Complementary 7	Split Complementary 60	Split Complementary 44	Split Complementary 1	

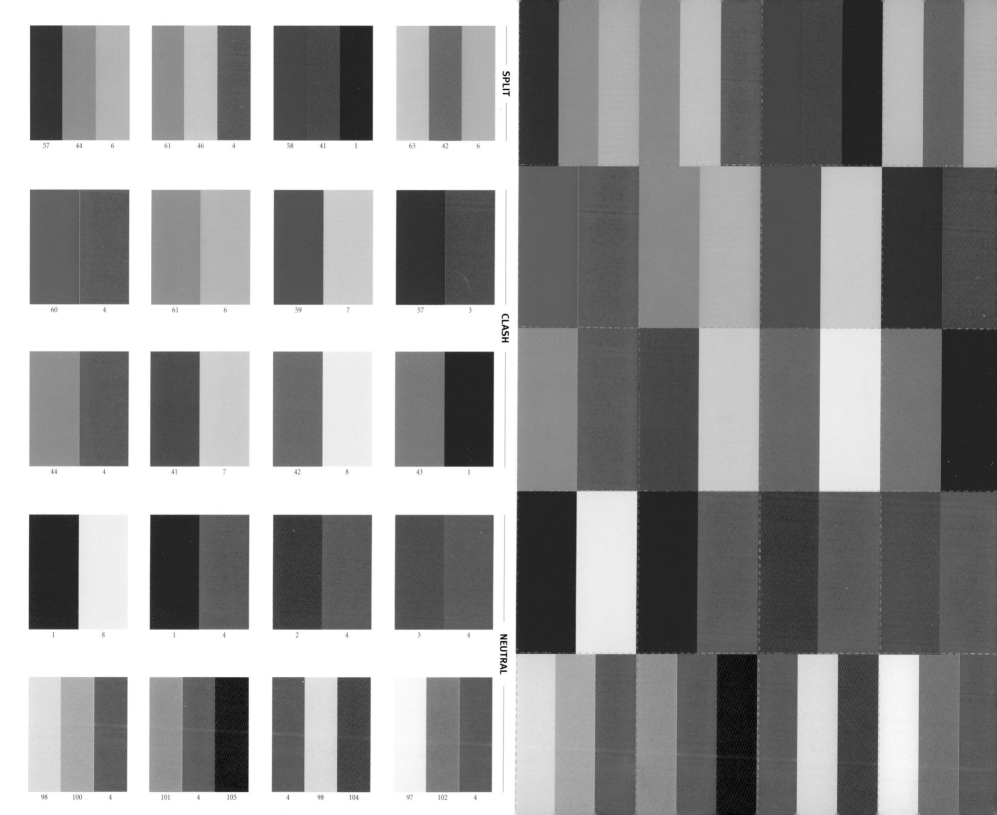

57 44 6

61 46 4

58 41 1

63 42 6

60 4

61 6

59 7

57 3

44 4

41 7

42 8

43 1

1 8

1 4

2 4

3 4

98 100 4

101 4 105

4 98 104

97 102 4

POWERFUL Split 6
POWERFUL Split 42
POWERFUL Split 63
POWERFUL Split 1
POWERFUL Split 41
POWERFUL Split 58
POWERFUL Split 4
POWERFUL Split 46
POWERFUL Split 61
POWERFUL Split 6
POWERFUL Split 44
POWERFUL Split 57

POWERFUL Clash 3
POWERFUL Clash 57
POWERFUL Clash 7
POWERFUL Clash 59
POWERFUL Clash 6
POWERFUL Clash 61
POWERFUL Clash 4
POWERFUL Clash 60

POWERFUL Clash 1
POWERFUL Clash 43
POWERFUL Clash 8
POWERFUL Clash 42
POWERFUL Clash 7
POWERFUL Clash 41
POWERFUL Clash 4
POWERFUL Clash 44

POWERFUL Neutral 4
POWERFUL Neutral 3
POWERFUL Neutral 4
POWERFUL Neutral 2
POWERFUL Neutral 4
POWERFUL Neutral 1
POWERFUL Neutral 8
POWERFUL Neutral 1

POWERFUL Neutral 4
POWERFUL Neutral 102
POWERFUL Neutral 97
POWERFUL Neutral 104
POWERFUL Neutral 98
POWERFUL Neutral 4
POWERFUL Neutral 105
POWERFUL Neutral 4
POWERFUL Neutral 101
POWERFUL Neutral 4
POWERFUL Neutral 100
POWERFUL Neutral 98

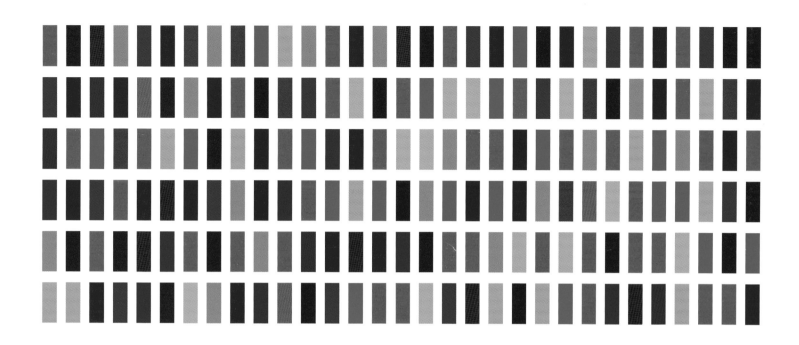

POWERFUL
Tips for Color Schemes

GENERAL COLOR

In choosing the proper red for a project, remember that it need not be strident to be powerful; a tint, tone or shade of red (or red-orange) may be a more appropriate, less demanding choice.

GRAPHIC DESIGN

A powerful color scheme is natural for graphic and advertising design. It is more appropriate for an attention-grabbing project—a poster, mailer or packaging—than for projects that require more "polite" hues (annual reports, invitations, and so on).

INTERIOR DESIGN

In using powerful color schemes, it is important to remember that red is a stimulating color; while it increases sexual ardor, it may be difficult to sleep in a red bedroom. It can, however, increase focus in an office or a study.

FINE ART

Using a powerful color scheme in the fine or applied arts can create a highly emotional response in a viewer, ranging from joy and exhilaration to discomfort.

ICI Paints, maker of the Glidden brand

GAD Design

Artist: Lesley Jacobs

RICH

The hues of gemstones, precious carpets, dark wood, and aged wine are the basis of a rich color scheme. The dominant feeling conveyed by a rich color scheme is of affluence, harmony, and age-old comfort. Colors are dominant without being overwhelming. A rich color scheme often includes complementary hues that have been deepened and enriched with black—think of the russet and maroon, forest green and olive, that are found in fine old carpets and tapestries. Touched with metallic golds and bronzes, rich colors have a traditional flavor, and appear to have been burnished with age.

Mellow shades of red are the starting point in a rich color scheme, and warm colors will generally dominate, though often in a surprising way: Polished wood may be the basic "color" of a rich interior, for example. Texture is important to a rich color scheme; in interiors, think of fabrics like moire and raw silk; in graphic design, paper will be heavy and pleasing to the touch; in the fine arts, there will be a tactile quality and perhaps visible brush strokes.

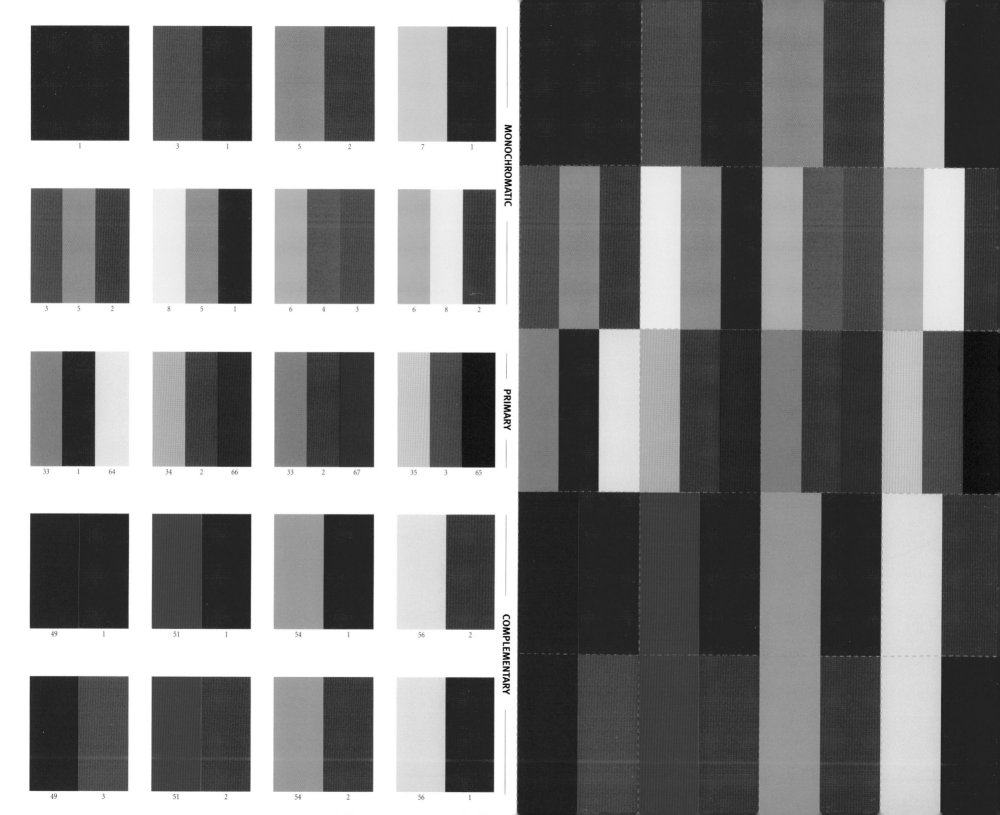

MONOCHROMATIC

1

3　1

5　2

7　1

3　5　2

8　5　1

6　4　3

6　8　2

PRIMARY

33　1　64

34　2　66

33　2　67

35　3　65

COMPLEMENTARY

49　1

51　1

54　1

56　2

49　3

51　2

54　2

56　1

RICH Complementary 1
RICH Complementary 56
RICH Complementary 2
RICH Complementary 54
RICH Complementary 2
RICH Complementary 51
RICH Complementary 3
RICH Complementary 49

RICH Complementary 2
RICH Complementary 56
RICH Complementary 1
RICH Complementary 54
RICH Complementary 1
RICH Complementary 51
RICH Complementary 1
RICH Complementary 49

RICH Primary 65
RICH Primary 3
RICH Primary 35
RICH Primary 67
RICH Primary 2
RICH Primary 33
RICH Primary 66
RICH Primary 2
RICH Primary 34
RICH Primary 64
RICH Primary 1
RICH Primary 33

RICH Monochromatic 2
RICH Monochromatic 8
RICH Monochromatic 6
RICH Monochromatic 3
RICH Monochromatic 4
RICH Monochromatic 6
RICH Monochromatic 1
RICH Monochromatic 5
RICH Monochromatic 8
RICH Monochromatic 2
RICH Monochromatic 5
RICH Monochromatic 3

RICH Monochromatic 1
RICH Monochromatic 7
RICH Monochromatic 2
RICH Monochromatic 5
RICH Monochromatic 1
RICH Monochromatic 3
RICH Monochromatic 1

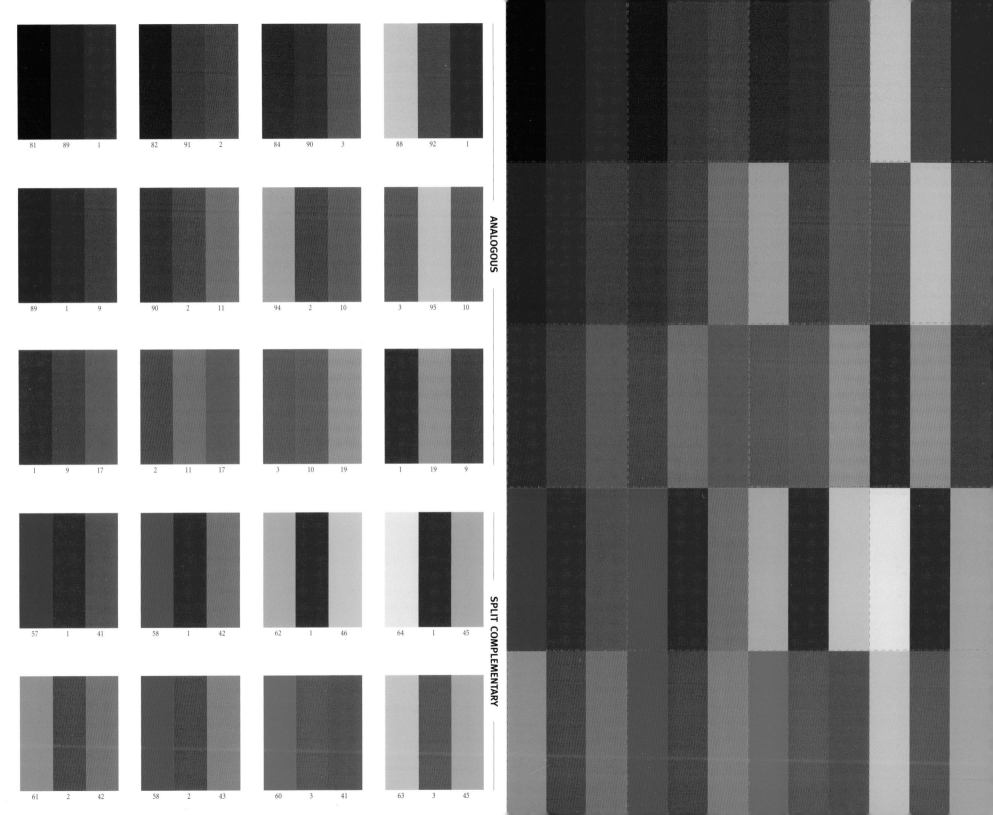

81 89 1

82 91 2

84 90 3

88 92 1

89 1 9

90 2 11

94 2 10

3 95 10

1 9 17

2 11 17

3 10 19

1 19 9

57 1 41

58 1 42

62 1 46

64 1 45

61 2 42

58 2 43

60 3 41

63 3 45

RICH Analogous 1
RICH Analogous 92
RICH Analogous 88
RICH Analogous 3
RICH Analogous 90
RICH Analogous 84
RICH Analogous 2
RICH Analogous 91
RICH Analogous 82
RICH Analogous 1
RICH Analogous 89
RICH Analogous 81

RICH Analogous 10
RICH Analogous 95
RICH Analogous 3
RICH Analogous 10
RICH Analogous 2
RICH Analogous 94
RICH Analogous 11
RICH Analogous 2
RICH Analogous 90
RICH Analogous 9
RICH Analogous 1
RICH Analogous 89

RICH Analogous 9
RICH Analogous 19
RICH Analogous 1
RICH Analogous 19
RICH Analogous 10
RICH Analogous 3
RICH Analogous 17
RICH Analogous 11
RICH Analogous 2
RICH Analogous 17
RICH Analogous 9
RICH Analogous 1

RICH Split Complementary 45
RICH Split Complementary 1
RICH Split Complementary 64
RICH Split Complementary 46
RICH Split Complementary 1
RICH Split Complementary 62
RICH Split Complementary 42
RICH Split Complementary 1
RICH Split Complementary 58
RICH Split Complementary 41
RICH Split Complementary 1
RICH Split Complementary 57

RICH Split Complementary 45
RICH Split Complementary 3
RICH Split Complementary 63
RICH Split Complementary 41
RICH Split Complementary 3
RICH Split Complementary 60
RICH Split Complementary 43
RICH Split Complementary 2
RICH Split Complementary 58
RICH Split Complementary 42
RICH Split Complementary 2
RICH Split Complementary 61

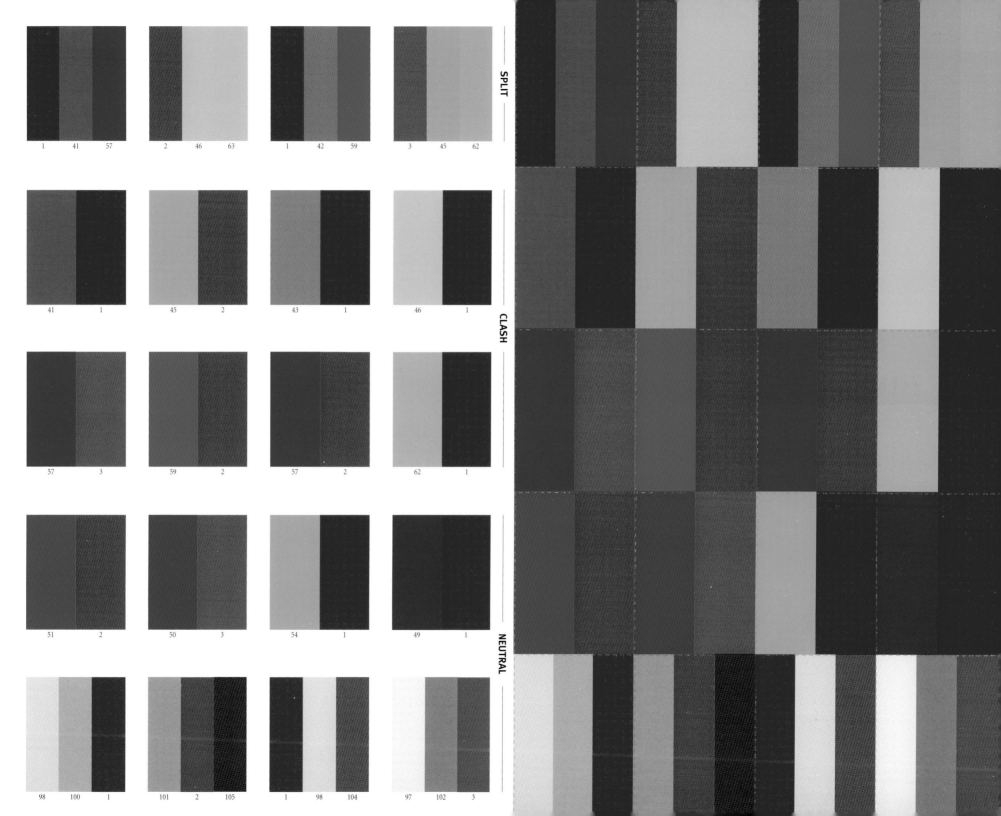

SPLIT

1	41	57
2	46	63
1	42	59
3	45	62

CLASH

41	1
45	2
43	1
46	1

57	3
59	2
57	2
62	1

NEUTRAL

51	2
50	3
54	1
49	1

98	100	1
101	2	105
1	98	104
97	102	3

RICH Split 62 · RICH Split 45 · RICH Split 3 · RICH Split 59 · RICH Split 42 · RICH Split 1 · RICH Split 63 · RICH Split 46 · RICH Split 2 · RICH Split 57 · RICH Split 41 · RICH Split 1

RICH Clash 1 · RICH Clash 46 · RICH Clash 1 · RICH Clash 43 · RICH Clash 2 · RICH Clash 45 · RICH Clash 1 · RICH Clash 41

RICH Clash 1 · RICH Clash 62 · RICH Clash 2 · RICH Clash 57 · RICH Clash 2 · RICH Clash 59 · RICH Clash 3 · RICH Clash 57

RICH Neutral 1 · RICH Neutral 49 · RICH Neutral 1 · RICH Neutral 54 · RICH Neutral 3 · RICH Neutral 50 · RICH Neutral 2 · RICH Neutral 51

RICH Neutral 3 · RICH Neutral 102 · RICH Neutral 97 · RICH Neutral 104 · RICH Neutral 98 · RICH Neutral 1 · RICH Neutral 105 · RICH Neutral 2 · RICH Neutral 101 · RICH Neutral 1 · RICH Neutral 100 · RICH Neutral 98

RICH
Tips for Color Schemes

GENERAL COLOR

Rich doesn't mean expensive; it just looks like it. A small amount of metallic gold (in the form of picture frames, mirrors, tassels, pillows, or —for graphic design—ink) enhances a rich color scheme immeasurably.

GRAPHIC DESIGN

Graphic designers will want to find the best possible paper a project's budget will withstand. Texture is crucial. A warm tone (creamy off-white) is preferable to a stark white.

INTERIOR DESIGN

To incorporate a rich color scheme into interior design, begin by finding a warm shade of red or gold for the walls. Polished wooden floors and furniture, as well as wainscoting, are other basics of a rich interior.

FINE ART

Fine artists should use oil paints instead of acrylics for a rich look. The depth, warmth and glow of oil paint makes up for its longer drying time.

Jewboy Corporation

Ann Pember
Peony Birth

ICI Paints, maker of the Glidden brand

ROMANTIC

A romantic color scheme is gentle, its delicate pastels evocative of early spring flowers. Surprisingly, red is the hue that is the basis for a romantic color scheme—red that's been gentled with white to make a pale pink tint, transforming a strident and passionate hue to a color that whispers softly of love and friendship. The eye is naturally drawn to pink because of its red hue; but pink attracts attention, where red demands it. Red is the symbolic color of Mars, the god of war; pink, on the other hand, is the color of Venus, goddess of love. Like Venus, pink is sensuous, captivating, and delicious, seductive without being threatening.

The romantic aspect of pink is combined most successfully with other pastel tints—pale lavenders and violets, light sky blue, peach, pale green, and yellow. These colors, which have an inherently feminine feel, recall Aubusson carpets, hand-tinted photographs, antique Chinese porcelains, and the palette of such painters as Degas and Fragonard.

complete color harmony workbook

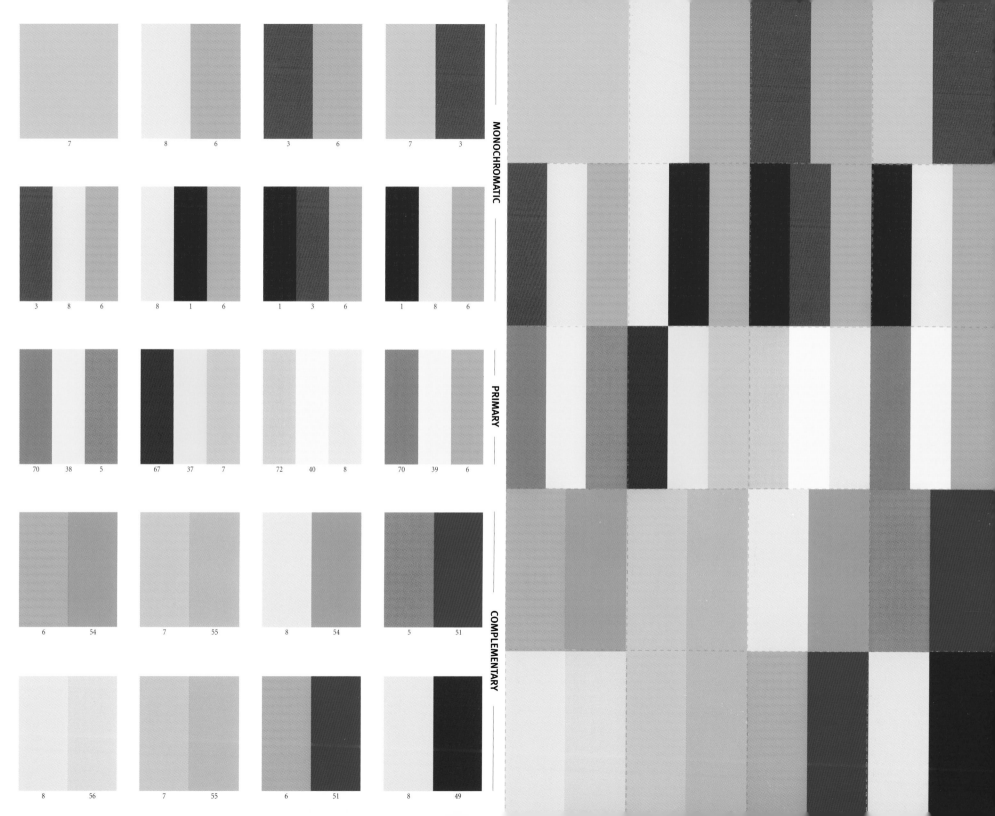

MONOCHROMATIC

7

8　　6

3　　6

7　　3

3　　8　　6

8　　1　　6

1　　3　　6

1　　8　　6

PRIMARY

70　　38　　5

67　　37　　7

72　　40　　8

70　　39　　6

COMPLEMENTARY

6　　54

7　　55

8　　54

5　　51

8　　56

7　　55

6　　51

8　　49

ROMANTIC Monochromatic 3
ROMANTIC Monochromatic 7
ROMANTIC Monochromatic 6
ROMANTIC Monochromatic 3
ROMANTIC Monochromatic 6
ROMANTIC Monochromatic 8
ROMANTIC Monochromatic 7

ROMANTIC Monochromatic 6
ROMANTIC Monochromatic 8
ROMANTIC Monochromatic 1
ROMANTIC Monochromatic 6
ROMANTIC Monochromatic 3
ROMANTIC Monochromatic 1
ROMANTIC Monochromatic 6
ROMANTIC Monochromatic 1
ROMANTIC Monochromatic 8
ROMANTIC Monochromatic 6
ROMANTIC Monochromatic 8
ROMANTIC Monochromatic 3

ROMANTIC Primary 6
ROMANTIC Primary 39
ROMANTIC Primary 70
ROMANTIC Primary 8
ROMANTIC Primary 40
ROMANTIC Primary 72
ROMANTIC Primary 7
ROMANTIC Primary 37
ROMANTIC Primary 67
ROMANTIC Primary 5
ROMANTIC Primary 38
ROMANTIC Primary 70

ROMANTIC Complementary 51
ROMANTIC Complementary 5
ROMANTIC Complementary 54
ROMANTIC Complementary 8
ROMANTIC Complementary 55
ROMANTIC Complementary 7
ROMANTIC Complementary 54
ROMANTIC Complementary 6

ROMANTIC Complementary 49
ROMANTIC Complementary 8
ROMANTIC Complementary 51
ROMANTIC Complementary 6
ROMANTIC Complementary 55
ROMANTIC Complementary 7
ROMANTIC Complementary 56
ROMANTIC Complementary 8

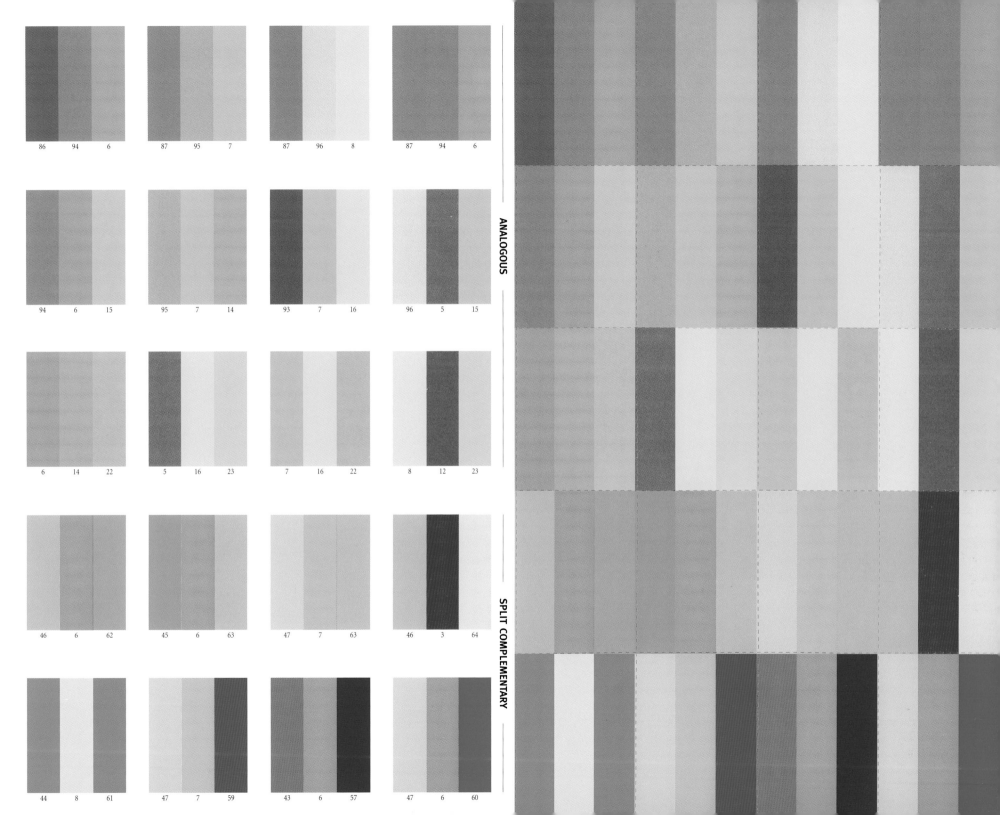

| 86 | 94 | 6 | | 87 | 95 | 7 | | 87 | 96 | 8 | | 87 | 94 | 6 |

ANALOGOUS

| 94 | 6 | 15 | | 95 | 7 | 14 | | 93 | 7 | 16 | | 96 | 5 | 15 |

| 6 | 14 | 22 | | 5 | 16 | 23 | | 7 | 16 | 22 | | 8 | 12 | 23 |

SPLIT COMPLEMENTARY

| 46 | 6 | 62 | | 45 | 6 | 63 | | 47 | 7 | 63 | | 46 | 3 | 64 |

| 44 | 8 | 61 | | 47 | 7 | 59 | | 43 | 6 | 57 | | 47 | 6 | 60 |

ROMANTIC Split Complementary	ROMANTIC Split Complementary	ROMANTIC Analogous	ROMANTIC Analogous	ROMANTIC Analogous
60	64	23	15	6
6	3	12	5	94
47	46	8	96	87
57	63	22	16	8
6	7	16	7	96
43	45	7	93	87
59	63	23	14	7
7	6	16	7	95
47	45	5	95	87
61	62	22	15	6
8	6	14	6	94
44	46	6	94	86

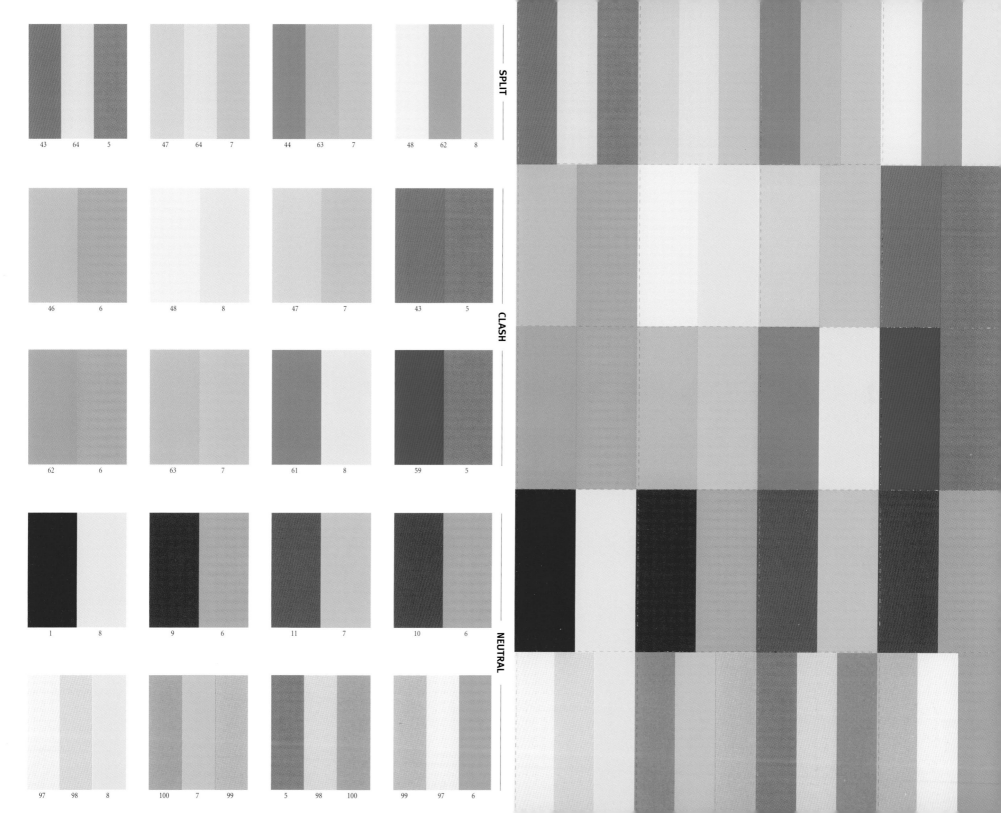

SPLIT

| 43 | 64 | 5 | | 47 | 64 | 7 | | 44 | 63 | 7 | | 48 | 62 | 8 |

CLASH

| 46 | 6 | | 48 | 8 | | 47 | 7 | | 43 | 5 |

| 62 | 6 | | 63 | 7 | | 61 | 8 | | 59 | 5 |

NEUTRAL

| 1 | 8 | | 9 | 6 | | 11 | 7 | | 10 | 6 |

| 97 | 98 | 8 | | 100 | 7 | 99 | | 5 | 98 | 100 | | 99 | 97 | 6 |

ROMANTIC Split 8
ROMANTIC Split 62
ROMANTIC Split 48
ROMANTIC Split 7
ROMANTIC Split 63
ROMANTIC Split 44
ROMANTIC Split 7
ROMANTIC Split 64
ROMANTIC Split 47
ROMANTIC Split 5
ROMANTIC Split 64
ROMANTIC Split 43

ROMANTIC Clash 5
ROMANTIC Clash 43
ROMANTIC Clash 7
ROMANTIC Clash 47
ROMANTIC Clash 8
ROMANTIC Clash 48
ROMANTIC Clash 6
ROMANTIC Clash 46

ROMANTIC Clash 5
ROMANTIC Clash 59
ROMANTIC Clash 8
ROMANTIC Clash 61
ROMANTIC Clash 7
ROMANTIC Clash 63
ROMANTIC Clash 6
ROMANTIC Clash 62

ROMANTIC Neutral 6
ROMANTIC Neutral 10
ROMANTIC Neutral 7
ROMANTIC Neutral 11
ROMANTIC Neutral 6
ROMANTIC Neutral 9
ROMANTIC Neutral 8
ROMANTIC Neutral 1

ROMANTIC Neutral 6
ROMANTIC Neutral 97
ROMANTIC Neutral 99
ROMANTIC Neutral 100
ROMANTIC Neutral 98
ROMANTIC Neutral 5
ROMANTIC Neutral 99
ROMANTIC Neutral 7
ROMANTIC Neutral 100
ROMANTIC Neutral 8
ROMANTIC Neutral 98
ROMANTIC Neutral 97

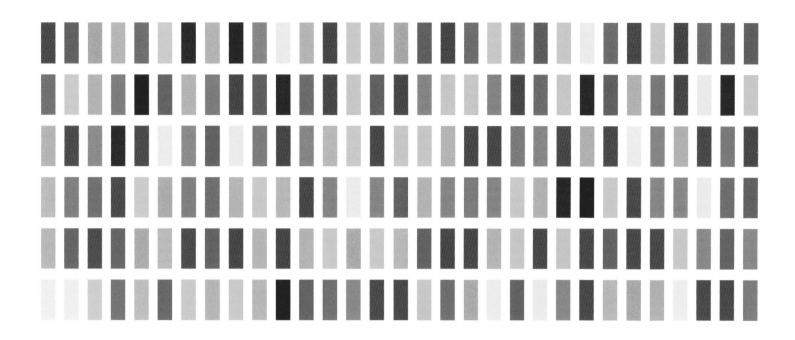

ROMANTIC
Tips for Color Schemes

GENERAL COLOR

When pastel pink is combined with stronger blues, blue-greens, and greens, the romantic color scheme takes on more sophistication.

GRAPHIC DESIGN

In graphic design, a romantic color scheme sets just the right feeling for such projects as wedding invitations, a woman's personal stationery, or cosmetic packaging.

INTERIOR DESIGN

The innocence projected by pink makes it the color of choice for the bedrooms of young girls.

FINE ART

Fine artists will find that watercolors, with their sheer, light quality, optimize the use of a romantic palette.

Coralie Alan Tweed
Roan Mt. Blackberry Bushes

Orlando Facioli Design

Maine Cottage Furniture

VITAL

Lively, expressive, youthful, and exuberant— that's the feeling conveyed by a vital color scheme, which is based around a red-orange hue. Red-orange is a cheerful color that has the effect of making one feel warm and energetic. On an esoteric level, it's the color projected by the root chakra, said to be the place where one's life force resides. There's a full-steam-ahead, let's-get-things-accomplished feeling to the vital color scheme—it implies dauntless courage and fearless risk-taking. Particularly in an analogous palette, a vital color scheme has the brilliant, almost vibratory quality of autumn leaves. The joyful and unrestrained nature of vital colors are frequently used in textile design, from the traditional (Indian saris and Thai plaid silks) to the contemporary (surfwear and other sportswear).

In graphic design, vital colors are useful in approaching projects that have a young, cutting-edge feeling; for example, cosmetics packaging for a trendy product line, brochures for high-tech or sports businesses, or any job that needs an uncomplicated "punch" of color. For interiors, a vital color scheme—particularly a complementary scheme, featuring red-orange paired with blue-green—provides a wonderful backdrop for furnishings with an exotic, Eastern flavor. The decidedly brilliant colors in the vital scheme are well suited to abstract paintings, wall hangings, and collages.

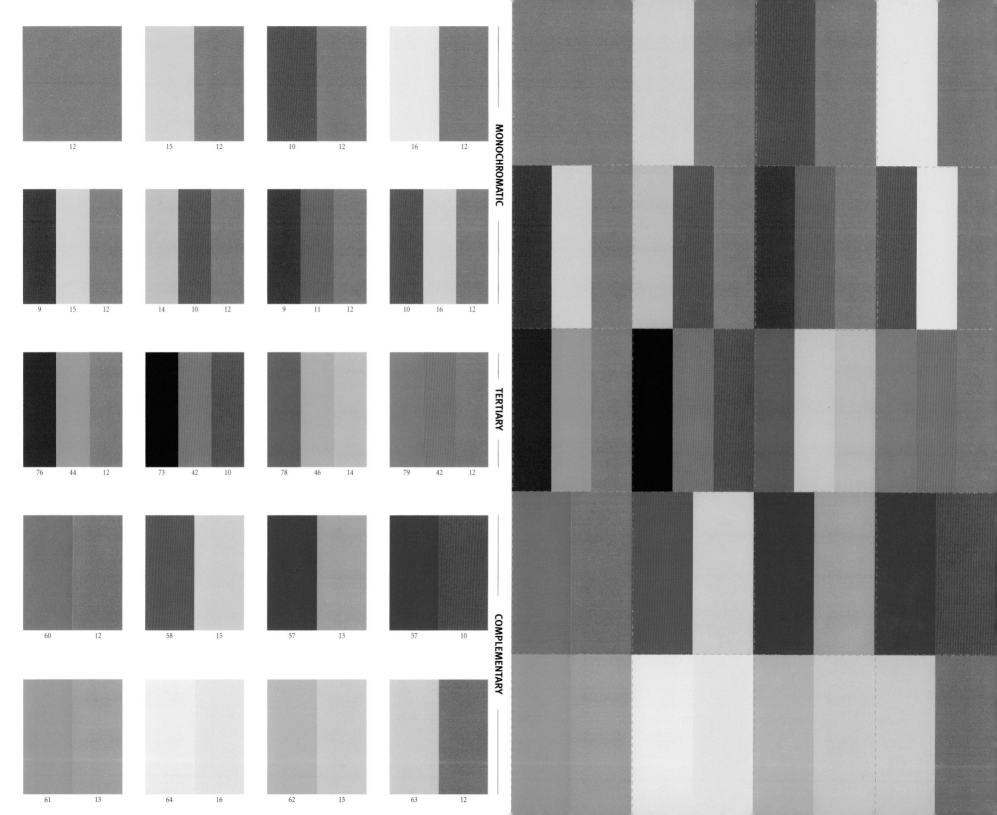

12

15 12

10 12

16 12

9 15 12

14 10 12

9 11 12

10 16 12

76 44 12

73 42 10

78 46 14

79 42 12

60 12

58 15

57 13

57 10

61 13

64 16

62 15

63 12

VITAL Monochromatic 12

VITAL Monochromatic 16

VITAL Monochromatic 12

VITAL Monochromatic 10

VITAL Monochromatic 12

VITAL Monochromatic 15

VITAL Monochromatic 12

VITAL Monochromatic 12

VITAL Monochromatic 16

VITAL Monochromatic 10

VITAL Monochromatic 12

VITAL Monochromatic 11

VITAL Monochromatic 9

VITAL Monochromatic 12

VITAL Monochromatic 10

VITAL Monochromatic 14

VITAL Monochromatic 12

VITAL Monochromatic 15

VITAL Monochromatic 9

VITAL Tertiary 12

VITAL Tertiary 42

VITAL Tertiary 79

VITAL Tertiary 14

VITAL Tertiary 46

VITAL Tertiary 78

VITAL Tertiary 10

VITAL Tertiary 42

VITAL Tertiary 73

VITAL Tertiary 12

VITAL Tertiary 44

VITAL Tertiary 76

VITAL Complementary 10

VITAL Complementary 57

VITAL Complementary 13

VITAL Complementary 57

VITAL Complementary 15

VITAL Complementary 58

VITAL Complementary 12

VITAL Complementary 60

VITAL Complementary 12

VITAL Complementary 63

VITAL Complementary 15

VITAL Complementary 62

VITAL Complementary 16

VITAL Complementary 64

VITAL Complementary 13

VITAL Complementary 61

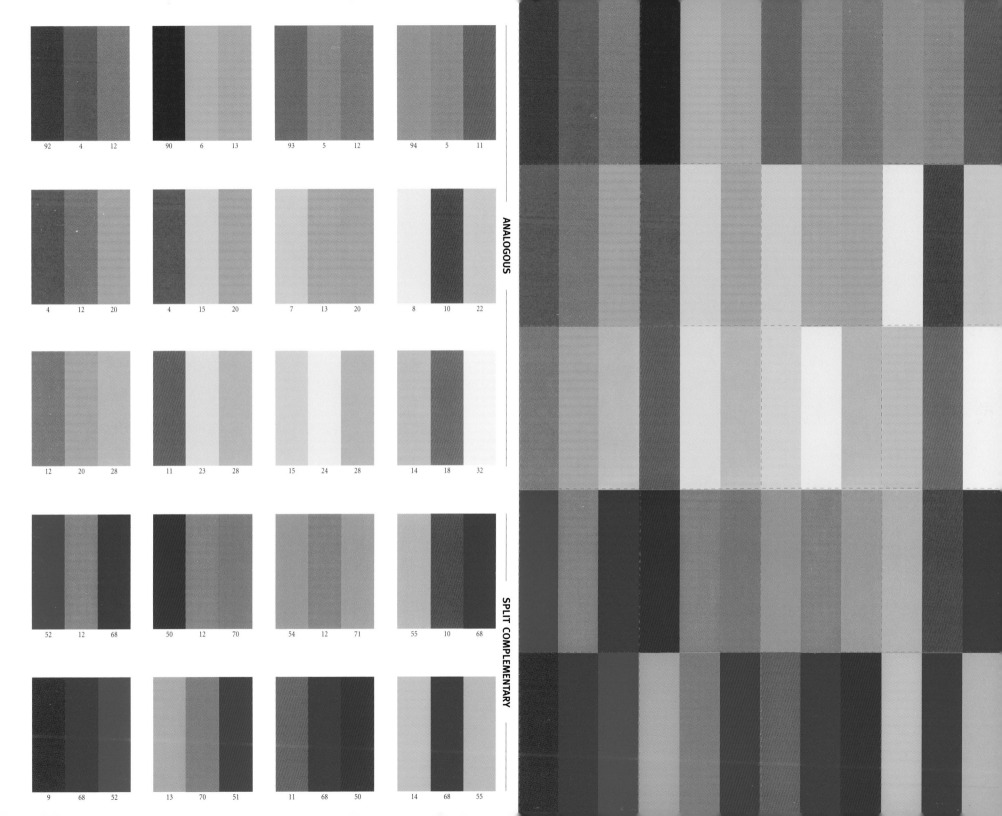

92 4 12 90 6 13 93 5 12 94 5 11

4 12 20 4 15 20 7 13 20 8 10 22

12 20 28 11 23 28 15 24 28 14 18 32

52 12 68 50 12 70 54 12 71 55 10 68

9 68 52 13 70 51 11 68 50 14 68 55

VITAL Split Complementary	VITAL Split Complementary	VITAL Analogous	VITAL Analogous	VITAL Analogous
55	68	32	22	11
68	10	18	10	5
14	55	14	8	94
50	71	28	20	12
68	12	24	13	5
11	54	15	7	93
51	70	28	20	13
70	12	23	15	6
13	50	11	4	90
52	68	28	20	12
68	12	20	12	4
9	52	12	4	92

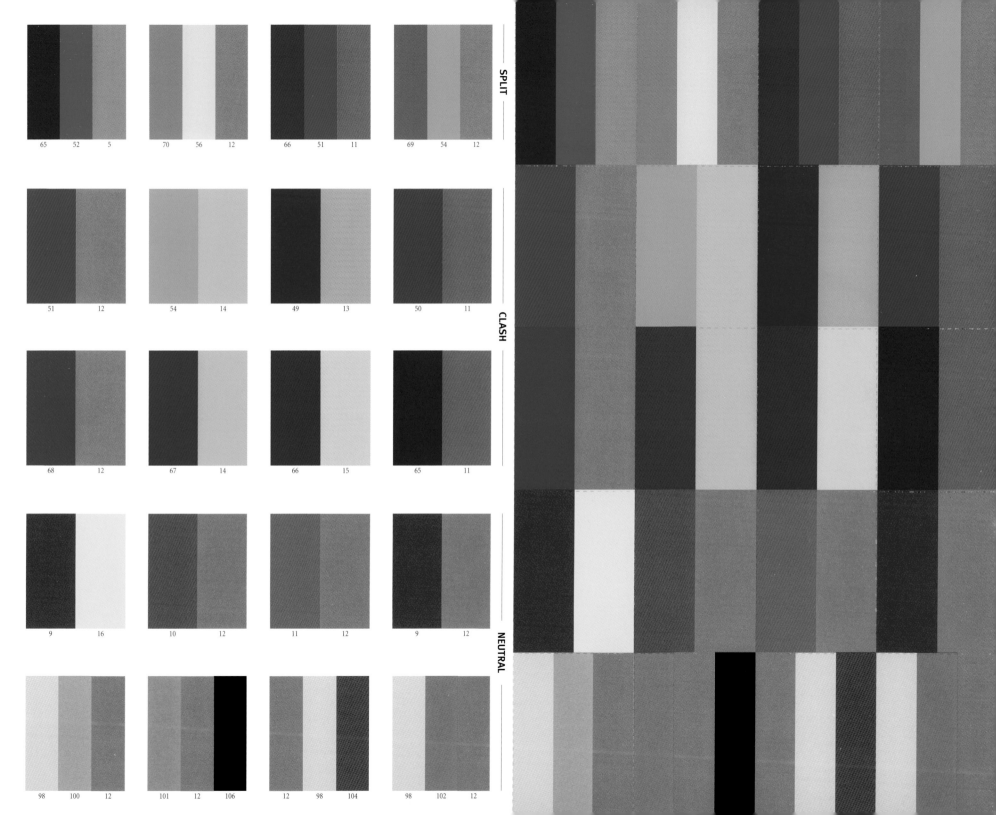

SPLIT

| 65 | 52 | 5 | | 70 | 56 | 12 | | 66 | 51 | 11 | | 69 | 54 | 12 |

CLASH

| 51 | 12 | | 54 | 14 | | 49 | 13 | | 50 | 11 |

| 68 | 12 | | 67 | 14 | | 66 | 15 | | 65 | 11 |

NEUTRAL

| 9 | 16 | | 10 | 12 | | 11 | 12 | | 9 | 12 |

| 98 | 100 | 12 | | 101 | 12 | 106 | | 12 | 98 | 104 | | 98 | 102 | 12 |

VITAL Split 12 — VITAL Split 54 — VITAL Split 69 — VITAL Split 11 — VITAL Split 51 — VITAL Split 66 — VITAL Split 12 — VITAL Split 56 — VITAL Split 70 — VITAL Split 5 — VITAL Split 52 — VITAL Split 65

VITAL Clash 11 — VITAL Clash 50 — VITAL Clash 13 — VITAL Clash 49 — VITAL Clash 14 — VITAL Clash 54 — VITAL Clash 12 — VITAL Clash 51

VITAL Clash 11 — VITAL Clash 65 — VITAL Clash 15 — VITAL Clash 66 — VITAL Clash 14 — VITAL Clash 67 — VITAL Clash 12 — VITAL Clash 68

VITAL Neutral 12 — VITAL Neutral 9 — VITAL Neutral 12 — VITAL Neutral 11 — VITAL Neutral 12 — VITAL Neutral 10 — VITAL Neutral 16 — VITAL Neutral 9

VITAL Neutral 12 — VITAL Neutral 102 — VITAL Neutral 98 — VITAL Neutral 104 — VITAL Neutral 98 — VITAL Neutral 12 — VITAL Neutral 106 — VITAL Neutral 12 — VITAL Neutral 101 — VITAL Neutral 12 — VITAL Neutral 100 — VITAL Neutral 98

VITAL
Tips for Color Schemes

GENERAL COLOR

A vital color scheme is an excellent choice for any art or design project in which an Asian flavor is desired. A vibrant cinnabar-red, combined with its complement or neutral gray and black, is particularly appropriate.

GRAPHIC DESIGN

Both inviting and attention-grabbing, a vital color scheme works well for posters, mailers, and packaging, particularly when a youthful, carefree mood is desired.

INTERIOR DESIGN

An instant sensation of warmth is produced when a vital color scheme is used in interior design, making it an ideal choice for cool or gloomy climates.

FINE ART

A vital color scheme is a natural choice in applied arts like ceramics, glassblowing, fiber art, and hand-woven clothing; these vivid, uncomplicated colors show off simple forms to advantage.

Tarek Atrissi Design

Artist: Brenda Murray

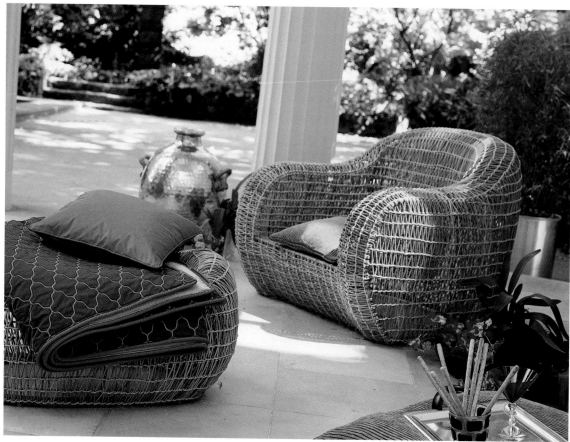

Zimmer + Rohde

EARTHY

Anyone who has driven across a desert at sunrise or sunset has seen the rich, resonant shade of red-orange that is at the heart of the earthy color scheme. This hue, the color of Mother Earth, stirs up an almost atavistic love of nature and is often used in art and design that allude to or include natural forms. The earthy color scheme transforms the high energy of red-orange with a hint of black, a great combination for stimulating energy while remaining "grounded."

It is hard to find a culture that has not used red clay, also called terra cotta, to create vessels, floor or roof tiles, or cooking pots; so this color scheme seems almost universally to hint of home and hearth. It calls to mind abundant and relaxed country living, and a warm climate (like that of the Mediterranean or the American Southwest). This is the chosen palette of many types of aboriginal arts and crafts; Native American jewelry, with its turquoise, copper and coral, the kilim rugs of the Middle East, Tibetan mandalas, and the sand paintings of Australian Aborigines all rely upon the earthy color scheme.

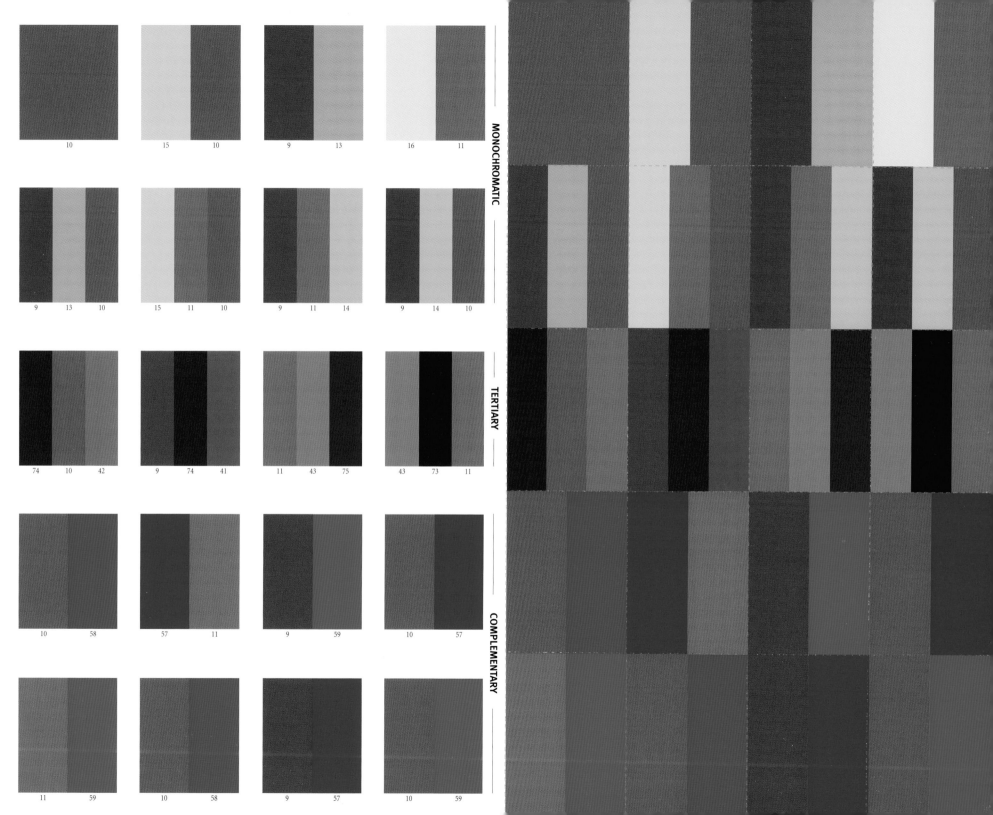

MONOCHROMATIC

10

15 10

9 13

16 11

9 13 10

15 11 10

9 11 14

9 14 10

TERTIARY

74 10 42

9 74 41

11 43 75

43 73 11

COMPLEMENTARY

10 58

57 11

9 59

10 57

11 59

10 58

9 57

10 59

EARTHY Complementary 59
EARTHY Complementary 10
EARTHY Complementary 57
EARTHY Complementary 9
EARTHY Complementary 58
EARTHY Complementary 10
EARTHY Complementary 59
EARTHY Complementary 11

EARTHY Complementary 57
EARTHY Complementary 10
EARTHY Complementary 59
EARTHY Complementary 9
EARTHY Complementary 11
EARTHY Complementary 57
EARTHY Complementary 58
EARTHY Complementary 10

EARTHY Tertiary 11
EARTHY Tertiary 73
EARTHY Tertiary 43
EARTHY Tertiary 75
EARTHY Tertiary 43
EARTHY Tertiary 11
EARTHY Tertiary 41
EARTHY Tertiary 74
EARTHY Tertiary 9
EARTHY Tertiary 42
EARTHY Tertiary 10
EARTHY Tertiary 74

EARTHY Monochromatic 10
EARTHY Monochromatic 14
EARTHY Monochromatic 9
EARTHY Monochromatic 14
EARTHY Monochromatic 11
EARTHY Monochromatic 9
EARTHY Monochromatic 10
EARTHY Monochromatic 11
EARTHY Monochromatic 15
EARTHY Monochromatic 10
EARTHY Monochromatic 13
EARTHY Monochromatic 9

EARTHY Monochromatic 11
EARTHY Monochromatic 16
EARTHY Monochromatic 13
EARTHY Monochromatic 9
EARTHY Monochromatic 10
EARTHY Monochromatic 15
EARTHY Monochromatic 10

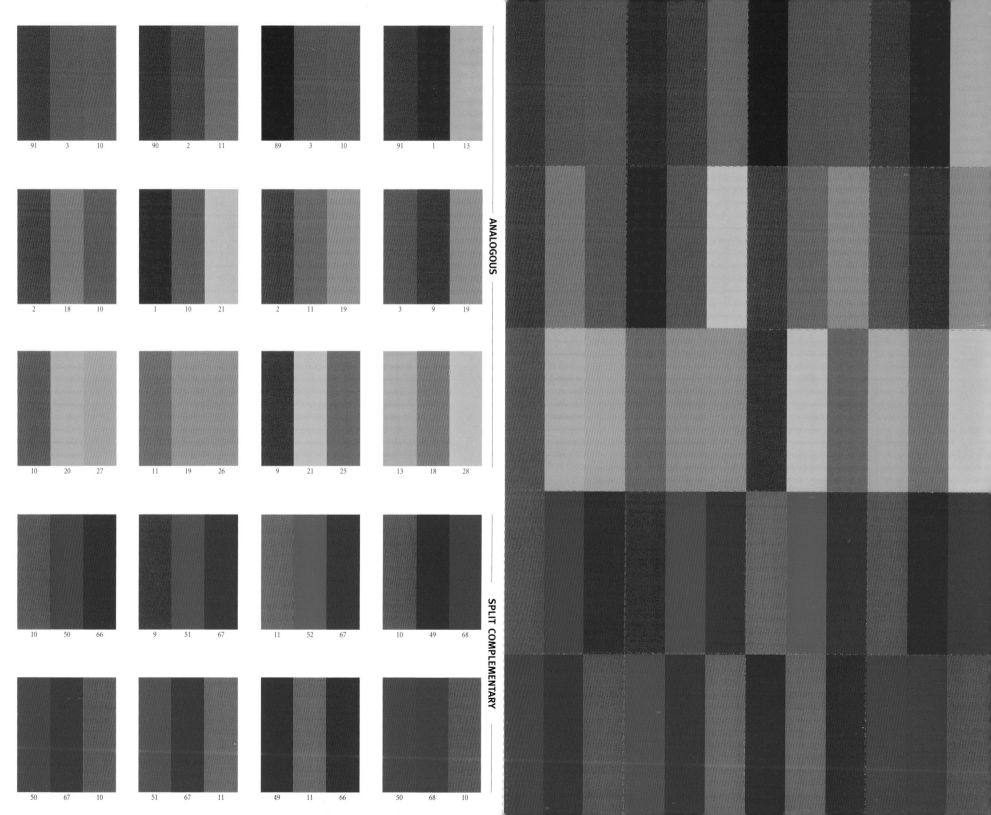

91	3	10

90	2	11

89	3	10

91	1	13

2	18	10

1	10	21

2	11	19

3	9	19

10	20	27

11	19	26

9	21	25

13	18	28

10	50	66

9	51	67

11	52	67

10	49	68

50	67	10

51	67	11

49	11	66

50	68	10

EARTHY Split Complementary 10

EARTHY Split Complementary 68

EARTHY Split Complementary 50

EARTHY Split Complementary 66

EARTHY Split Complementary 11

EARTHY Split Complementary 49

EARTHY Split Complementary 11

EARTHY Split Complementary 67

EARTHY Split Complementary 51

EARTHY Split Complementary 10

EARTHY Split Complementary 67

EARTHY Split Complementary 50

EARTHY Split Complementary 68

EARTHY Split Complementary 49

EARTHY Split Complementary 10

EARTHY Split Complementary 67

EARTHY Split Complementary 52

EARTHY Split Complementary 11

EARTHY Split Complementary 67

EARTHY Split Complementary 51

EARTHY Split Complementary 9

EARTHY Split Complementary 66

EARTHY Split Complementary 50

EARTHY Split Complementary 10

EARTHY Analogous 28

EARTHY Analogous 18

EARTHY Analogous 13

EARTHY Analogous 25

EARTHY Analogous 21

EARTHY Analogous 9

EARTHY Analogous 26

EARTHY Analogous 19

EARTHY Analogous 11

EARTHY Analogous 27

EARTHY Analogous 20

EARTHY Analogous 10

EARTHY Analogous 19

EARTHY Analogous 9

EARTHY Analogous 3

EARTHY Analogous 19

EARTHY Analogous 11

EARTHY Analogous 2

EARTHY Analogous 21

EARTHY Analogous 10

EARTHY Analogous 1

EARTHY Analogous 10

EARTHY Analogous 18

EARTHY Analogous 2

EARTHY Analogous 13

EARTHY Analogous 1

EARTHY Analogous 91

EARTHY Analogous 10

EARTHY Analogous 3

EARTHY Analogous 89

EARTHY Analogous 11

EARTHY Analogous 2

EARTHY Analogous 90

EARTHY Analogous 10

EARTHY Analogous 3

EARTHY Analogous 91

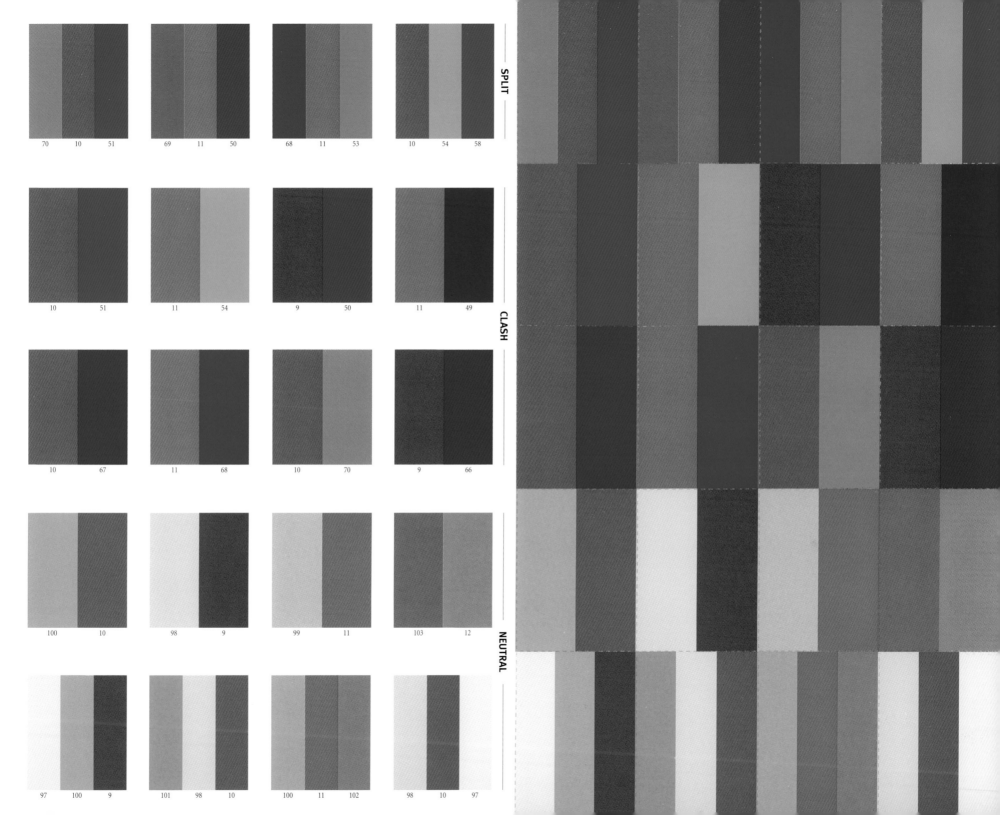

70 10 51 69 11 50 68 11 53 10 54 58

10 51 11 54 9 50 11 49

10 67 11 68 10 70 9 66

100 10 98 9 99 11 103 12

97 100 9 101 98 10 100 11 102 98 10 97

EARTHY Split 58
EARTHY Split 54
EARTHY Split 10
EARTHY Split 53
EARTHY Split 11
EARTHY Split 68
EARTHY Split 50
EARTHY Split 11
EARTHY Split 69
EARTHY Split 51
EARTHY Split 10
EARTHY Split 70

EARTHY Clash 49
EARTHY Clash 11
EARTHY Clash 50
EARTHY Clash 9
EARTHY Clash 54
EARTHY Clash 11
EARTHY Clash 51
EARTHY Clash 10

EARTHY Clash 66
EARTHY Clash 9
EARTHY Clash 70
EARTHY Clash 10
EARTHY Clash 68
EARTHY Clash 11
EARTHY Clash 67
EARTHY Clash 10

EARTHY Neutral 12
EARTHY Neutral 103
EARTHY Neutral 11
EARTHY Neutral 99
EARTHY Neutral 9
EARTHY Neutral 98
EARTHY Neutral 10
EARTHY Neutral 100

EARTHY Neutral 97
EARTHY Neutral 10
EARTHY Neutral 98
EARTHY Neutral 102
EARTHY Neutral 11
EARTHY Neutral 100
EARTHY Neutral 10
EARTHY Neutral 98
EARTHY Neutral 101
EARTHY Neutral 9
EARTHY Neutral 100
EARTHY Neutral 97

EARTHY
Tips for Color Schemes

GENERAL COLOR

Using undyed, un-slick natural materials—wood, bamboo, rice paper, hemp, raffia, canvas—enhances the relaxed energy of the earthy color scheme in interior and graphic design.

GRAPHIC DESIGN

In graphic design, earthy colors are effectively used in projects that deal with ecology and the environment, relaxation and leisure activities, or hint at ancient or aboriginal civilizations—Minoan, Mayan, Native American, and so on.

INTERIOR DESIGN

The relaxed colors of the earth are evocative of nature. Whether inspired by the American Southwest or the Mediterranean, this color scheme links us to a feeling of warmth and home. Terra cotta tile, mosaics, rich kilim rugs, and hand-woven fabrics are essential in an earthy color scheme.

FINE ART

Fine artists will find the earthy color scheme a natural starting place in rendering desert landscapes and other exotic, or arid, locations. Quick-drying, matte acrylic paints work well for this palette.

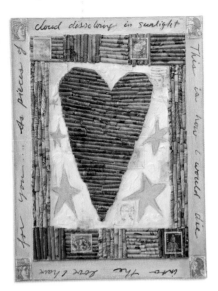

Artist: Monica Riffe

Watts Design

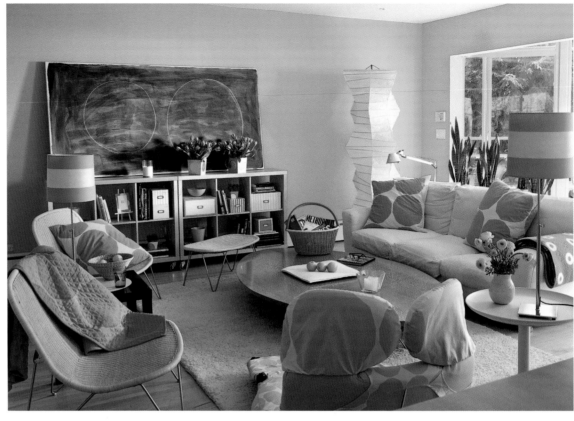

ICI Paints, maker of the Glidden brand

FRIENDLY

A true orange hue is warm, comforting and undemanding, and is the central hue of a friendly color scheme. Orange is uncomplicated and direct; when paired with its complement, blue, both hues take on added crispness and definition (akin to looking at fall leaves against a clear, brilliant October sky). In its more penetrating aspect, orange is the international color of rescue and is generally used in outdoor safety gear because of its high visibility.

As the anchor in the friendly color scheme, orange recalls marigolds and California poppies, polished copper, and glowing fires. It's not an elitist hue— safety, comfort, and the pleasures of family life are implied by an orange hue. This color scheme is quite flexible, suitable for both "high" and "low" uses. It is seen not only in fast-food restaurants and automotive advertising, but in the seventeenth century paintings by Dutch artists like Vermeer and Rembrandt, who glorified the mundane activities of daily life. This sociable hue is known to stimulate optimism, confidence, tolerance, and a sense of community.

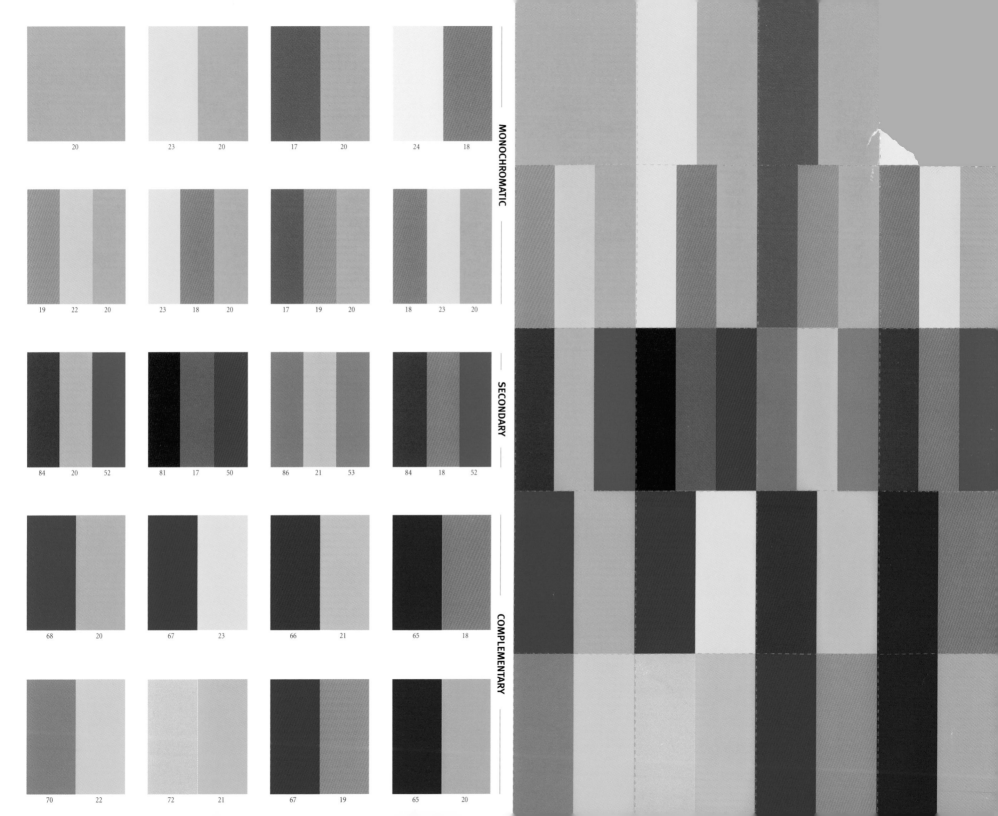

20

23 20

17 20

24 18

MONOCHROMATIC

19 22 20

23 18 20

17 19 20

18 23 20

SECONDARY

84 20 52

81 17 50

86 21 53

84 18 52

COMPLEMENTARY

68 20

67 23

66 21

65 18

70 22

72 21

67 19

65 20

FRIENDLY
Monochromatic
20

FRIENDLY
Monochromatic
17

FRIENDLY
Monochromatic
20

FRIENDLY
Monochromatic
23

FRIENDLY
Monochromatic
20

FRIENDLY
Monochromatic
20

FRIENDLY
Monochromatic
23

FRIENDLY
Monochromatic
18

FRIENDLY
Monochromatic
20

FRIENDLY
Monochromatic
19

FRIENDLY
Monochromatic
17

FRIENDLY
Monochromatic
20

FRIENDLY
Monochromatic
18

FRIENDLY
Monochromatic
23

FRIENDLY
Monochromatic
20

FRIENDLY
Monochromatic
22

FRIENDLY
Monochromatic
19

FRIENDLY
Secondary
52

FRIENDLY
Secondary
18

FRIENDLY
Secondary
84

FRIENDLY
Secondary
53

FRIENDLY
Secondary
21

FRIENDLY
Secondary
86

FRIENDLY
Secondary
50

FRIENDLY
Secondary
17

FRIENDLY
Secondary
81

FRIENDLY
Secondary
52

FRIENDLY
Secondary
20

FRIENDLY
Secondary
84

FRIENDLY
Complementary
18

FRIENDLY
Complementary
65

FRIENDLY
Complementary
21

FRIENDLY
Complementary
66

FRIENDLY
Complementary
23

FRIENDLY
Complementary
67

FRIENDLY
Complementary
20

FRIENDLY
Complementary
68

FRIENDLY
Complementary
20

FRIENDLY
Complementary
65

FRIENDLY
Complementary
19

FRIENDLY
Complementary
67

FRIENDLY
Complementary
21

FRIENDLY
Complementary
72

FRIENDLY
Complementary
22

FRIENDLY
Complementary
70

friendly color schemes

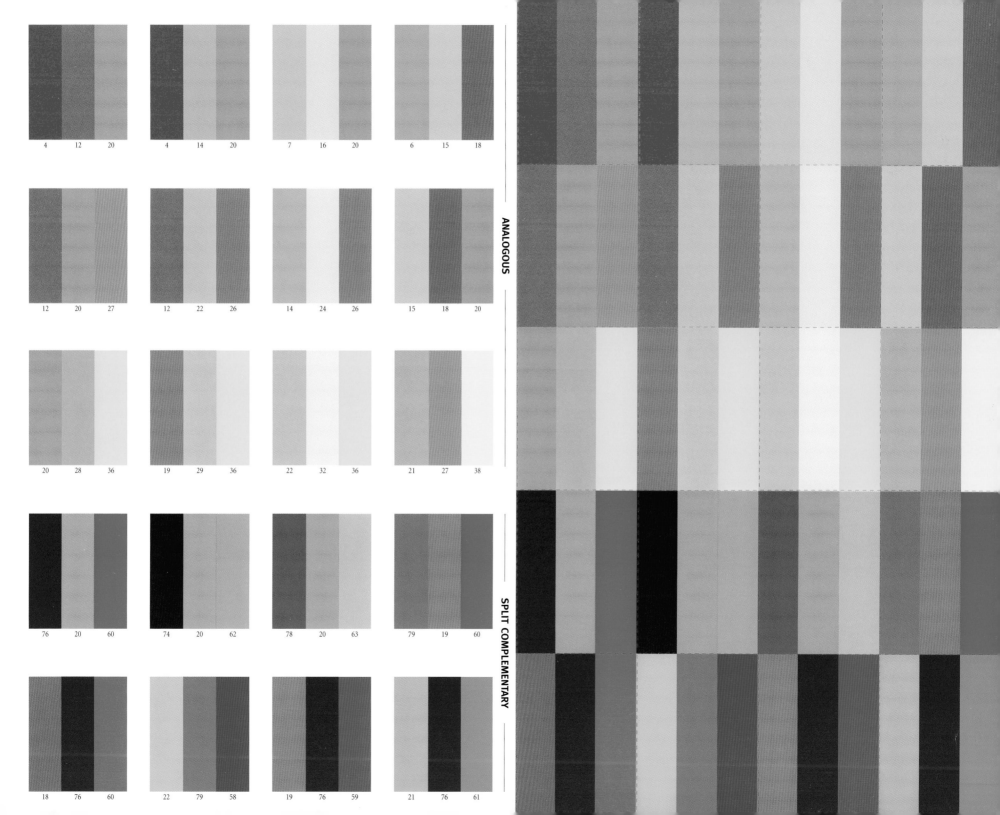

4	12	20
4	14	20
7	16	20
6	15	18

12	20	27
12	22	26
14	24	26
15	18	20

20	28	36
19	29	36
22	32	36
21	27	38

76	20	60
74	20	62
78	20	63
79	19	60

18	76	60
22	79	58
19	76	59
21	76	61

FRIENDLY Analogous 18
FRIENDLY Analogous 15
FRIENDLY Analogous 6
FRIENDLY Analogous 20
FRIENDLY Analogous 16
FRIENDLY Analogous 7
FRIENDLY Analogous 20
FRIENDLY Analogous 14
FRIENDLY Analogous 4
FRIENDLY Analogous 20
FRIENDLY Analogous 12
FRIENDLY Analogous 4

FRIENDLY Analogous 20
FRIENDLY Analogous 18
FRIENDLY Analogous 15
FRIENDLY Analogous 26
FRIENDLY Analogous 24
FRIENDLY Analogous 14
FRIENDLY Analogous 26
FRIENDLY Analogous 22
FRIENDLY Analogous 12
FRIENDLY Analogous 27
FRIENDLY Analogous 20
FRIENDLY Analogous 12

FRIENDLY Analogous 38
FRIENDLY Analogous 27
FRIENDLY Analogous 21
FRIENDLY Analogous 36
FRIENDLY Analogous 32
FRIENDLY Analogous 22
FRIENDLY Analogous 36
FRIENDLY Analogous 29
FRIENDLY Analogous 19
FRIENDLY Analogous 36
FRIENDLY Analogous 28
FRIENDLY Analogous 20

FRIENDLY Split Complementary 60
FRIENDLY Split Complementary 19
FRIENDLY Split Complementary 79
FRIENDLY Split Complementary 63
FRIENDLY Split Complementary 20
FRIENDLY Split Complementary 78
FRIENDLY Split Complementary 62
FRIENDLY Split Complementary 20
FRIENDLY Split Complementary 74
FRIENDLY Split Complementary 60
FRIENDLY Split Complementary 20
FRIENDLY Split Complementary 76

FRIENDLY Split Complementary 61
FRIENDLY Split Complementary 76
FRIENDLY Split Complementary 21
FRIENDLY Split Complementary 59
FRIENDLY Split Complementary 76
FRIENDLY Split Complementary 19
FRIENDLY Split Complementary 58
FRIENDLY Split Complementary 79
FRIENDLY Split Complementary 22
FRIENDLY Split Complementary 60
FRIENDLY Split Complementary 76
FRIENDLY Split Complementary 18

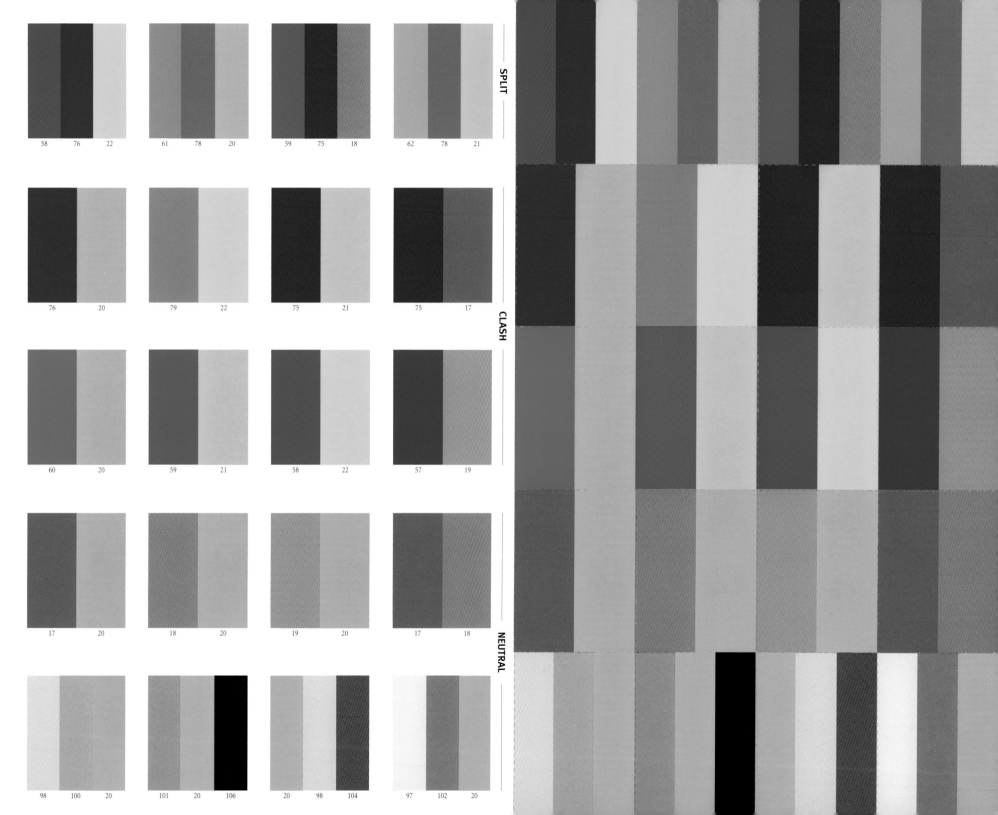

FRIENDLY Split 21
FRIENDLY Split 78
FRIENDLY Split 62
FRIENDLY Split 18
FRIENDLY Split 75
FRIENDLY Split 59
FRIENDLY Split 20
FRIENDLY Split 78
FRIENDLY Split 61
FRIENDLY Split 22
FRIENDLY Split 76
FRIENDLY Split 58

FRIENDLY Clash 17
FRIENDLY Clash 75
FRIENDLY Clash 21
FRIENDLY Clash 75
FRIENDLY Clash 22
FRIENDLY Clash 79
FRIENDLY Clash 20
FRIENDLY Clash 76

FRIENDLY Clash 19
FRIENDLY Clash 57
FRIENDLY Clash 22
FRIENDLY Clash 58
FRIENDLY Clash 21
FRIENDLY Clash 59
FRIENDLY Clash 20
FRIENDLY Clash 60

FRIENDLY Neutral 18
FRIENDLY Neutral 17
FRIENDLY Neutral 20
FRIENDLY Neutral 19
FRIENDLY Neutral 20
FRIENDLY Neutral 18
FRIENDLY Neutral 20
FRIENDLY Neutral 17

FRIENDLY Neutral 20
FRIENDLY Neutral 102
FRIENDLY Neutral 97
FRIENDLY Neutral 104
FRIENDLY Neutral 98
FRIENDLY Neutral 20
FRIENDLY Neutral 106
FRIENDLY Neutral 20
FRIENDLY Neutral 101
FRIENDLY Neutral 20
FRIENDLY Neutral 100
FRIENDLY Neutral 98

FRIENDLY
Tips for Color Schemes

GENERAL COLOR

Any product or project destined for the table—including food packaging, menu designs, ceramic tableware or linens—benefits from the use of a friendly color scheme.

GRAPHIC DESIGN

A natural sense of humor—even clowning—is projected by the friendly color scheme; use it for any poster, invitation, advertising, or packaging that requires a lighthearted, humorous feeling.

INTERIOR DESIGN

People often feel attracted to, and more sociable in, an orange-hued room; so a dining room, guest bedroom, or bathroom is the perfect place for inviting pumpkin-colored walls or linens.

FINE ART

Fine and applied artists will find that there's a spring-like, just-bloomed freshness to the friendly palette; it's good for floral paintings, handmade greeting cards, and illustrations for children's books.

Joyce Gow, M.W.S.
Petals

Brave: Branding & Corporate Design

ICI Paints, maker of the Glidden brand

SOFT

The combination of gentle pastel tints verging on the neutral creates a soft color scheme. Most often, a soft color scheme contains peach, a tint that combines the purity of white with the openness and sociability of orange. The feeling produced by a soft color scheme is generally pleasing; calm, inviting, and relaxing, with an understated quality that makes it almost invisible. Peach is a luscious, sensuous color; it is attractive, easy on the eye, and flattering to most skin tones. The silky, sybaritic quality of a soft color scheme makes it one frequently employed in decorating day spas, hair salons, retail stores, and restaurants, as well as residential and hotel interiors.

The implication of quiet luxury and elegance gives the soft color scheme almost limitless possibilities in terms of graphic and interior design. The nuance of romance evoked by a soft color scheme is aptly used by fine and applied artists in creating still life and floral designs. Whether used for invitations, personal or business stationery, shopping bags, textiles, interiors, or paintings, the soft color scheme produces a soothing, unhurried, and open appeal.

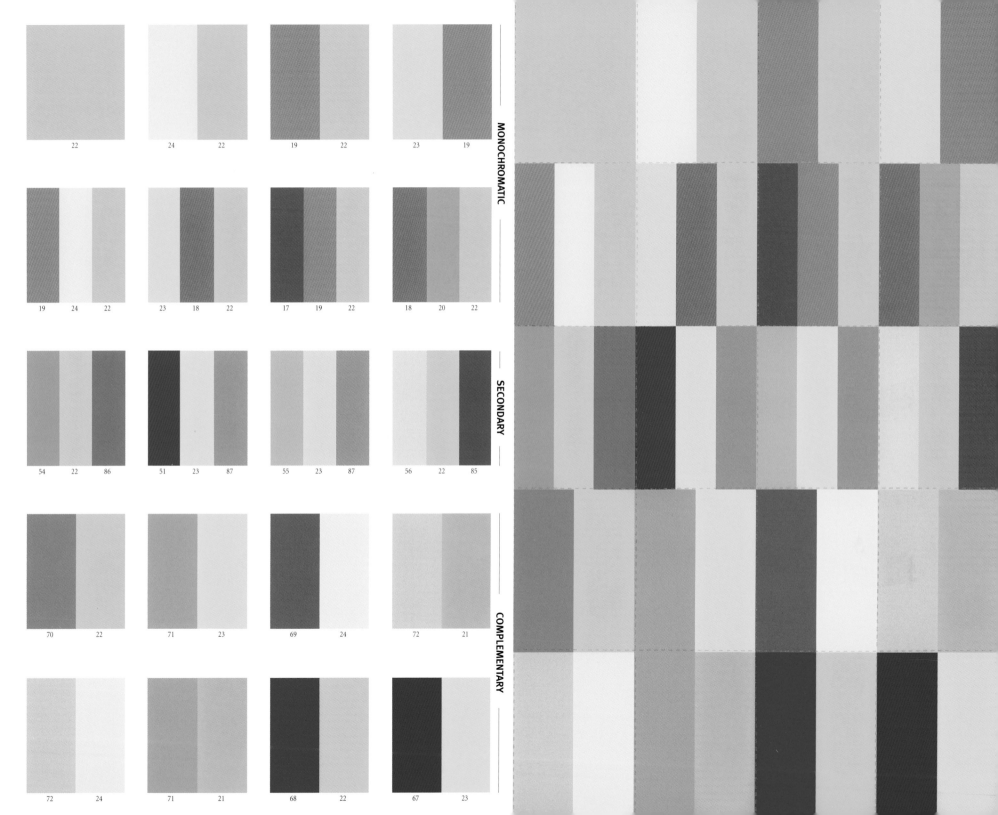

22

24 22

19 22

23 19

19 24 22

23 18 22

17 19 22

18 20 22

54 22 86

51 23 87

55 23 87

56 22 85

70 22

71 23

69 24

72 21

72 24

71 21

68 22

67 23

SOFT Monochromatic 19
SOFT Monochromatic 23
SOFT Monochromatic 22
SOFT Monochromatic 19
SOFT Monochromatic 22
SOFT Monochromatic 24
SOFT Monochromatic 22

SOFT Monochromatic 22
SOFT Monochromatic 20
SOFT Monochromatic 18
SOFT Monochromatic 22
SOFT Monochromatic 19
SOFT Monochromatic 17
SOFT Monochromatic 22
SOFT Monochromatic 18
SOFT Monochromatic 23
SOFT Monochromatic 22
SOFT Monochromatic 24
SOFT Monochromatic 19

SOFT Secondary 85
SOFT Secondary 22
SOFT Secondary 56
SOFT Secondary 87
SOFT Secondary 23
SOFT Secondary 55
SOFT Secondary 87
SOFT Secondary 23
SOFT Secondary 51
SOFT Secondary 86
SOFT Secondary 22
SOFT Secondary 54

SOFT Complementary 21
SOFT Complementary 72
SOFT Complementary 24
SOFT Complementary 69
SOFT Complementary 23
SOFT Complementary 71
SOFT Complementary 22
SOFT Complementary 70

SOFT Complementary 23
SOFT Complementary 67
SOFT Complementary 22
SOFT Complementary 68
SOFT Complementary 21
SOFT Complementary 71
SOFT Complementary 24
SOFT Complementary 72

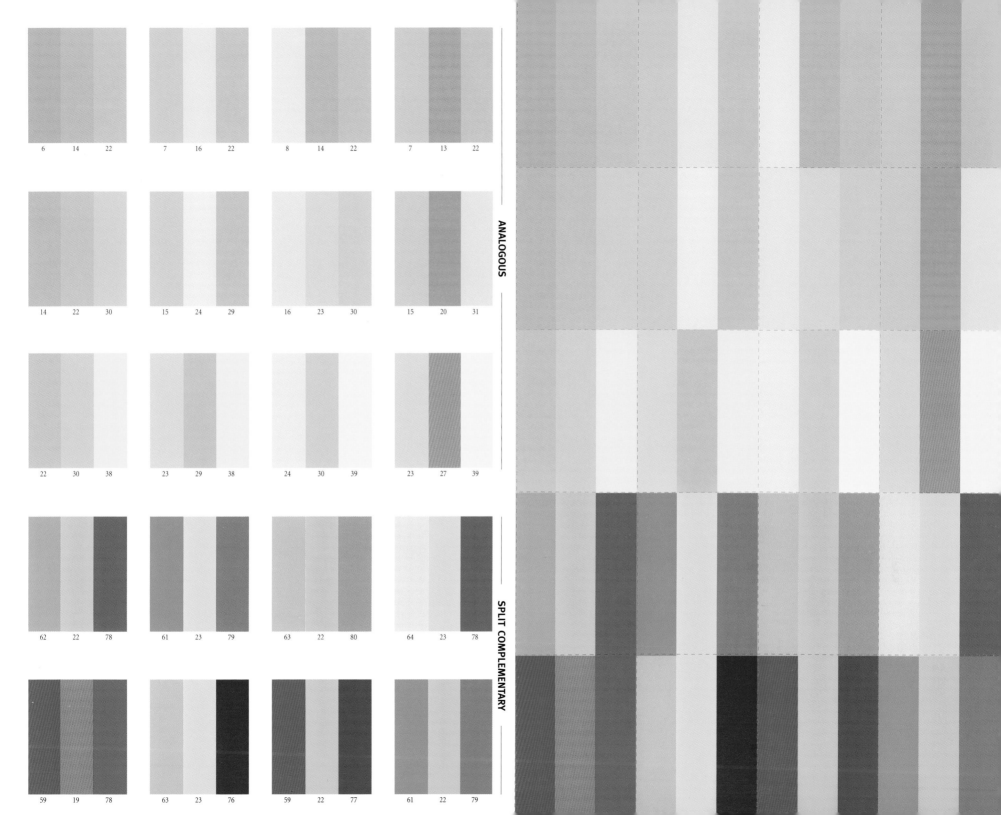

6 14 22 7 16 22 8 14 22 7 13 22

14 22 30 15 24 29 16 23 30 15 20 31

22 30 38 23 29 38 24 30 39 23 27 39

62 22 78 61 23 79 63 22 80 64 23 78

59 19 78 63 23 76 59 22 77 61 22 79

SOFT Analogous 22
SOFT Analogous 13
SOFT Analogous 7
SOFT Analogous 22
SOFT Analogous 14
SOFT Analogous 8
SOFT Analogous 22
SOFT Analogous 16
SOFT Analogous 7
SOFT Analogous 22
SOFT Analogous 14
SOFT Analogous 6

SOFT Analogous 31
SOFT Analogous 20
SOFT Analogous 15
SOFT Analogous 30
SOFT Analogous 23
SOFT Analogous 16
SOFT Analogous 29
SOFT Analogous 24
SOFT Analogous 15
SOFT Analogous 30
SOFT Analogous 22
SOFT Analogous 14

SOFT Analogous 39
SOFT Analogous 27
SOFT Analogous 23
SOFT Analogous 39
SOFT Analogous 30
SOFT Analogous 24
SOFT Analogous 38
SOFT Analogous 29
SOFT Analogous 23
SOFT Analogous 38
SOFT Analogous 30
SOFT Analogous 22

SOFT Split Complementary 78
SOFT Split Complementary 23
SOFT Split Complementary 64
SOFT Split Complementary 80
SOFT Split Complementary 22
SOFT Split Complementary 63
SOFT Split Complementary 79
SOFT Split Complementary 23
SOFT Split Complementary 61
SOFT Split Complementary 78
SOFT Split Complementary 22
SOFT Split Complementary 62

SOFT Split Complementary 79
SOFT Split Complementary 22
SOFT Split Complementary 61
SOFT Split Complementary 77
SOFT Split Complementary 22
SOFT Split Complementary 59
SOFT Split Complementary 76
SOFT Split Complementary 23
SOFT Split Complementary 63
SOFT Split Complementary 78
SOFT Split Complementary 19
SOFT Split Complementary 59

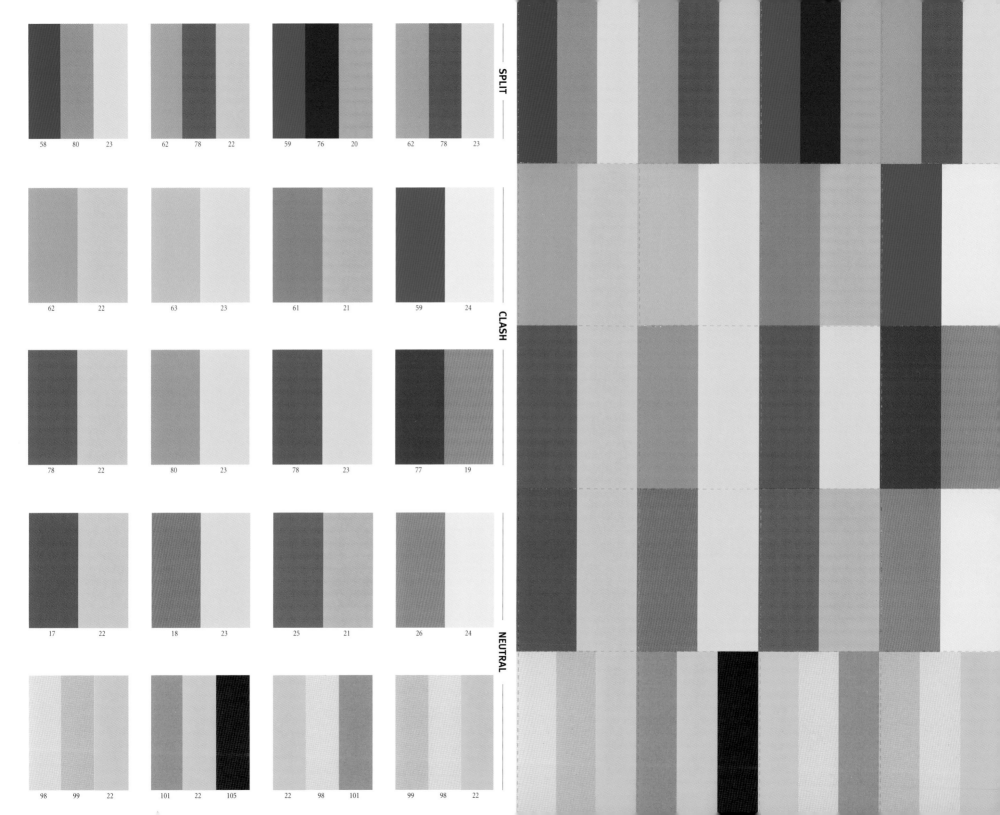

58 80 23

62 78 22

59 76 20

62 78 23

62 22

63 23

61 21

59 24

78 22

80 23

78 23

77 19

17 22

18 23

25 21

26 24

98 99 22

101 22 105

22 98 101

99 98 22

SOFT Split 23 SOFT Split 78 SOFT Split 62 SOFT Split 20 SOFT Split 76 SOFT Split 59 SOFT Split 22 SOFT Split 78 SOFT Split 62 SOFT Split 23 SOFT Split 80 SOFT Split 58

SOFT Clash 24 SOFT Clash 59 SOFT Clash 21 SOFT Clash 61 SOFT Clash 23 SOFT Clash 63 SOFT Clash 22 SOFT Clash 62

SOFT Clash 19 SOFT Clash 77 SOFT Clash 23 SOFT Clash 78 SOFT Clash 23 SOFT Clash 80 SOFT Clash 22 SOFT Clash 78

SOFT Neutral 24 SOFT Neutral 26 SOFT Neutral 21 SOFT Neutral 25 SOFT Neutral 23 SOFT Neutral 18 SOFT Neutral 22 SOFT Neutral 17

SOFT Neutral 22 SOFT Neutral 98 SOFT Neutral 99 SOFT Neutral 101 SOFT Neutral 98 SOFT Neutral 22 SOFT Neutral 105 SOFT Neutral 22 SOFT Neutral 101 SOFT Neutral 22 SOFT Neutral 99 SOFT Neutral 98

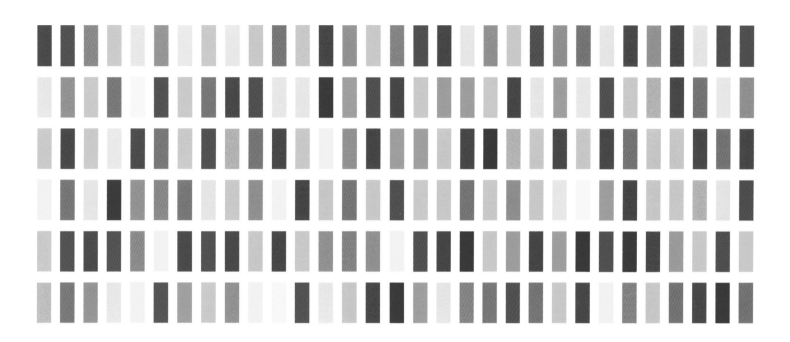

SOFT
Tips for Color Schemes

GENERAL COLOR

When using the soft color scheme, keep all colors used at the same low level of chroma and contrast; adding a stronger color is simply jarring.

GRAPHIC DESIGN

The restrained warmth of soft colors gives them an almost utilitarian usefulness in graphic design. A soft peach is a good starting point for any stationery, brochure, poster, or packaging requiring an understated elegance.

INTERIOR DESIGN

Because of their undemanding nature, soft colors are extremely livable over the long-term, making them ideal for home interiors.

FINE ART

Soft colors evoke the fleshiness of a painting by Reubens; fine artists will find this palette useful in portraiture, owing to its subtle combinations of peach and pink, beige and gold.

Christopher Leeper
Volant

ICI Paints,
maker of the Glidden brand

Tank Design

WELCOMING

A welcoming color scheme is one that includes the warm glow of yellow-orange, also called amber. This honeyed color combines the sociable, outgoing qualities of orange and the sincere, expressive qualities of yellow. Open, honest, and congenial, a welcoming color scheme has a classic appeal; particularly in its complementary and monochromatic combinations, which convey an age-old conviviality. Because of the expansive nature of the yellow hue, art or design that

includes the honeyed glow of yellow-orange seems to reach out to observers, inviting them to enter the painting, poster, retail store, or dining room, in which this hue predominates. In its tones and shades, yellow-orange is referred to as Titian, after the painter who so masterfully used the hue. In its pure, high-chroma form, yellow-orange has a spiritual connotation, reflected in the saffron robes worn by Buddhist monks. It is a color that is considered expressive, neat, and intellectual.

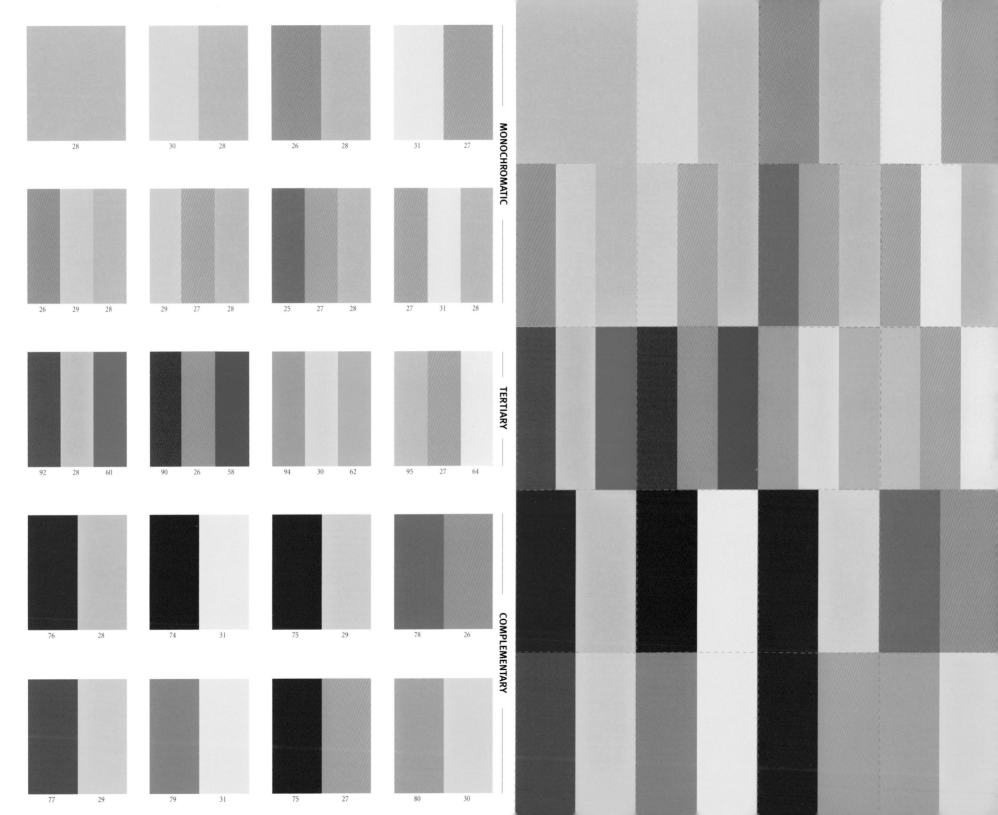

28

30 28

26 28

31 27

26 29 28

29 27 28

25 27 28

27 31 28

92 28 60

90 26 58

94 30 62

95 27 64

76 28

74 31

75 29

78 26

77 29

79 31

75 27

80 30

WELCOMING Monochromatic 27

WELCOMING Monochromatic 31

WELCOMING Monochromatic 28

WELCOMING Monochromatic 26

WELCOMING Monochromatic 28

WELCOMING Monochromatic 30

WELCOMING Monochromatic 28

WELCOMING Monochromatic 28

WELCOMING Monochromatic 31

WELCOMING Monochromatic 27

WELCOMING Monochromatic 28

WELCOMING Monochromatic 27

WELCOMING Monochromatic 25

WELCOMING Monochromatic 28

WELCOMING Monochromatic 27

WELCOMING Monochromatic 29

WELCOMING Monochromatic 28

WELCOMING Monochromatic 29

WELCOMING Monochromatic 26

WELCOMING Tertiary 64

WELCOMING Tertiary 27

WELCOMING Tertiary 95

WELCOMING Tertiary 62

WELCOMING Tertiary 30

WELCOMING Tertiary 94

WELCOMING Tertiary 58

WELCOMING Tertiary 26

WELCOMING Tertiary 90

WELCOMING Tertiary 60

WELCOMING Tertiary 28

WELCOMING Tertiary 92

WELCOMING Complementary 26

WELCOMING Complementary 78

WELCOMING Complementary 29

WELCOMING Complementary 75

WELCOMING Complementary 31

WELCOMING Complementary 74

WELCOMING Complementary 28

WELCOMING Complementary 76

WELCOMING Complementary 30

WELCOMING Complementary 80

WELCOMING Complementary 27

WELCOMING Complementary 75

WELCOMING Complementary 31

WELCOMING Complementary 79

WELCOMING Complementary 29

WELCOMING Complementary 77

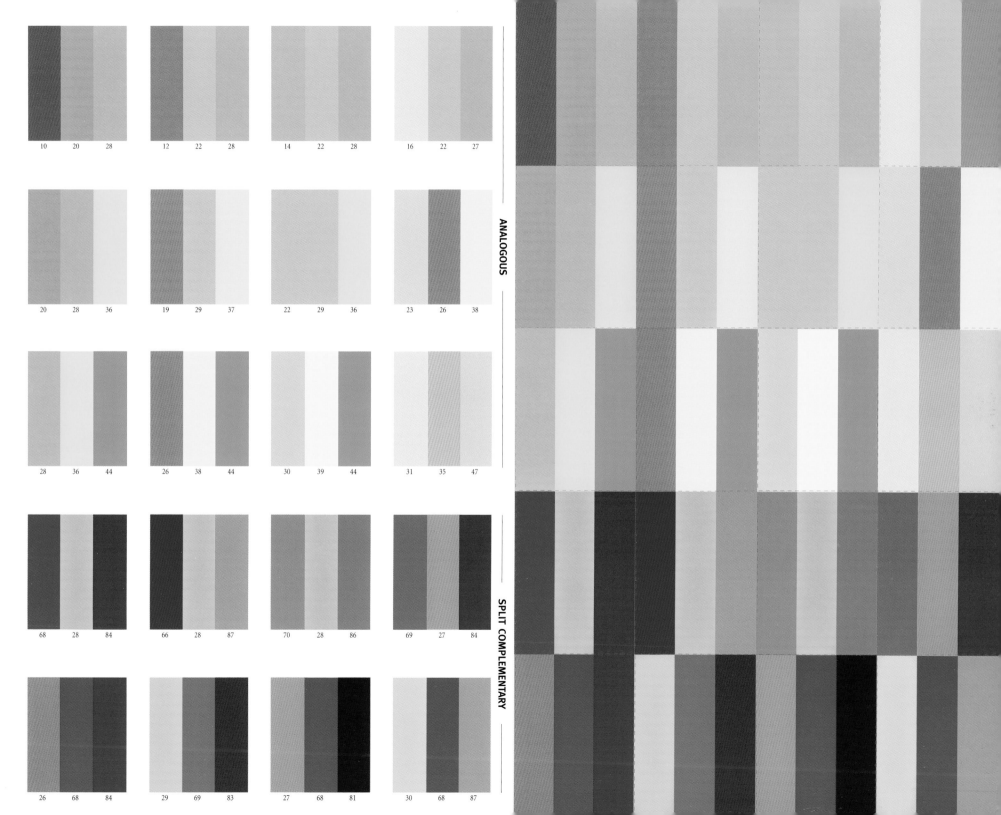

10	20	28
12	22	28
14	22	28
16	22	27

20	28	36
19	29	37
22	29	36
23	26	38

28	36	44
26	38	44
30	39	44
31	35	47

68	28	84
66	28	87
70	28	86
69	27	84

26	68	84
29	69	83
27	68	81
30	68	87

WELCOMING Analogous 27
WELCOMING Analogous 22
WELCOMING Analogous 16
WELCOMING Analogous 28
WELCOMING Analogous 22
WELCOMING Analogous 14
WELCOMING Analogous 28
WELCOMING Analogous 22
WELCOMING Analogous 12
WELCOMING Analogous 28
WELCOMING Analogous 20
WELCOMING Analogous 10

WELCOMING Analogous 38
WELCOMING Analogous 26
WELCOMING Analogous 23
WELCOMING Analogous 36
WELCOMING Analogous 29
WELCOMING Analogous 22
WELCOMING Analogous 37
WELCOMING Analogous 29
WELCOMING Analogous 19
WELCOMING Analogous 36
WELCOMING Analogous 28
WELCOMING Analogous 20

WELCOMING Analogous 47
WELCOMING Analogous 35
WELCOMING Analogous 31
WELCOMING Analogous 44
WELCOMING Analogous 39
WELCOMING Analogous 30
WELCOMING Analogous 44
WELCOMING Analogous 38
WELCOMING Analogous 26
WELCOMING Analogous 44
WELCOMING Analogous 36
WELCOMING Analogous 28

WELCOMING Split Complementary 84
WELCOMING Split Complementary 27
WELCOMING Split Complementary 69
WELCOMING Split Complementary 86
WELCOMING Split Complementary 28
WELCOMING Split Complementary 70
WELCOMING Split Complementary 87
WELCOMING Split Complementary 28
WELCOMING Split Complementary 66
WELCOMING Split Complementary 84
WELCOMING Split Complementary 28
WELCOMING Split Complementary 68

WELCOMING Split Complementary 87
WELCOMING Split Complementary 68
WELCOMING Split Complementary 30
WELCOMING Split Complementary 81
WELCOMING Split Complementary 68
WELCOMING Split Complementary 27
WELCOMING Split Complementary 83
WELCOMING Split Complementary 69
WELCOMING Split Complementary 29
WELCOMING Split Complementary 84
WELCOMING Split Complementary 68
WELCOMING Split Complementary 26

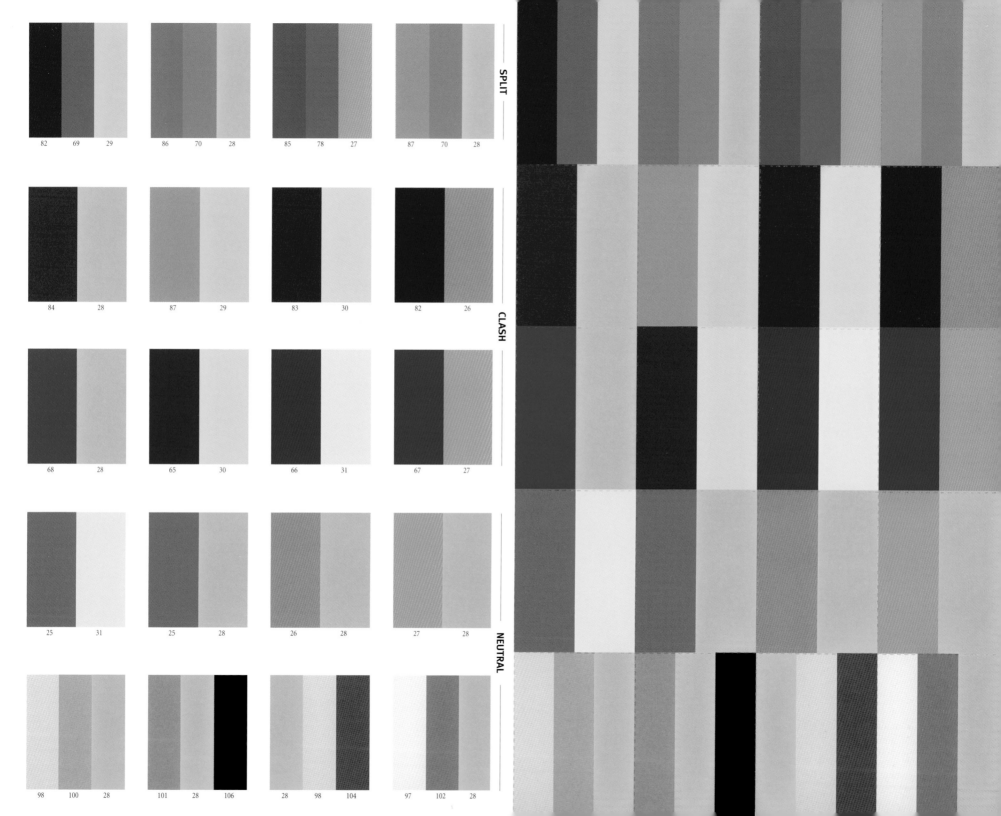

SPLIT

82 69 29 86 70 28 85 78 27 87 70 28

CLASH

84 28 87 29 83 30 82 26

68 28 65 30 66 31 67 27

NEUTRAL

25 31 25 28 26 28 27 28

98 100 28 101 28 106 28 98 104 97 102 28

WELCOMING Split 28
WELCOMING Split 70
WELCOMING Split 87
WELCOMING Split 27
WELCOMING Split 78
WELCOMING Split 85
WELCOMING Split 28
WELCOMING Split 70
WELCOMING Split 86
WELCOMING Split 29
WELCOMING Split 69
WELCOMING Split 82

WELCOMING Clash 26
WELCOMING Clash 82
WELCOMING Clash 30
WELCOMING Clash 83
WELCOMING Clash 29
WELCOMING Clash 87
WELCOMING Clash 28
WELCOMING Clash 84

WELCOMING Clash 27
WELCOMING Clash 67
WELCOMING Clash 31
WELCOMING Clash 66
WELCOMING Clash 30
WELCOMING Clash 65
WELCOMING Clash 28
WELCOMING Clash 68

WELCOMING Neutral 28
WELCOMING Neutral 27
WELCOMING Neutral 28
WELCOMING Neutral 26
WELCOMING Neutral 28
WELCOMING Neutral 25
WELCOMING Neutral 31
WELCOMING Neutral 25

WELCOMING Neutral 28
WELCOMING Neutral 102
WELCOMING Neutral 97
WELCOMING Neutral 104
WELCOMING Neutral 98
WELCOMING Neutral 28
WELCOMING Neutral 106
WELCOMING Neutral 28
WELCOMING Neutral 101
WELCOMING Neutral 28
WELCOMING Neutral 100
WELCOMING Neutral 98

WELCOMING
Tips for Color Schemes

GENERAL COLOR

The classic nature of the welcoming color scheme makes it very flexible for graphic design; it's great for the "caring" professions, including nursing, therapy, and bodywork, and is also a good choice for food and drink packaging that conveys an inviting elegance.

GRAPHIC DESIGN

A welcoming color scheme paired with a scriptlike typeface can create effects ranging from homey and modest to traditional and elegant—good for press kits, stationery, invitations, and shopping bags.

INTERIOR DESIGN

In home interiors, a welcoming color scheme may include blond wood or rattan for an overall amber glow. It is well suited to family rooms, living rooms, and dining rooms.

FINE ART

Artists instinctively use a yellow-orange hue to create a warm, sunlit, approachable feeling in paintings. The warmth of a sunset can be caught on canvas with welcoming colors.

Fons Hickmann

Artist: Teesha Moore

ICI Paints, maker of the Glidden brand

MOVING

A moving color scheme centers around the lightest primary color, yellow. Yellow creates motion; it is expansive, often dominating other colors, and is a hue that advances toward the viewer. The energetic nature of the sun is often represented by children as a big yellow ball in the sky. In maximum saturation, yellow can be the most aggressive of hues, more so even than red. When mixed with white, yellow conveys even more lightness and energy. The last of the true warm colors on the color wheel, yellow is cheerful, uplifting and spirited; it stimulates communication, intellect, and attention to detail. In China, yellow was traditionally the color of the emperor, and it carries the connotation of power, wisdom, tolerance, and patience.

The active nature of primary yellow is unleashed when it is paired with its complement, violet; the combination vibrates with energy and motion, and is often seen in nature—for example, lupine and Scotch broom blooming in the wild, and early spring flowers like daffodils, iris, crocus, and freesia.

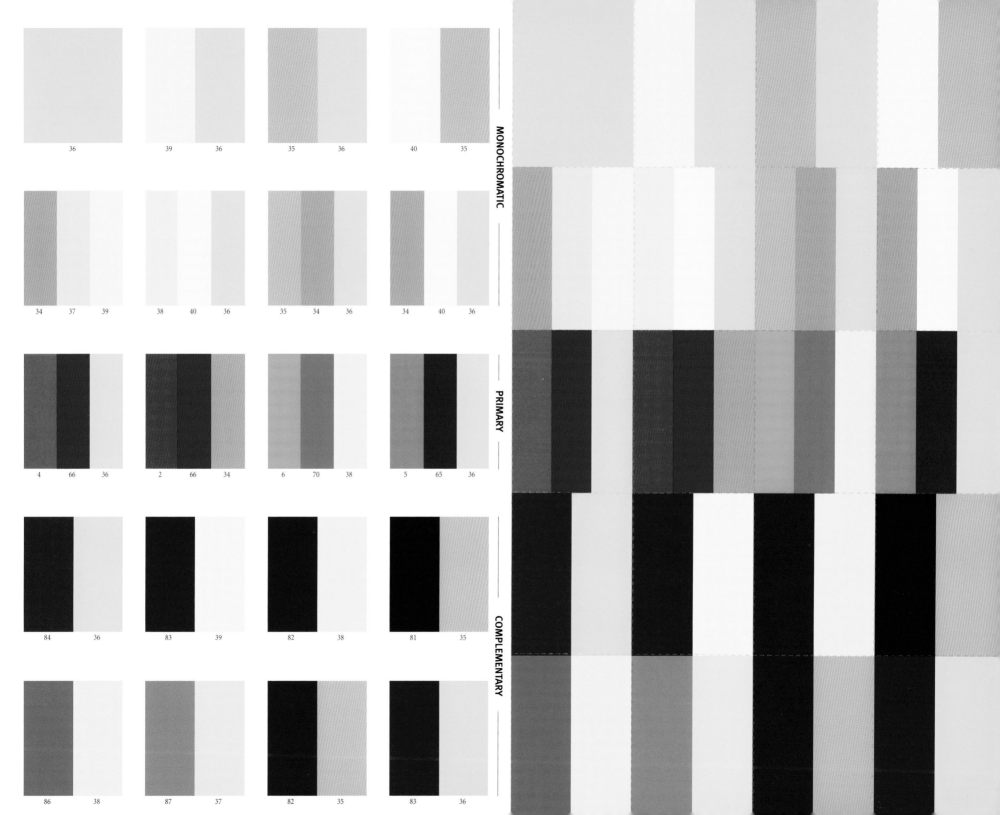

36

39 36

35 36

40 35

34 37 39

38 40 36

35 34 36

34 40 36

4 66 36

2 66 34

6 70 38

5 65 36

84 36

83 39

82 38

81 35

86 38

87 37

82 35

83 36

MOVING
Complementary
36

MOVING
Complementary
83

MOVING
Complementary
35

MOVING
Complementary
82

MOVING
Complementary
37

MOVING
Complementary
87

MOVING
Complementary
38

MOVING
Complementary
86

MOVING
Complementary
35

MOVING
Complementary
81

MOVING
Complementary
38

MOVING
Complementary
82

MOVING
Complementary
39

MOVING
Complementary
83

MOVING
Complementary
36

MOVING
Complementary
84

MOVING
Primary
36

MOVING
Primary
65

MOVING
Primary
5

MOVING
Primary
38

MOVING
Primary
70

MOVING
Primary
6

MOVING
Primary
34

MOVING
Primary
66

MOVING
Primary
2

MOVING
Primary
36

MOVING
Primary
66

MOVING
Primary
4

MOVING
Monochromatic
36

MOVING
Monochromatic
40

MOVING
Monochromatic
34

MOVING
Monochromatic
36

MOVING
Monochromatic
34

MOVING
Monochromatic
35

MOVING
Monochromatic
36

MOVING
Monochromatic
40

MOVING
Monochromatic
38

MOVING
Monochromatic
39

MOVING
Monochromatic
37

MOVING
Monochromatic
34

MOVING
Monochromatic
35

MOVING
Monochromatic
40

MOVING
Monochromatic
36

MOVING
Monochromatic
35

MOVING
Monochromatic
36

MOVING
Monochromatic
39

MOVING
Monochromatic
36

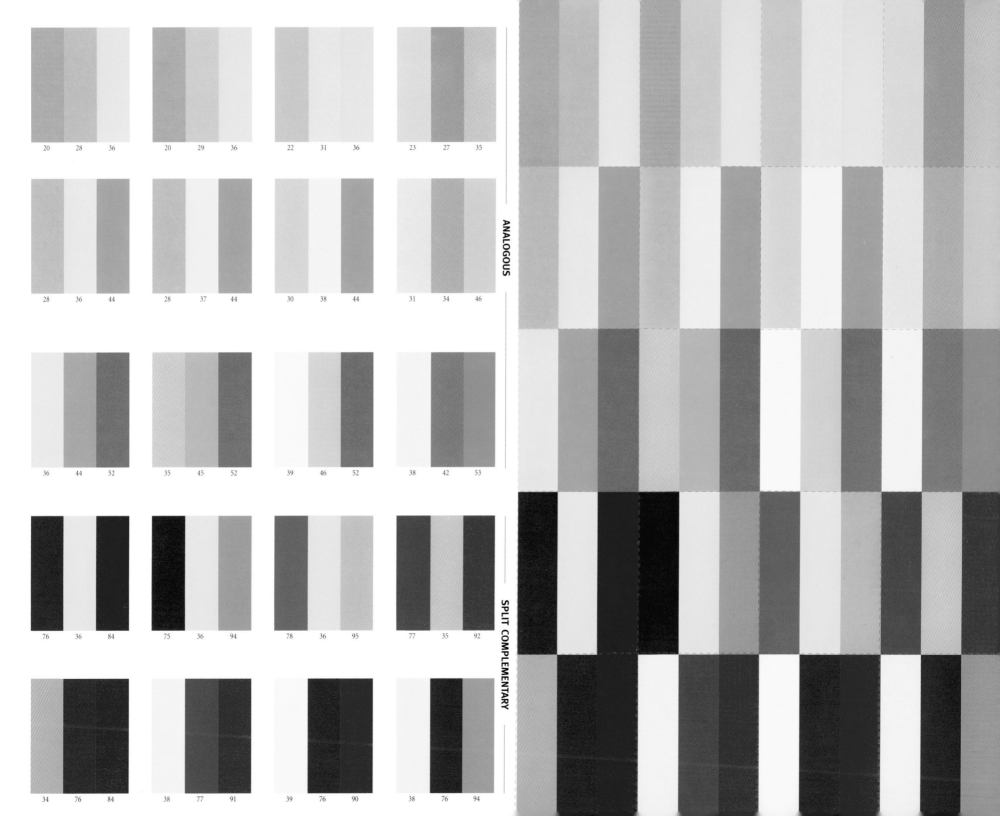

20	28	36
20	29	36
22	31	36
23	27	35

28	36	44
28	37	44
30	38	44
31	34	46

36	44	52
35	45	52
39	46	52
38	42	53

76	36	84
75	36	94
78	36	95
77	35	92

34	76	84
38	77	91
39	76	90
38	76	94

MOVING Split Complementary	MOVING Split Complementary	MOVING Analogous	MOVING Analogous	MOVING Analogous
94	92	53	46	35
76	35	42	34	27
38	77	38	31	23
90	95	52	44	36
76	36	46	38	31
39	78	39	30	22
91	94	52	44	36
77	36	45	37	29
38	75	35	28	20
84	84	52	44	36
76	36	44	36	28
34	76	36	28	20

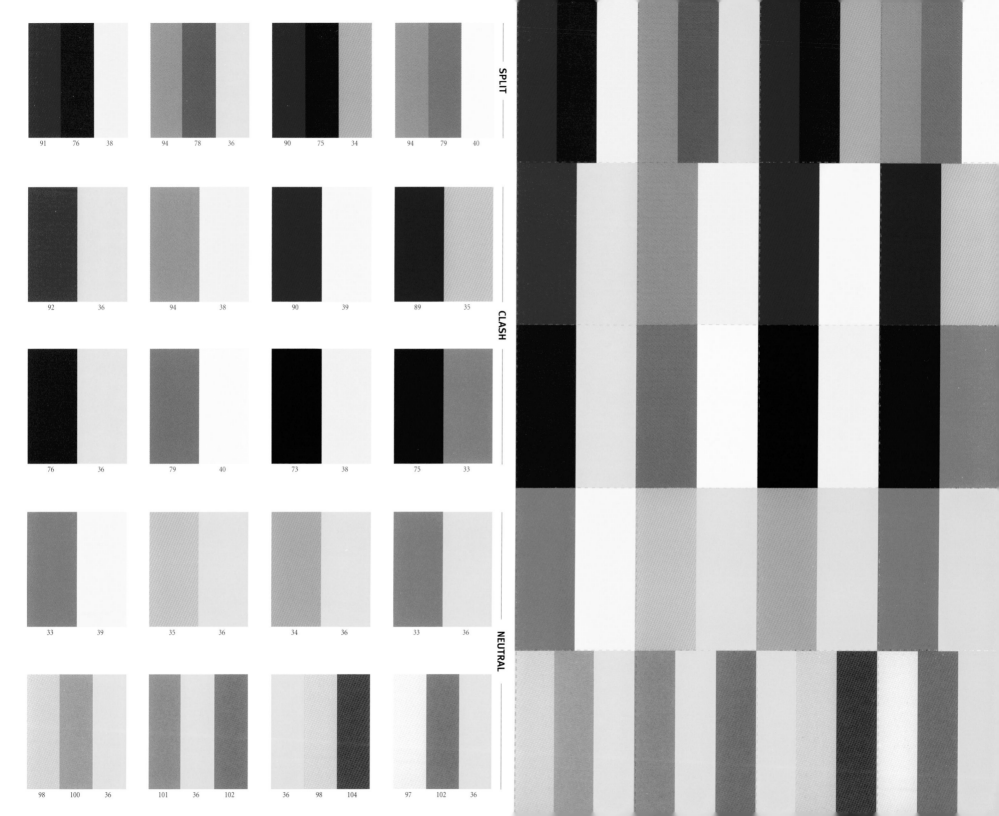

SPLIT

| 91 | 76 | 38 | 94 | 78 | 36 | 90 | 75 | 34 | 94 | 79 | 40 |

CLASH

| 92 | | 36 | 94 | | 38 | 90 | | 39 | 89 | | 35 |

| 76 | 36 | 79 | 40 | 73 | 38 | 75 | 33 |

NEUTRAL

| 33 | | 39 | 35 | | 36 | 34 | | 36 | 33 | | 36 |

| 98 | 100 | 36 | 101 | 36 | 102 | 36 | 98 | 104 | 97 | 102 | 36 |

MOVING Split 40
MOVING Split 79
MOVING Split 94
MOVING Split 34
MOVING Split 75
MOVING Split 90
MOVING Split 36
MOVING Split 78
MOVING Split 94
MOVING Split 38
MOVING Split 76
MOVING Split 91

MOVING Clash 35
MOVING Clash 89
MOVING Clash 39
MOVING Clash 90
MOVING Clash 38
MOVING Clash 94
MOVING Clash 36
MOVING Clash 92

MOVING Clash 33
MOVING Clash 75
MOVING Clash 38
MOVING Clash 73
MOVING Clash 40
MOVING Clash 79
MOVING Clash 36
MOVING Clash 76

MOVING Neutral 36
MOVING Neutral 33
MOVING Neutral 36
MOVING Neutral 34
MOVING Neutral 36
MOVING Neutral 35
MOVING Neutral 39
MOVING Neutral 33

MOVING Neutral 36
MOVING Neutral 102
MOVING Neutral 97
MOVING Neutral 104
MOVING Neutral 98
MOVING Neutral 36
MOVING Neutral 102
MOVING Neutral 36
MOVING Neutral 101
MOVING Neutral 36
MOVING Neutral 100
MOVING Neutral 98

MOVING
Tips for Color Schemes

GENERAL COLOR

For a sense of pure, uncomplicated warmth and energy, nothing beats a yellow hue in its clash and complementary palettes. And nothing looks lighter than yellow—the lightest of hues—against blue, the darkest of hues.

GRAPHIC DESIGN

Because of its quality of motion, a moving color scheme works well in design oriented toward sports or sporting goods.

INTERIOR DESIGN

Yellow is a great color for spaces where intellectual clarity and detail orientation is required—for example, in a home office.

FINE ART

Because the eye follows yellow, artists can use a moving color scheme to direct the viewer's eye around a painting.

ICI Paints, maker of the Glidden brand

Bluelounge Design

Artist: Teesha Moore

ELEGANT

The ultimate in restraint, the elegant color scheme is a graceful melding of the faintest tints, suffused with the warmth of palest yellow. In this tint, the active nature of yellow is mollified with white, which creates a creamy color that is the hands-down classic for interior walls; it has a reflective, expansive quality that seems to cast a room in a golden light. Classics in fashion—pearls, cashmere sweaters, even pale blond hair—are often found in the understated pastels of the elegant color scheme. There's a translucent quality to the elegant color scheme; it hints of china and fine crystal, opulent sheer drapes, and whisper-thin linen. Intelligence, calm, and ease are projected by this color scheme, the ultimate in good taste. Even in complementary, split complementary, and clash variations, the elegant color scheme is never jarring, always maintaining a sense of harmony, clarity, and grace.

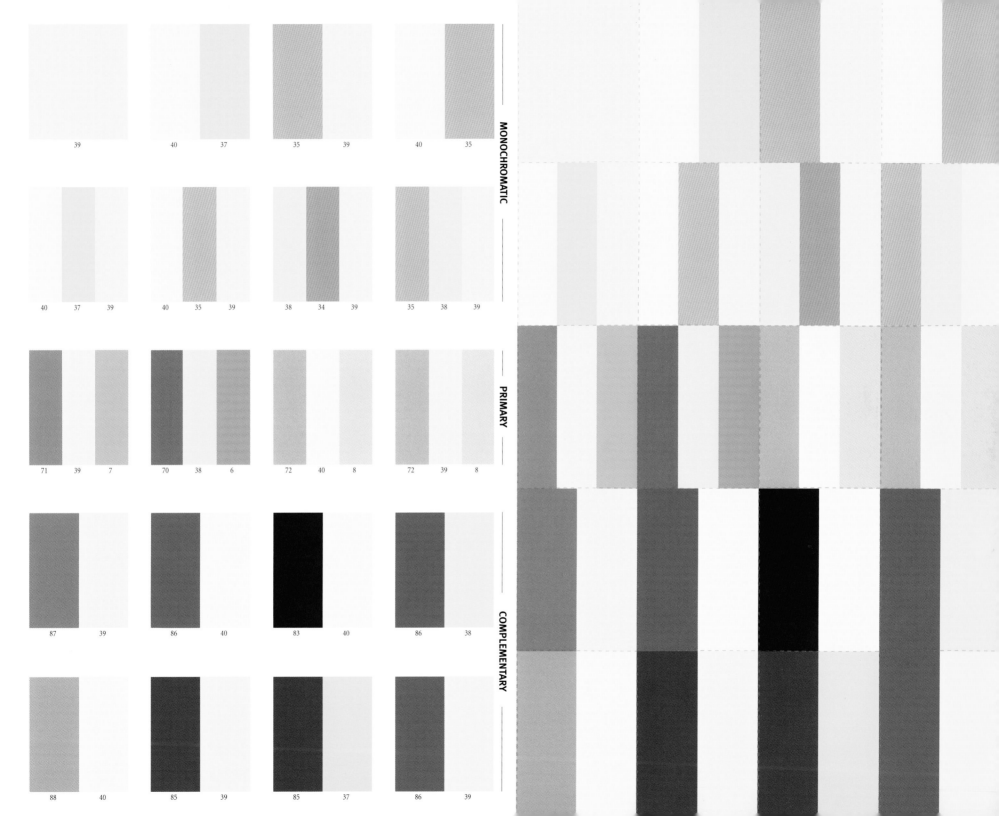

39

40　37

35　39

40　35

40　37　39

40　35　39

38　34　39

35　38　39

71　39　7

70　38　6

72　40　8

72　39　8

87　39

86　40

83　40

86　38

88　40

85　39

85　37

86　39

ELEGANT Monochromatic 35

ELEGANT Monochromatic 40

ELEGANT Monochromatic 39

ELEGANT Monochromatic 35

ELEGANT Monochromatic 37

ELEGANT Monochromatic 40

ELEGANT Monochromatic 39

ELEGANT Monochromatic 39

aELEGANT Monochromatic 38

ELEGANT Monochromatic 35

ELEGANT Monochromatic 39

ELEGANT Monochromatic 34

ELEGANT Monochromatic 38

ELEGANT Monochromatic 39

ELEGANT Monochromatic 35

ELEGANT Monochromatic 40

ELEGANT Monochromatic 39

ELEGANT Monochromatic 37

ELEGANT Monochromatic 40

ELEGANT Primary 8

ELEGANT Primary 39

ELEGANT Primary 72

ELEGANT Primary 8

ELEGANT Primary 40

ELEGANT Primary 72

ELEGANT Primary 6

ELEGANT Primary 38

ELEGANT Primary 70

ELEGANT Primary 7

ELEGANT Primary 39

ELEGANT Primary 71

ELEGANT Complementary 38

ELEGANT Complementary 86

ELEGANT Complementary 40

ELEGANT Complementary 83

ELEGANT Complementary 40

ELEGANT Complementary 86

ELEGANT Complementary 39

ELEGANT Complementary 87

ELEGANT Complementary 39

ELEGANT Complementary 86

ELEGANT Complementary 37

ELEGANT Complementary 85

ELEGANT Complementary 39

ELEGANT Complementary 85

ELEGANT Complementary 40

ELEGANT Complementary 88

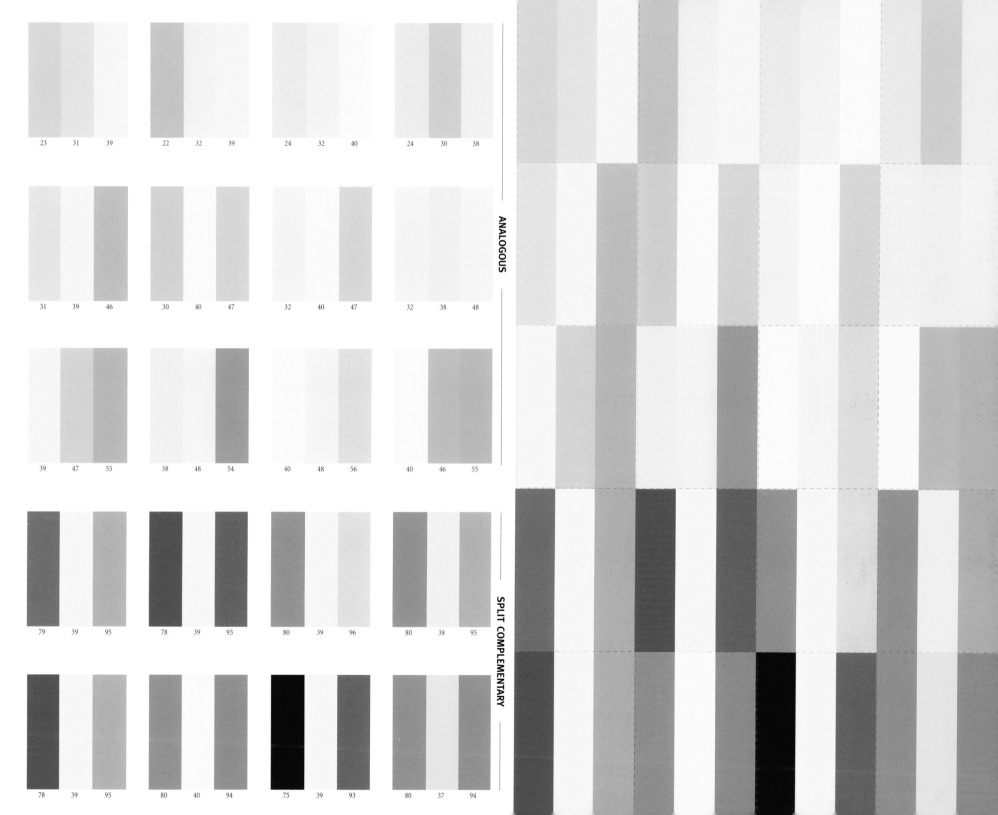

| 23 | 31 | 39 | | 22 | 32 | 39 | | 24 | 32 | 40 | | 24 | 30 | 38 |

| 31 | 39 | 46 | | 30 | 40 | 47 | | 32 | 40 | 47 | | 32 | 38 | 48 |

| 39 | 47 | 55 | | 38 | 48 | 54 | | 40 | 48 | 56 | | 40 | 46 | 55 |

| 79 | 39 | 95 | | 78 | 39 | 93 | | 80 | 39 | 96 | | 80 | 38 | 95 |

| 78 | 39 | 95 | | 80 | 40 | 94 | | 75 | 39 | 93 | | 80 | 37 | 94 |

ELEGANT Split Complementary 94
ELEGANT Split Complementary 37
ELEGANT Split Complementary 80
ELEGANT Split Complementary 93
ELEGANT Split Complementary 39
ELEGANT Split Complementary 75
ELEGANT Split Complementary 94
ELEGANT Split Complementary 40
ELEGANT Split Complementary 80
ELEGANT Split Complementary 95
ELEGANT Split Complementary 39
ELEGANT Split Complementary 78

ELEGANT Split Complementary 95
ELEGANT Split Complementary 38
ELEGANT Split Complementary 80
ELEGANT Split Complementary 96
ELEGANT Split Complementary 39
ELEGANT Split Complementary 80
ELEGANT Split Complementary 93
ELEGANT Split Complementary 39
ELEGANT Split Complementary 78
ELEGANT Split Complementary 95
ELEGANT Split Complementary 39
ELEGANT Split Complementary 79

ELEGANT Analogous 55
ELEGANT Analogous 46
ELEGANT Analogous 40
ELEGANT Analogous 56
ELEGANT Analogous 48
ELEGANT Analogous 40
ELEGANT Analogous 54
ELEGANT Analogous 48
ELEGANT Analogous 38
ELEGANT Analogous 55
ELEGANT Analogous 47
ELEGANT Analogous 39

ELEGANT Analogous 48
ELEGANT Analogous 38
ELEGANT Analogous 32
ELEGANT Analogous 47
ELEGANT Analogous 40
ELEGANT Analogous 32
ELEGANT Analogous 47
ELEGANT Analogous 40
ELEGANT Analogous 30
ELEGANT Analogous 46
ELEGANT Analogous 39
ELEGANT Analogous 31

ELEGANT Analogous 38
ELEGANT Analogous 30
ELEGANT Analogous 24
ELEGANT Analogous 40
ELEGANT Analogous 32
ELEGANT Analogous 24
ELEGANT Analogous 39
ELEGANT Analogous 32
ELEGANT Analogous 22
ELEGANT Analogous 39
ELEGANT Analogous 31
ELEGANT Analogous 23

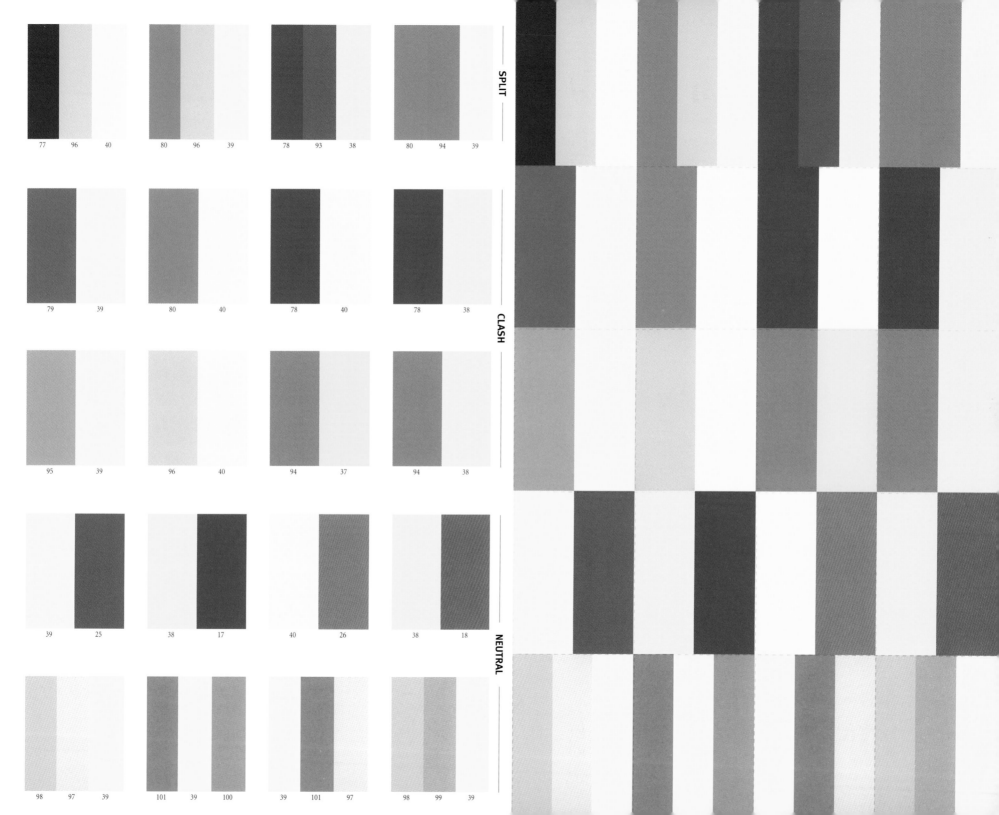

77 96 40

80 96 39

78 93 38

80 94 39

79 39

80 40

78 40

78 38

95 39

96 40

94 37

94 38

39 25

38 17

40 26

38 18

98 97 39

101 39 100

39 101 97

98 99 39

ELEGANT Split 39

ELEGANT Split 94

ELEGANT Split 80

ELEGANT Split 38

ELEGANT Split 93

ELEGANT Split 78

ELEGANT Split 39

ELEGANT Split 96

ELEGANT Split 80

ELEGANT Split 40

ELEGANT Split 96

ELEGANT Split 77

ELEGANT Clash 38

ELEGANT Clash 78

ELEGANT Clash 40

ELEGANT Clash 78

ELEGANT Clash 40

ELEGANT Clash 80

ELEGANT Clash 39

ELEGANT Clash 79

ELEGANT Clash 38

ELEGANT Clash 94

ELEGANT Clash 37

ELEGANT Clash 94

ELEGANT Clash 40

ELEGANT Clash 96

ELEGANT Clash 39

ELEGANT Clash 95

ELEGANT Neutral 18

ELEGANT Neutral 38

ELEGANT Neutral 26

ELEGANT Neutral 40

ELEGANT Neutral 17

ELEGANT Neutral 38

ELEGANT Neutral 25

ELEGANT Neutral 39

ELEGANT Neutral 39

ELEGANT Neutral 99

ELEGANT Neutral 98

ELEGANT Neutral 97

ELEGANT Neutral 101

ELEGANT Neutral 39

ELEGANT Neutral 100

ELEGANT Neutral 39

ELEGANT Neutral 101

ELEGANT Neutral 39

ELEGANT Neutral 97

ELEGANT Neutral 98

ELEGANT
Tips for Color Schemes

GENERAL COLOR

Whether used in interior design, graphic design, or fine arts, metallic gold lends an added touch of elegance that never seems too flamboyant with this color scheme. Just a touch—a gold frame, a gold-embossed business card—adds impact.

GRAPHIC DESIGN

In the absence of much color, texture becomes a primary consideration. Fabrics, paints, and papers should have a fine visible texture to add tactile appeal.

INTERIOR DESIGN

When using an elegant color scheme, think translucent. That means sheer fabrics, glass, and Lucite furniture and accessories for interior design.

FINE ART

Fine artists will want to maintain the clarity of elegant colors by using thin washes of translucent watercolors; oil pastels are also a good choice, if not overworked.

Kinetic Singapore

Kathy Shumway-Tunney
Morning-Hill Top Park (1995)

ICI Paints, maker of the Glidden brand

FRESH

A fresh color scheme revolves around the universally appealing secondary color, green. Green is a color associated with healing, prosperity, rebirth, harmony, tranquillity, and generosity. This lovely hue strikes a balance between warm and cool, and conveys the extroverted, communicative aspect of yellow with the peaceful, inspired effects of blue. A fresh color scheme is restful to the eye, giving a sense of relaxed readiness and eternal spring.

Because green is a hue that graciously recedes, other hues—particularly its complement, red—seem to advance and grow brighter in its presence. The fresh color palette recalls misty green islands, rain forests, pristine lawns, and fields of tulips. In its analogous palette, it suggests green hills above a blue-green ocean. The tender beauty of a natural environment is always evoked by this color scheme.

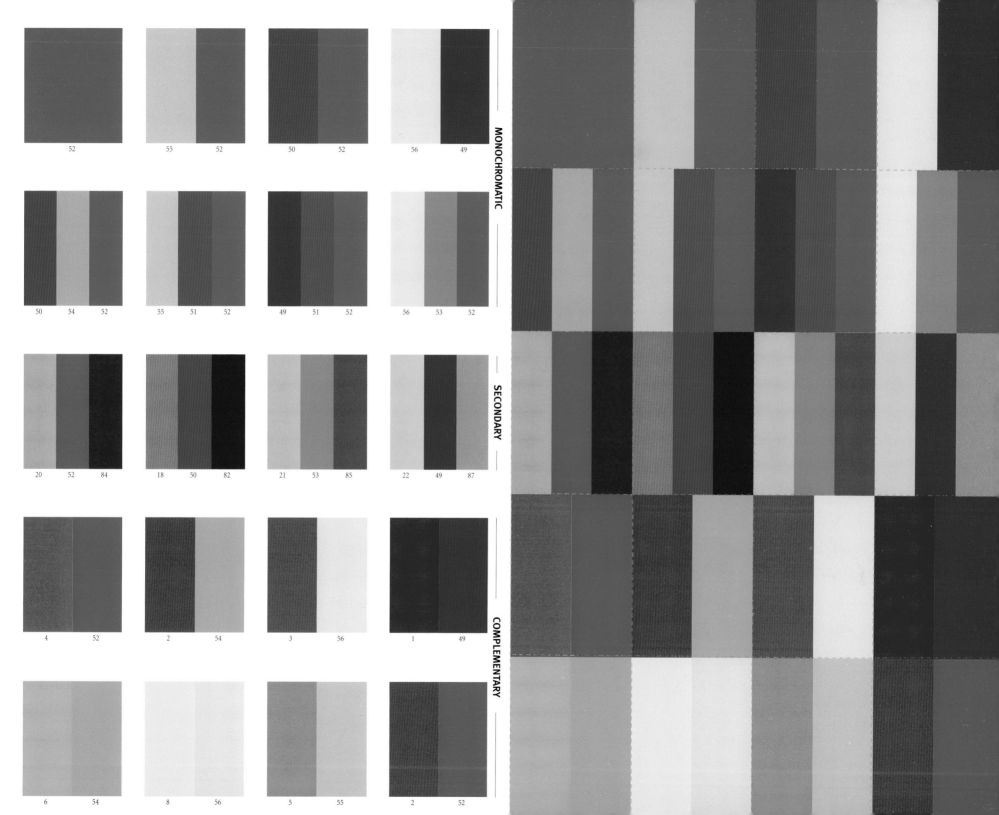

52

55 52

50 52

56 49

50 54 52

55 51 52

49 51 52

56 53 52

20 52 84

18 50 82

21 53 85

22 49 87

4 52

2 54

3 56

1 49

6 54

8 56

5 55

2 52

FRESH Monochromatic 49

FRESH Monochromatic 56

FRESH Monochromatic 52

FRESH Monochromatic 50

FRESH Monochromatic 52

FRESH Monochromatic 55

FRESH Monochromatic 52

FRESH Monochromatic 52

FRESH Monochromatic 53

FRESH Monochromatic 56

FRESH Monochromatic 52

FRESH Monochromatic 51

FRESH Monochromatic 49

FRESH Monochromatic 52

FRESH Monochromatic 51

FRESH Monochromatic 55

FRESH Monochromatic 52

FRESH Monochromatic 54

FRESH Monochromatic 50

FRESH Secondary 87

FRESH Secondary 49

FRESH Secondary 22

FRESH Secondary 85

FRESH Secondary 53

FRESH Secondary 21

FRESH Secondary 82

FRESH Secondary 50

FRESH Secondary 18

FRESH Secondary 84

FRESH Secondary 52

FRESH Secondary 20

FRESH Complementary 49

FRESH Complementary 1

FRESH Complementary 56

FRESH Complementary 3

FRESH Complementary 54

FRESH Complementary 2

FRESH Complementary 52

FRESH Complementary 4

FRESH Complementary 52

FRESH Complementary 2

FRESH Complementary 55

FRESH Complementary 5

FRESH Complementary 56

FRESH Complementary 8

FRESH Complementary 54

FRESH Complementary 6

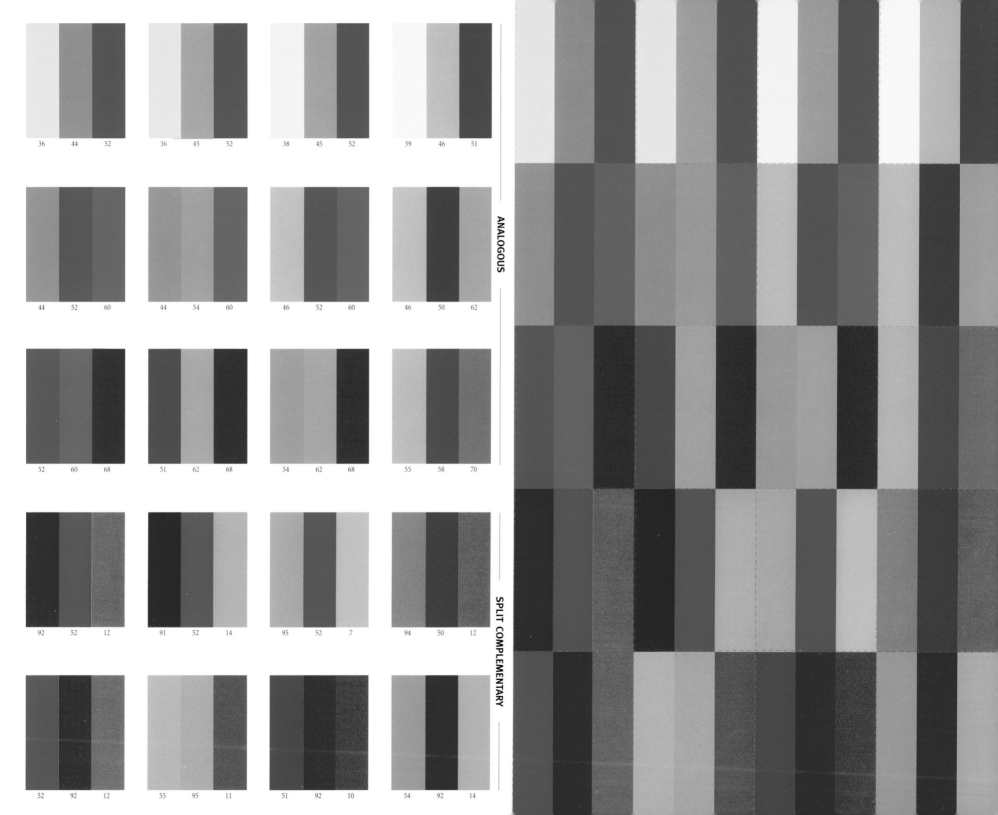

36	44	52
36	45	52
38	45	52
39	46	51

44	52	60
44	54	60
46	52	60
46	50	62

52	60	68
51	62	68
54	62	68
55	58	70

92	52	12
91	52	14
95	52	7
94	50	12

52	92	12
55	95	11
51	92	10
54	92	14

FRESH Split Complementary	FRESH Split Complementary	FRESH Analogous	FRESH Analogous	FRESH Analogous
14	12	70	62	51
92	50	58	50	46
54	94	55	46	39
10	7	68	60	52
92	52	62	52	45
51	95	54	46	38
11	14	68	60	52
95	52	62	54	45
55	91	51	44	36
12	12	68	60	52
92	52	60	52	44
52	92	52	44	36

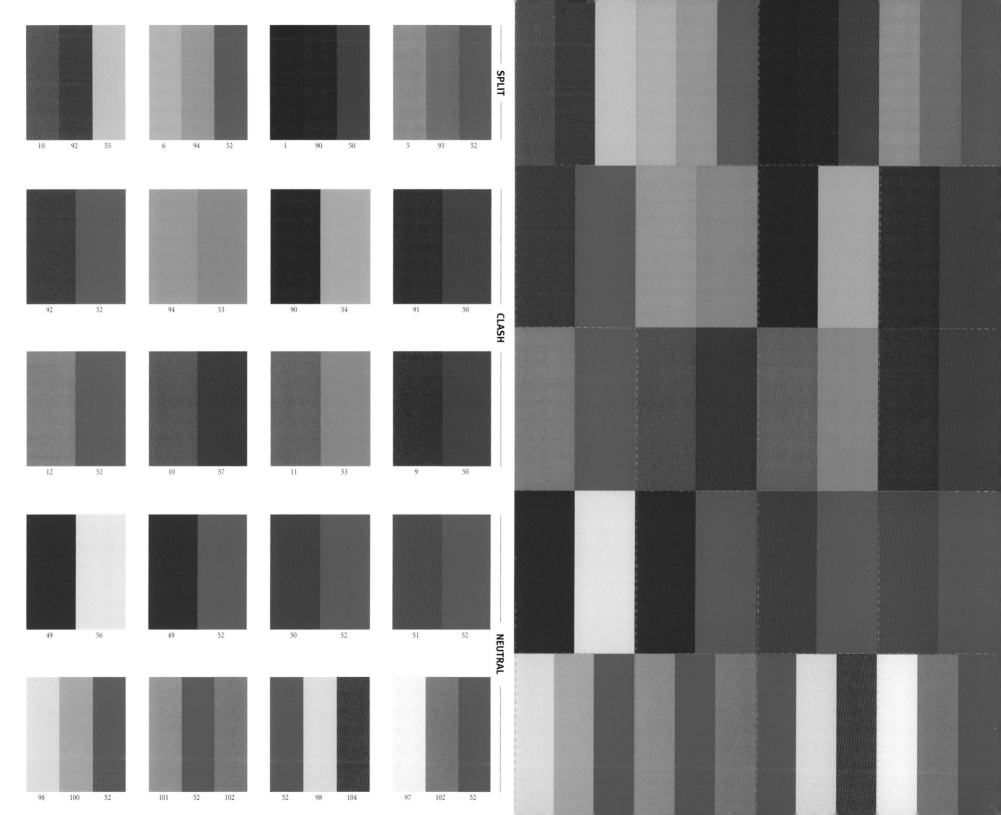

SPLIT

| 10 | 92 | 55 | 6 | 94 | 52 | 1 | 90 | 50 | 5 | 93 | 52 |

CLASH

| 92 | 52 | 94 | 53 | 90 | 54 | 91 | 50 |

| 12 | 52 | 10 | 57 | 11 | 53 | 9 | 50 |

NEUTRAL

| 49 | 56 | 49 | 52 | 50 | 52 | 51 | 52 |

| 98 | 100 | 52 | 101 | 52 | 102 | 52 | 98 | 104 | 97 | 102 | 52 |

FRESH Split 52 · FRESH Split 93 · FRESH Split 5 · FRESH Split 50 · FRESH Split 90 · FRESH Split 1 · FRESH Split 52 · FRESH Split 94 · FRESH Split 6 · FRESH Split 55 · FRESH Split 92 · FRESH Split 10

FRESH Clash 50 · FRESH Clash 91 · FRESH Clash 54 · FRESH Clash 90 · FRESH Clash 53 · FRESH Clash 94 · FRESH Clash 52 · FRESH Clash 92

FRESH Clash 50 · FRESH Clash 9 · FRESH Clash 53 · FRESH Clash 11 · FRESH Clash 57 · FRESH Clash 10 · FRESH Clash 52 · FRESH Clash 12

FRESH Neutral 52 · FRESH Neutral 51 · FRESH Neutral 52 · FRESH Neutral 50 · FRESH Neutral 52 · FRESH Neutral 49 · FRESH Neutral 56 · FRESH Neutral 49

FRESH Neutral 52 · FRESH Neutral 102 · FRESH Neutral 97 · FRESH Neutral 104 · FRESH Neutral 98 · FRESH Neutral 52 · FRESH Neutral 102 · FRESH Neutral 52 · FRESH Neutral 101 · FRESH Neutral 52 · FRESH Neutral 100 · FRESH Neutral 98

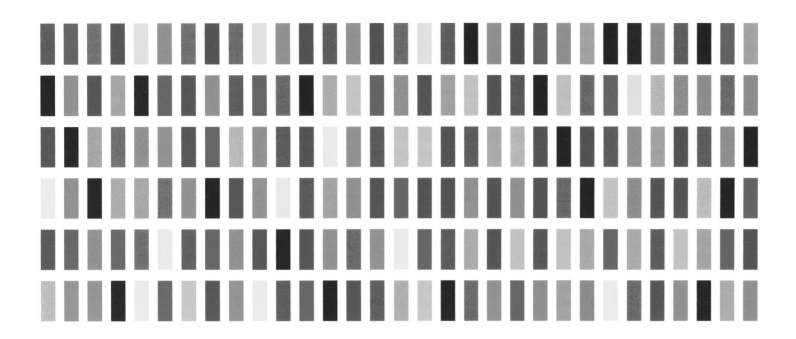

FRESH
Tips for Color Schemes

GENERAL COLOR

Because of their inviting nature, fresh colors work wonderfully well for ceramic tableware, fine china, tablecloths and napkins, and so on.

GRAPHIC DESIGN

Graphic designers will find this color scheme excellent for projects involving ecology and nature.

INTERIOR DESIGN

In residential interiors, a fresh color scheme is good for bedrooms and bathrooms, owing to its sense of renewal and relaxation.

FINE ART

For fine artists, a fresh palette is an obvious choice for creating a springlike mood. Because green tends to recede, consider adding a small amount of its complementary red hue to add energy to a painting or drawing.

Wilma Wethington
Falls Mill

Andrew Lewis Design © Schumacher

TRADITIONAL

Traditional color schemes, with their deep, rich shades and tones, evoke a sense of history—it's as if these colors, darkened with age, have come straight out of a medieval tapestry. The shaded greens that anchor this color scheme combine the stability of black with the prosperous, regenerative aspect of green, evoking ancient evergreen forests. These shaded greens are "the color of money"—which may be why so many financial institutions are decorated in bottle green. There is a conservative, yet precious, aspect to the traditional palette; it implies safety, inherited wealth, and old values.

There is also a rather masculine edge to this color scheme. Beyond the use of dark greens in military uniforms, the more jewel-like traditional colors are those used in men's silk ties, the only color acceptable in a conservative man's wardrobe.

Even in their complementary and clash aspects, traditional colors blend seamlessly together, creating a pleasant backdrop that never calls attention to itself, as in the textiles and wallpaper of English designer William Morris, c. 1900. It is a classically "tasteful" color scheme.

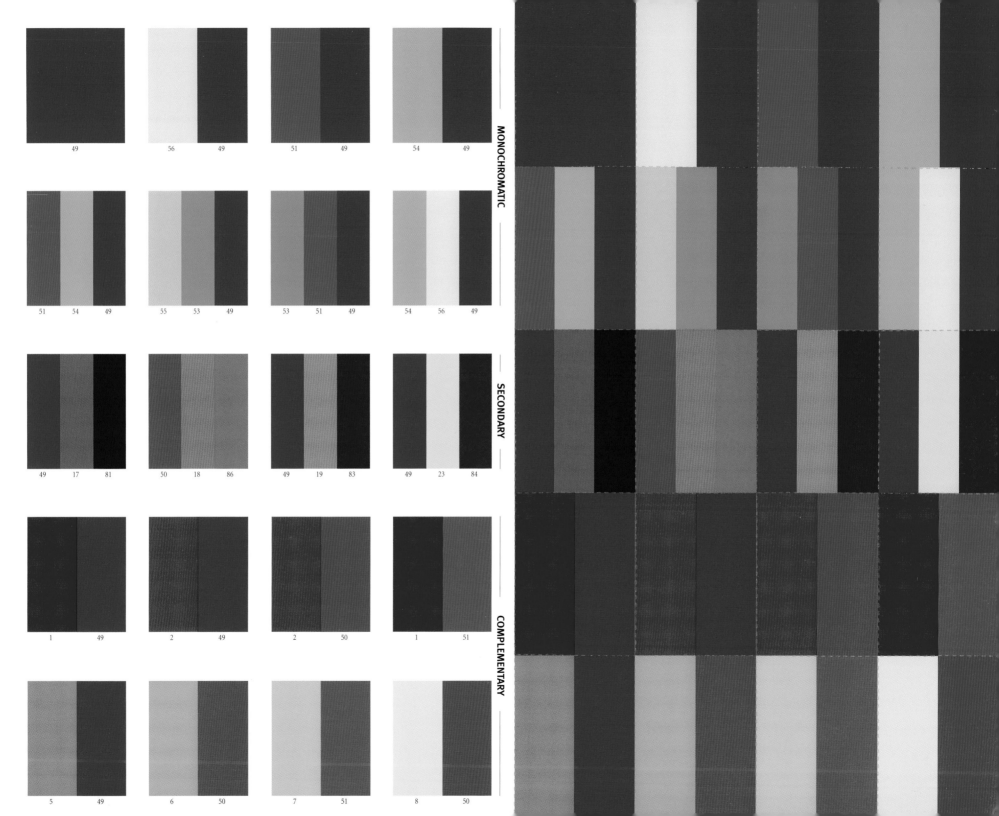

49

56 49

51 49

54 49

51 54 49

55 53 49

53 51 49

54 56 49

49 17 81

50 18 86

49 19 83

49 23 84

1 49

2 49

2 50

1 51

5 49

6 50

7 51

8 50

TRADITIONAL
Complementary
50

TRADITIONAL
Complementary
51

TRADITIONAL
Secondary
84

TRADITIONAL
Monochromatic
49

TRADITIONAL
Monochromatic
49

TRADITIONAL
Complementary
8

TRADITIONAL
Complementary
1

TRADITIONAL
Secondary
23

TRADITIONAL
Monochromatic
56

TRADITIONAL
Complementary
51

TRADITIONAL
Complementary
50

TRADITIONAL
Secondary
49

TRADITIONAL
Monochromatic
54

TRADITIONAL
Monochromatic
54

TRADITIONAL
Complementary
7

TRADITIONAL
Complementary
2

TRADITIONAL
Secondary
83

TRADITIONAL
Monochromatic
49

TRADITIONAL
Complementary
50

TRADITIONAL
Complementary
49

TRADITIONAL
Secondary
19

TRADITIONAL
Monochromatic
51

TRADITIONAL
Monochromatic
49

TRADITIONAL
Complementary
6

TRADITIONAL
Complementary
2

TRADITIONAL
Secondary
49

TRADITIONAL
Monochromatic
53

TRADITIONAL
Complementary
49

TRADITIONAL
Complementary
49

TRADITIONAL
Secondary
86

TRADITIONAL
Monochromatic
49

TRADITIONAL
Monochromatic
51

TRADITIONAL
Complementary
5

TRADITIONAL
Complementary
1

TRADITIONAL
Secondary
18

TRADITIONAL
Monochromatic
53

TRADITIONAL
Secondary
50

TRADITIONAL
Monochromatic
55

TRADITIONAL
Monochromatic
56

TRADITIONAL
Secondary
81

TRADITIONAL
Monochromatic
49

TRADITIONAL
Secondary
17

TRADITIONAL
Monochromatic
54

TRADITIONAL
Monochromatic
49

TRADITIONAL
Secondary
49

TRADITIONAL
Monochromatic
51

traditional color schemes

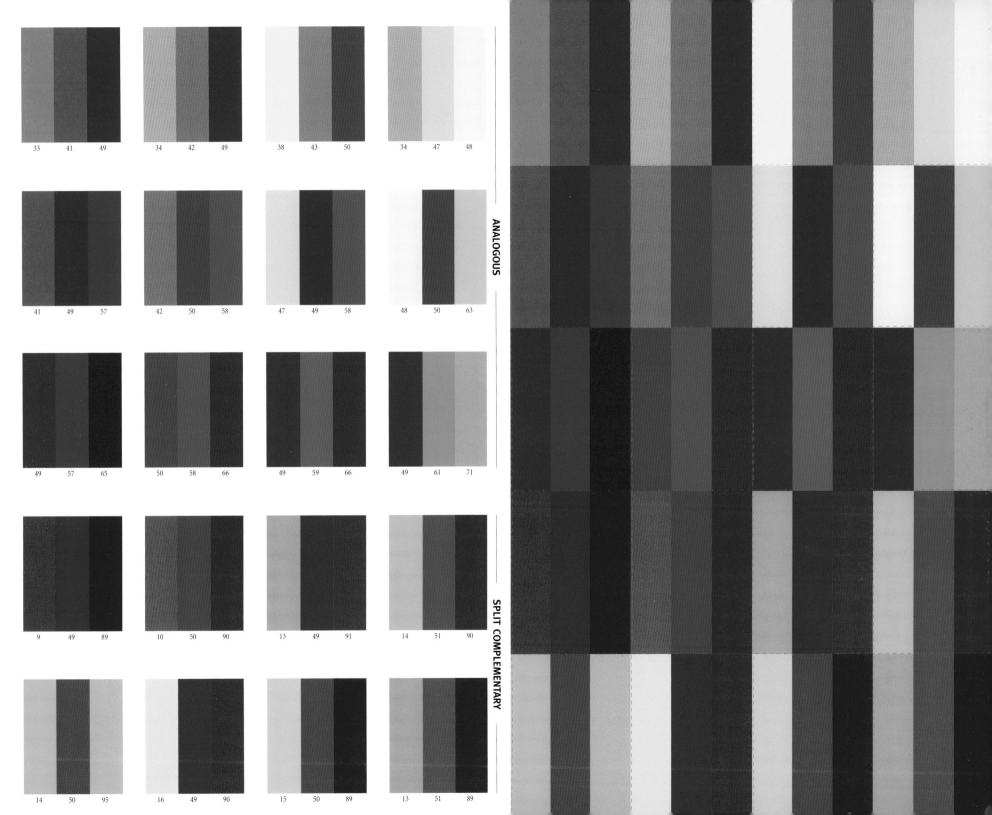

33 41 49 34 42 49 38 43 50 34 47 48

41 49 57 42 50 58 47 49 58 48 50 63

ANALOGOUS

49 57 65 50 58 66 49 59 66 49 61 71

9 49 89 10 50 90 13 49 91 14 51 90

SPLIT COMPLEMENTARY

14 50 95 16 49 90 15 50 89 13 51 89

TRADITIONAL Analogous 48 | **TRADITIONAL** Analogous 47 | **TRADITIONAL** Analogous 34 | **TRADITIONAL** Analogous 50 | **TRADITIONAL** Analogous 43 | **TRADITIONAL** Analogous 38 | **TRADITIONAL** Analogous 49 | **TRADITIONAL** Analogous 42 | **TRADITIONAL** Analogous 34 | **TRADITIONAL** Analogous 49 | **TRADITIONAL** Analogous 41 | **TRADITIONAL** Analogous 33

TRADITIONAL Analogous 63 | **TRADITIONAL** Analogous 50 | **TRADITIONAL** Analogous 48 | **TRADITIONAL** Analogous 58 | **TRADITIONAL** Analogous 49 | **TRADITIONAL** Analogous 47 | **TRADITIONAL** Analogous 58 | **TRADITIONAL** Analogous 50 | **TRADITIONAL** Analogous 42 | **TRADITIONAL** Analogous 57 | **TRADITIONAL** Analogous 49 | **TRADITIONAL** Analogous 41

TRADITIONAL Analogous 71 | **TRADITIONAL** Analogous 61 | **TRADITIONAL** Analogous 49 | **TRADITIONAL** Analogous 66 | **TRADITIONAL** Analogous 59 | **TRADITIONAL** Analogous 49 | **TRADITIONAL** Analogous 66 | **TRADITIONAL** Analogous 58 | **TRADITIONAL** Analogous 50 | **TRADITIONAL** Analogous 65 | **TRADITIONAL** Analogous 57 | **TRADITIONAL** Analogous 49

TRADITIONAL Split Complementary 90 | **TRADITIONAL** Split Complementary 51 | **TRADITIONAL** Split Complementary 14 | **TRADITIONAL** Split Complementary 91 | **TRADITIONAL** Split Complementary 49 | **TRADITIONAL** Split Complementary 13 | **TRADITIONAL** Split Complementary 90 | **TRADITIONAL** Split Complementary 50 | **TRADITIONAL** Split Complementary 10 | **TRADITIONAL** Split Complementary 89 | **TRADITIONAL** Split Complementary 49 | **TRADITIONAL** Split Complementary 9

TRADITIONAL Split Complementary 89 | **TRADITIONAL** Split Complementary 51 | **TRADITIONAL** Split Complementary 13 | **TRADITIONAL** Split Complementary 89 | **TRADITIONAL** Split Complementary 50 | **TRADITIONAL** Split Complementary 15 | **TRADITIONAL** Split Complementary 90 | **TRADITIONAL** Split Complementary 49 | **TRADITIONAL** Split Complementary 16 | **TRADITIONAL** Split Complementary 95 | **TRADITIONAL** Split Complementary 50 | **TRADITIONAL** Split Complementary 14

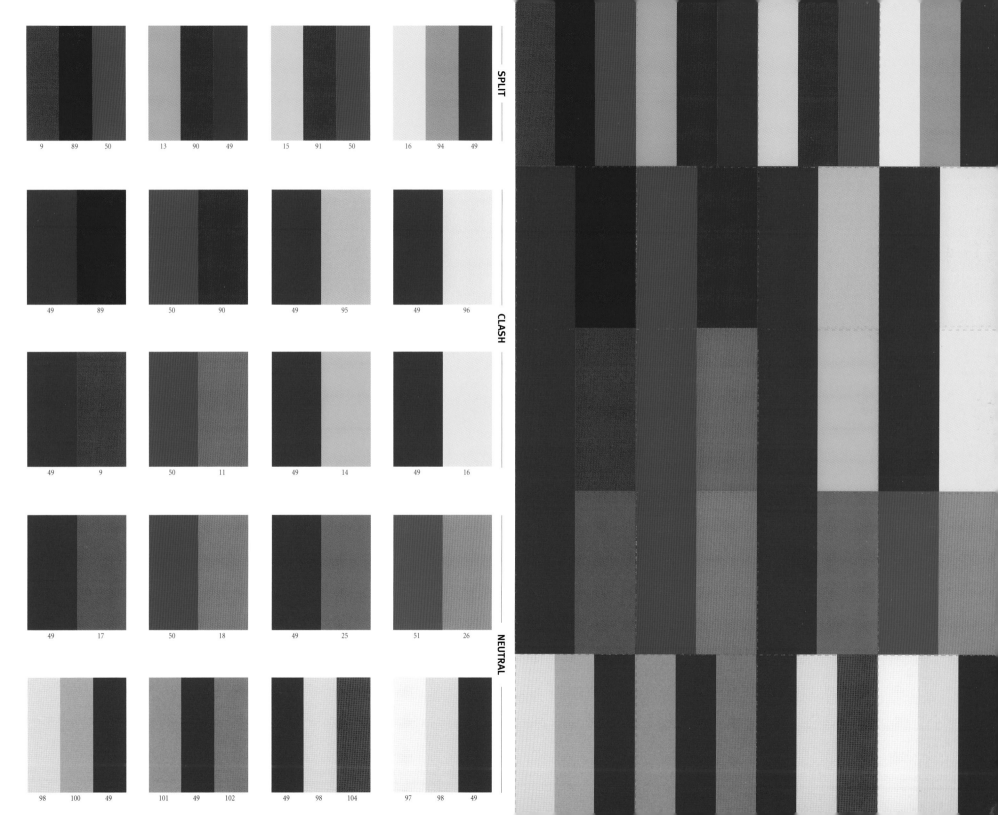

9 89 50 13 90 49 15 91 50 16 94 49

49 89 50 90 49 95 49 96

49 9 50 11 49 14 49 16

49 17 50 18 49 25 51 26

98 100 49 101 49 102 49 98 104 97 98 49

TRADITIONAL Split 49
TRADITIONAL Split 94
TRADITIONAL Split 16
TRADITIONAL Split 50
TRADITIONAL Split 91
TRADITIONAL Split 15
TRADITIONAL Split 49
TRADITIONAL Split 90
TRADITIONAL Split 13
TRADITIONAL Split 50
TRADITIONAL Split 89
TRADITIONAL Split 9

TRADITIONAL Clash 96
TRADITIONAL Clash 49
TRADITIONAL Clash 95
TRADITIONAL Clash 49
TRADITIONAL Clash 90
TRADITIONAL Clash 50
TRADITIONAL Clash 89
TRADITIONAL Clash 49

TRADITIONAL Clash 16
TRADITIONAL Clash 49
TRADITIONAL Clash 14
TRADITIONAL Clash 49
TRADITIONAL Clash 11
TRADITIONAL Clash 50
TRADITIONAL Clash 9
TRADITIONAL Clash 49

TRADITIONAL Neutral 26
TRADITIONAL Neutral 51
TRADITIONAL Neutral 25
TRADITIONAL Neutral 49
TRADITIONAL Neutral 18
TRADITIONAL Neutral 50
TRADITIONAL Neutral 17
TRADITIONAL Neutral 49

TRADITIONAL Neutral 49
TRADITIONAL Neutral 98
TRADITIONAL Neutral 97
TRADITIONAL Neutral 104
TRADITIONAL Neutral 98
TRADITIONAL Neutral 49
TRADITIONAL Neutral 102
TRADITIONAL Neutral 49
TRADITIONAL Neutral 101
TRADITIONAL Neutral 49
TRADITIONAL Neutral 100
TRADITIONAL Neutral 98

traditional color schemes

124

TRADITIONAL
Tips for Color Schemes

GENERAL COLOR

The inherent mellowness of traditional colors allows them to blend with harmonious richness in carpets, textiles, and wallpaper.

GRAPHIC DESIGN

In graphic design, a traditional color scheme implies age-old wealth, prudence, and conservatism—good for brokerage firms, traditional restaurants, booksellers, and so on.

INTERIOR DESIGN

When combined with dark polished wood floors, furniture, or wainscoting, traditional colors give an interior the feeling of a hereditary manor—excellent for formal dining rooms, libraries, banks, and so on.

FINE ART

Fine artists will find this palette useful in creating work that implies the ancient calm of nature, and for any work that requires a sense of history.

Artist: Ann Baldwin

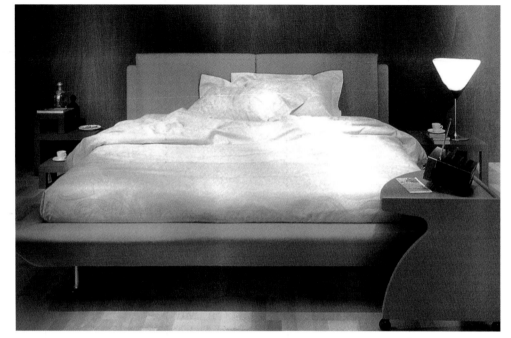

Cassina

Ogilvy & Mather
Brand Integration

REFRESHING

A refreshing color scheme always includes the clear, energetic color blue-green. An auspicious, youthful color, blue-green (also known as teal or aqua) has the calming, relaxing effect of blue but still contains a warm touch of yellow. Refreshing colors imply physical fitness, health, and mental clarity. As the name implies, aqua always suggests cool water, and in fact blue-green is the color of swimming pools. This is an expansive, happy color scheme, ideal for bathrooms, bedrooms, and patios. Blue-green is considered to be one of the most healing colors.

Particularly in combination with its complementary red-orange hue, teal suggests a desert oasis. When combined with white, it suggests an Aegean island, like Santorini.

A refreshing color scheme is contemporary, effervescent, cooling, rejuvenating, and energizing. It is frequently seen in design for sportswear (especially swimwear), cosmetic products for the bath, and glassware. The works of artists David Hockney, Helen Frankenthaler, and Richard Diebenkorn are identified with a refreshing palette.

complete color harmony workbook

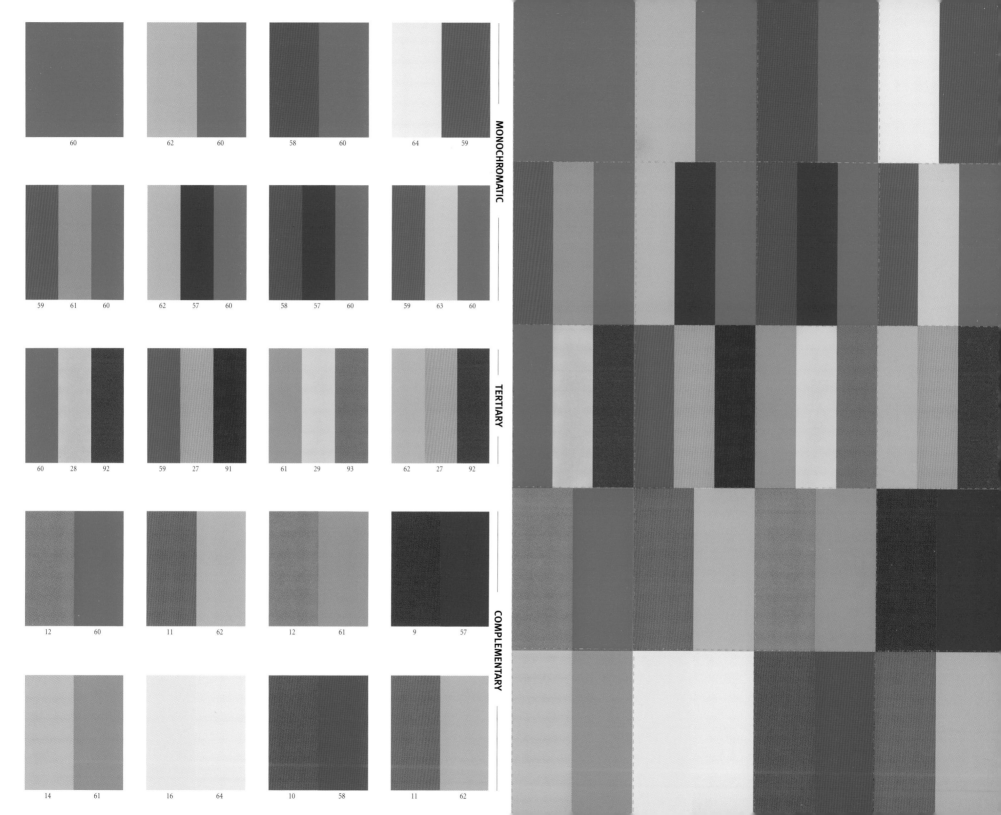

60

62 60

58 60

64 59

59 61 60

62 57 60

58 57 60

59 63 60

60 28 92

59 27 91

61 29 93

62 27 92

12 60

11 62

12 61

9 57

14 61

16 64

10 58

11 62

REFRESHING
Monochromatic
59

REFRESHING
Monochromatic
64

REFRESHING
Monochromatic
60

REFRESHING
Monochromatic
58

REFRESHING
Monochromatic
60

REFRESHING
Monochromatic
62

REFRESHING
Monochromatic
60

REFRESHING
Monochromatic
60

REFRESHING
Monochromatic
63

REFRESHING
Monochromatic
59

REFRESHING
Monochromatic
60

REFRESHING
Monochromatic
57

REFRESHING
Monochromatic
58

REFRESHING
Monochromatic
60

REFRESHING
Monochromatic
57

REFRESHING
Monochromatic
62

REFRESHING
Monochromatic
60

REFRESHING
Monochromatic
61

REFRESHING
Monochromatic
59

REFRESHING
Tertiary
92

REFRESHING
Tertiary
27

REFRESHING
Tertiary
62

REFRESHING
Tertiary
93

REFRESHING
Tertiary
29

REFRESHING
Tertiary
61

REFRESHING
Tertiary
91

REFRESHING
Tertiary
27

REFRESHING
Tertiary
59

REFRESHING
Tertiary
92

REFRESHING
Tertiary
28

REFRESHING
Tertiary
60

REFRESHING
Complementary
57

REFRESHING
Complementary
9

REFRESHING
Complementary
61

REFRESHING
Complementary
12

REFRESHING
Complementary
62

REFRESHING
Complementary
11

REFRESHING
Complementary
60

REFRESHING
Complementary
12

REFRESHING
Complementary
62

REFRESHING
Complementary
11

REFRESHING
Complementary
58

REFRESHING
Complementary
10

REFRESHING
Complementary
64

REFRESHING
Complementary
16

REFRESHING
Complementary
61

REFRESHING
Complementary
14

refreshing color schemes

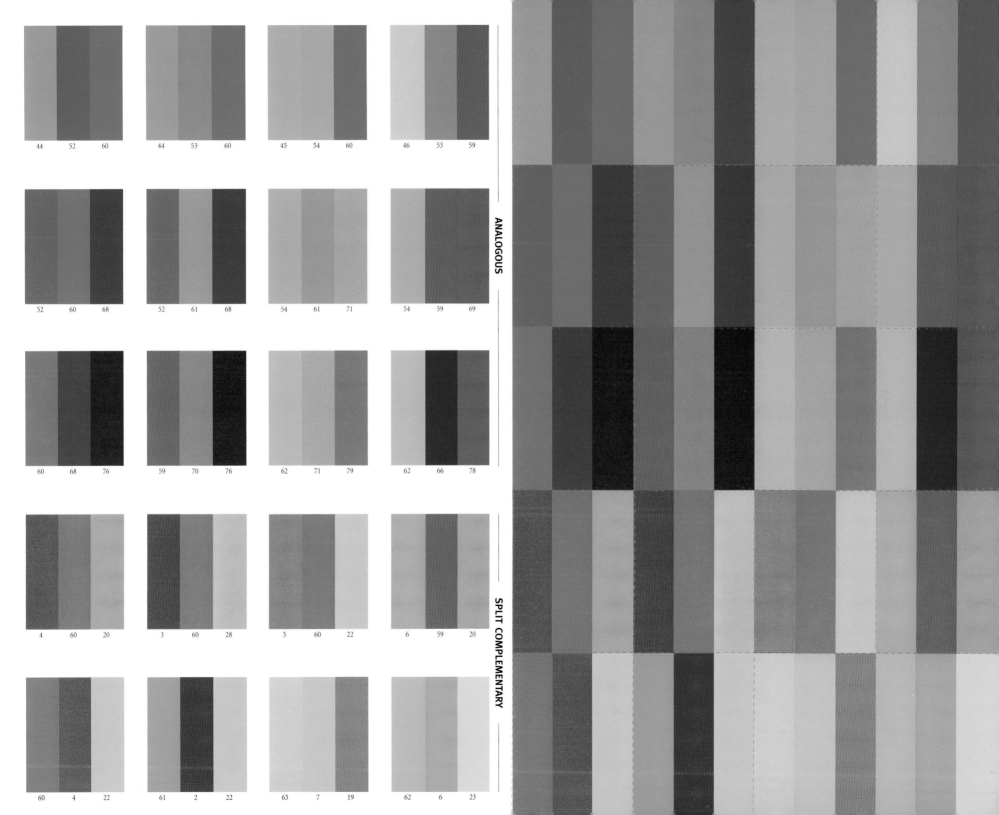

44 52 60

44 53 60

45 54 60

46 53 59

52 60 68

52 61 68

54 61 71

54 59 69

60 68 76

59 70 76

62 71 79

62 66 78

4 60 20

3 60 28

5 60 22

6 59 20

60 4 22

61 2 22

63 7 19

62 6 23

REFRESHING Analogous 59	REFRESHING Analogous 53	REFRESHING Analogous 46	REFRESHING Analogous 60	REFRESHING Analogous 54	REFRESHING Analogous 45	REFRESHING Analogous 60	REFRESHING Analogous 53	REFRESHING Analogous 44	REFRESHING Analogous 60	REFRESHING Analogous 52	REFRESHING Analogous 44
REFRESHING Analogous 69	REFRESHING Analogous 59	REFRESHING Analogous 54	REFRESHING Analogous 71	REFRESHING Analogous 61	REFRESHING Analogous 54	REFRESHING Analogous 68	REFRESHING Analogous 61	REFRESHING Analogous 52	REFRESHING Analogous 68	REFRESHING Analogous 60	REFRESHING Analogous 52
REFRESHING Analogous 78	REFRESHING Analogous 66	REFRESHING Analogous 62	REFRESHING Analogous 79	REFRESHING Analogous 71	REFRESHING Analogous 62	REFRESHING Analogous 76	REFRESHING Analogous 70	REFRESHING Analogous 59	REFRESHING Analogous 76	REFRESHING Analogous 68	REFRESHING Analogous 60
REFRESHING Split Complementary 20	REFRESHING Split Complementary 59	REFRESHING Split Complementary 6	REFRESHING Split Complementary 22	REFRESHING Split Complementary 60	REFRESHING Split Complementary 5	REFRESHING Split Complementary 28	REFRESHING Split Complementary 60	REFRESHING Split Complementary 3	REFRESHING Split Complementary 20	REFRESHING Split Complementary 60	REFRESHING Split Complementary 4
REFRESHING Split Complementary 23	REFRESHING Split Complementary 6	REFRESHING Split Complementary 62	REFRESHING Split Complementary 19	REFRESHING Split Complementary 7	REFRESHING Split Complementary 63	REFRESHING Split Complementary 22	REFRESHING Split Complementary 2	REFRESHING Split Complementary 61	REFRESHING Split Complementary 22	REFRESHING Split Complementary 4	REFRESHING Split Complementary 60

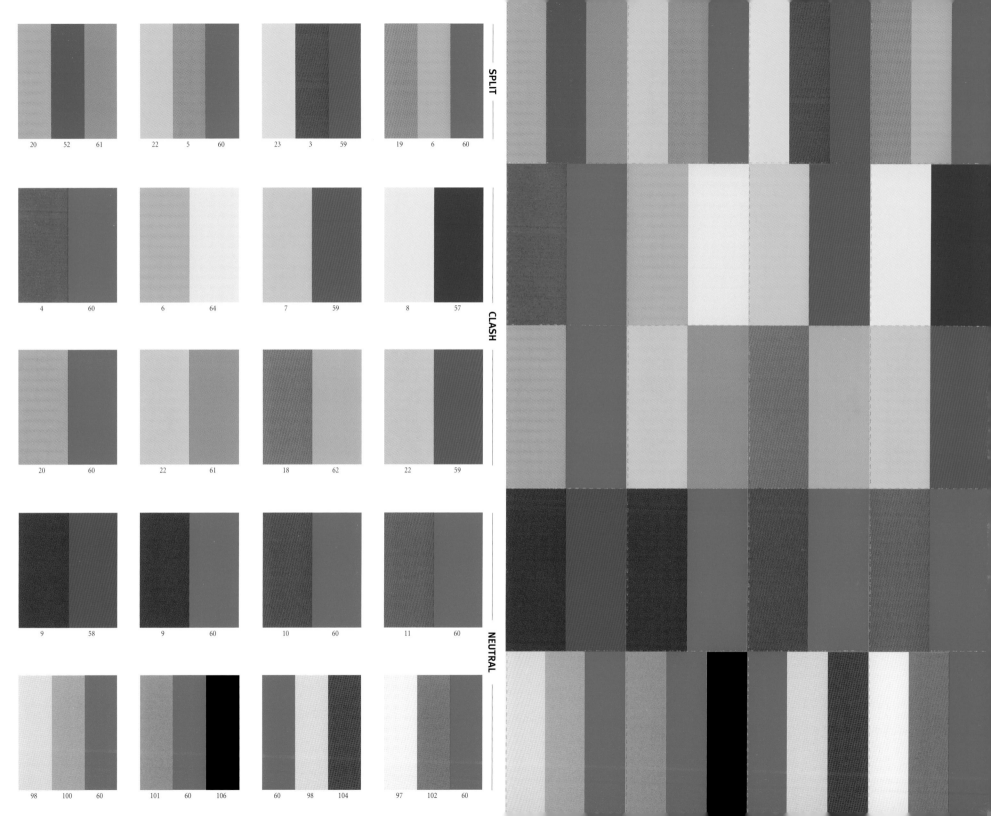

| 20 | 52 | 61 |

| 22 | 5 | 60 |

| 23 | 3 | 59 |

| 19 | 6 | 60 |

| 4 | 60 |

| 6 | 64 |

| 7 | 59 |

| 8 | 57 |

| 20 | 60 |

| 22 | 61 |

| 18 | 62 |

| 22 | 59 |

| 9 | 58 |

| 9 | 60 |

| 10 | 60 |

| 11 | 60 |

| 98 | 100 | 60 |

| 101 | 60 | 106 |

| 60 | 98 | 104 |

| 97 | 102 | 60 |

REFRESHING Split 60
REFRESHING Split 6
REFRESHING Split 19
REFRESHING Split 59
REFRESHING Split 3
REFRESHING Split 23
REFRESHING Split 60
REFRESHING Split 5
REFRESHING Split 22
REFRESHING Split 61
REFRESHING Split 52
REFRESHING Split 20

REFRESHING Clash 57
REFRESHING Clash 8
REFRESHING Clash 59
REFRESHING Clash 7
REFRESHING Clash 64
REFRESHING Clash 6
REFRESHING Clash 60
REFRESHING Clash 4

REFRESHING Clash 59
REFRESHING Clash 22
REFRESHING Clash 62
REFRESHING Clash 18
REFRESHING Clash 61
REFRESHING Clash 22
REFRESHING Clash 60
REFRESHING Clash 20

REFRESHING Neutral 60
REFRESHING Neutral 11
REFRESHING Neutral 60
REFRESHING Neutral 10
REFRESHING Neutral 60
REFRESHING Neutral 9
REFRESHING Neutral 58
REFRESHING Neutral 9

REFRESHING Neutral 60
REFRESHING Neutral 102
REFRESHING Neutral 97
REFRESHING Neutral 104
REFRESHING Neutral 98
REFRESHING Neutral 60
REFRESHING Neutral 106
REFRESHING Neutral 60
REFRESHING Neutral 101
REFRESHING Neutral 60
REFRESHING Neutral 100
REFRESHING Neutral 98

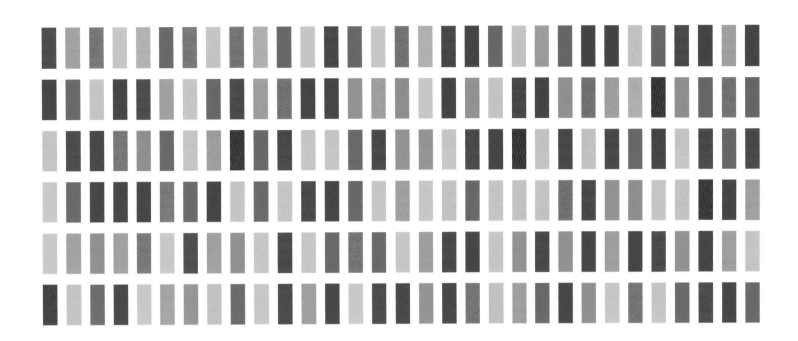

REFRESHING
Tips for Color Schemes

GENERAL COLOR

There's an uncloying exoticism to refreshing colors, which hint at the art of Islam, Oceania, and Native America.

GRAPHIC DESIGN

Advertising, packaging, and shopping bags for bath, body, and other "home spa" products are naturally appealing in refreshing colors.

INTERIOR DESIGN

In designing bathrooms, kitchens, and outdoor areas, glazed ceramic tiles in refreshing colors can add a year-round feeling of summertime relaxation.

FINE ART

Whether it is the pastels of a watercolor, or the intricacy of a mosaic, refreshing colors are appealing to the eye and stimulating to the imagination.

Duffy & Partners

ICI Paints, maker of the Glidden brand

TROPICAL

The tropical color scheme differs from the refreshing color scheme in the addition of white; the resultant pastels imply brilliant sunshine reflecting off water, flowers, and sandy beaches, with a feeling of light and transparency. These serene tints suggest island life at its most relaxing, filled with fragrant flowers, sun-bleached pastel houses, exotic fish, and frosty drinks imbibed in view of the ocean. Leisure and travel are certainly implied by the tropical color scheme; these are the exterior colors seen in many resorts, including Caribbean hot spots and the Art Deco hotels of Palm Beach.

This color scheme works well in virtually any interior, particularly when combined with the freshness of white. Soft, sensuous, and uncomplicated, this is a palette favored by artists who create optimistic work with large, cheerful forms; Henri Matisse's famous cut-out stencils were often executed in tropical colors. Joy, happiness, and carefree romance are also conveyed by the tropical color scheme.

complete color harmony workbook

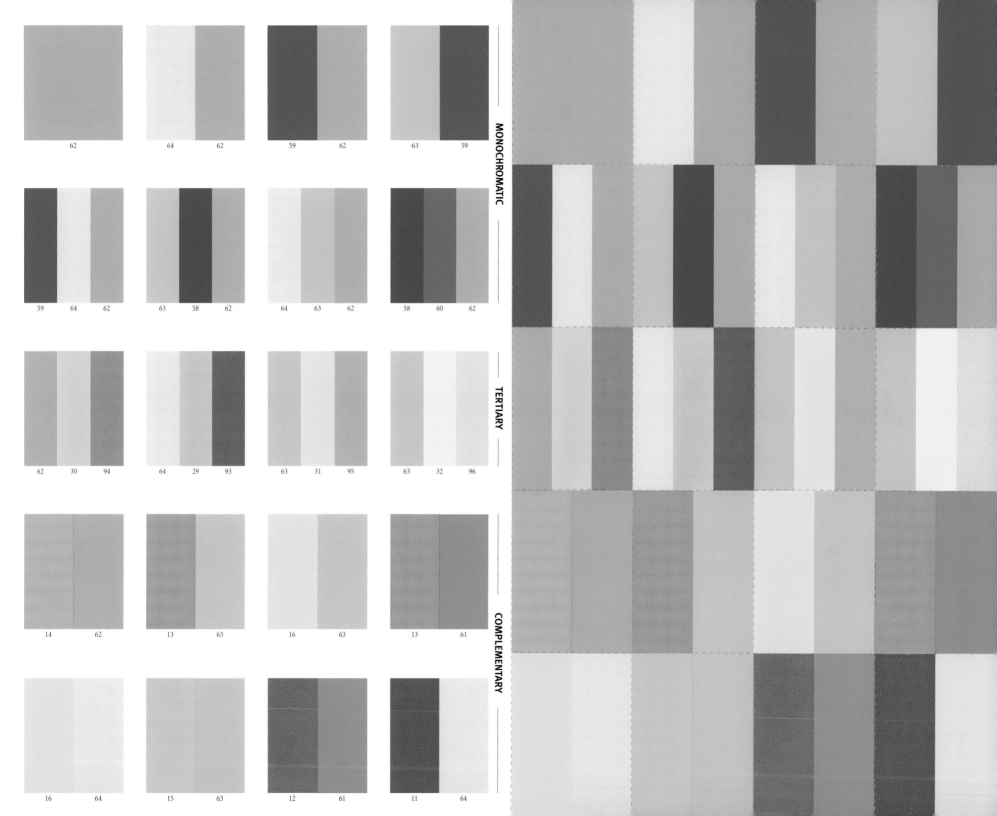

MONOCHROMATIC

62

64 62

59 62

63 59

59 64 62

63 58 62

64 63 62

58 60 62

TERTIARY

62 30 94

64 29 93

63 31 95

63 32 96

COMPLEMENTARY

14 62

13 63

16 63

13 61

16 64

15 63

12 61

11 64

TROPICAL
Monochromatic
59

TROPICAL
Monochromatic
63

TROPICAL
Monochromatic
62

TROPICAL
Monochromatic
59

TROPICAL
Monochromatic
62

TROPICAL
Monochromatic
64

TROPICAL
Monochromatic
62

TROPICAL
Monochromatic
62

TROPICAL
Monochromatic
60

TROPICAL
Monochromatic
58

TROPICAL
Monochromatic
62

TROPICAL
Monochromatic
63

TROPICAL
Monochromatic
64

TROPICAL
Monochromatic
62

TROPICAL
Monochromatic
58

TROPICAL
Monochromatic
63

TROPICAL
Monochromatic
62

TROPICAL
Monochromatic
64

TROPICAL
Monochromatic
59

TROPICAL
Tertiary
96

TROPICAL
Tertiary
32

TROPICAL
Tertiary
63

TROPICAL
Tertiary
95

TROPICAL
Tertiary
31

TROPICAL
Tertiary
63

TROPICAL
Tertiary
93

TROPICAL
Tertiary
29

TROPICAL
Tertiary
64

TROPICAL
Tertiary
94

TROPICAL
Tertiary
30

TROPICAL
Tertiary
62

TROPICAL
Complementary
61

TROPICAL
Complementary
13

TROPICAL
Complementary
63

TROPICAL
Complementary
16

TROPICAL
Complementary
63

TROPICAL
Complementary
13

TROPICAL
Complementary
62

TROPICAL
Complementary
14

TROPICAL
Complementary
64

TROPICAL
Complementary
11

TROPICAL
Complementary
61

TROPICAL
Complementary
12

TROPICAL
Complementary
63

TROPICAL
Complementary
15

TROPICAL
Complementary
64

TROPICAL
Complementary
16

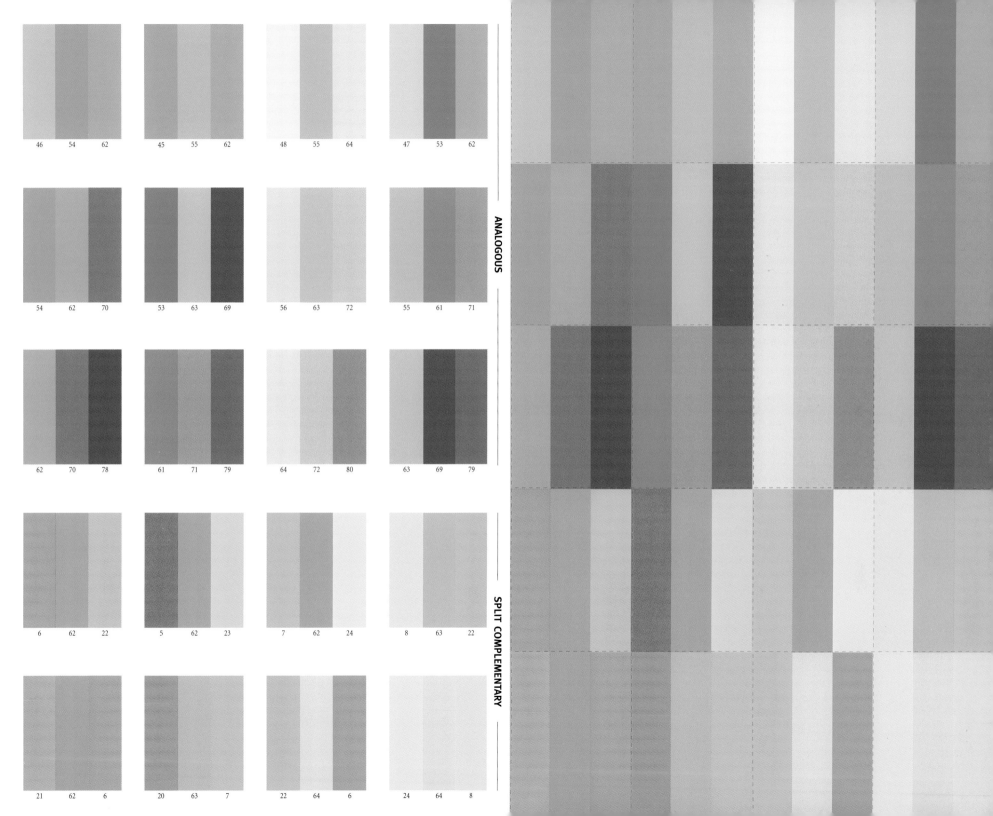

| 46 | 54 | 62 | | 45 | 55 | 62 | | 48 | 55 | 64 | | 47 | 53 | 62 |

| 54 | 62 | 70 | | 53 | 63 | 69 | | 56 | 63 | 72 | | 55 | 61 | 71 |

| 62 | 70 | 78 | | 61 | 71 | 79 | | 64 | 72 | 80 | | 63 | 69 | 79 |

ANALOGOUS

| 6 | 62 | 22 | | 5 | 62 | 23 | | 7 | 62 | 24 | | 8 | 63 | 22 |

| 21 | 62 | 6 | | 20 | 63 | 7 | | 22 | 64 | 6 | | 24 | 64 | 8 |

SPLIT COMPLEMENTARY

TROPICAL
Analogous
62

TROPICAL
Analogous
53

TROPICAL
Analogous
47

TROPICAL
Analogous
64

TROPICAL
Analogous
55

TROPICAL
Analogous
48

TROPICAL
Analogous
62

TROPICAL
Analogous
55

TROPICAL
Analogous
45

TROPICAL
Analogous
62

TROPICAL
Analogous
54

TROPICAL
Analogous
46

TROPICAL
Analogous
71

TROPICAL
Analogous
61

TROPICAL
Analogous
55

TROPICAL
Analogous
72

TROPICAL
Analogous
63

TROPICAL
Analogous
56

TROPICAL
Analogous
69

TROPICAL
Analogous
63

TROPICAL
Analogous
53

TROPICAL
Analogous
70

TROPICAL
Analogous
62

TROPICAL
Analogous
54

TROPICAL
Analogous
79

TROPICAL
Analogous
69

TROPICAL
Analogous
63

TROPICAL
Analogous
80

TROPICAL
Analogous
72

TROPICAL
Analogous
64

TROPICAL
Analogous
79

TROPICAL
Analogous
71

TROPICAL
Analogous
61

TROPICAL
Analogous
78

TROPICAL
Analogous
70

TROPICAL
Analogous
62

TROPICAL
Split Complementary
22

TROPICAL
Split Complementary
63

TROPICAL
Split Complementary
8

TROPICAL
Split Complementary
24

TROPICAL
Split Complementary
62

TROPICAL
Split Complementary
7

TROPICAL
Split Complementary
23

TROPICAL
Split Complementary
62

TROPICAL
Split Complementary
5

TROPICAL
Split Complementary
22

TROPICAL
Split Complementary
62

TROPICAL
Split Complementary
6

TROPICAL
Split Complementary
8

TROPICAL
Split Complementary
64

TROPICAL
Split Complementary
24

TROPICAL
Split Complementary
6

TROPICAL
Split Complementary
64

TROPICAL
Split Complementary
22

TROPICAL
Split Complementary
7

TROPICAL
Split Complementary
63

TROPICAL
Split Complementary
20

TROPICAL
Split Complementary
6

TROPICAL
Split Complementary
62

TROPICAL
Split Complementary
21

tropical color schemes

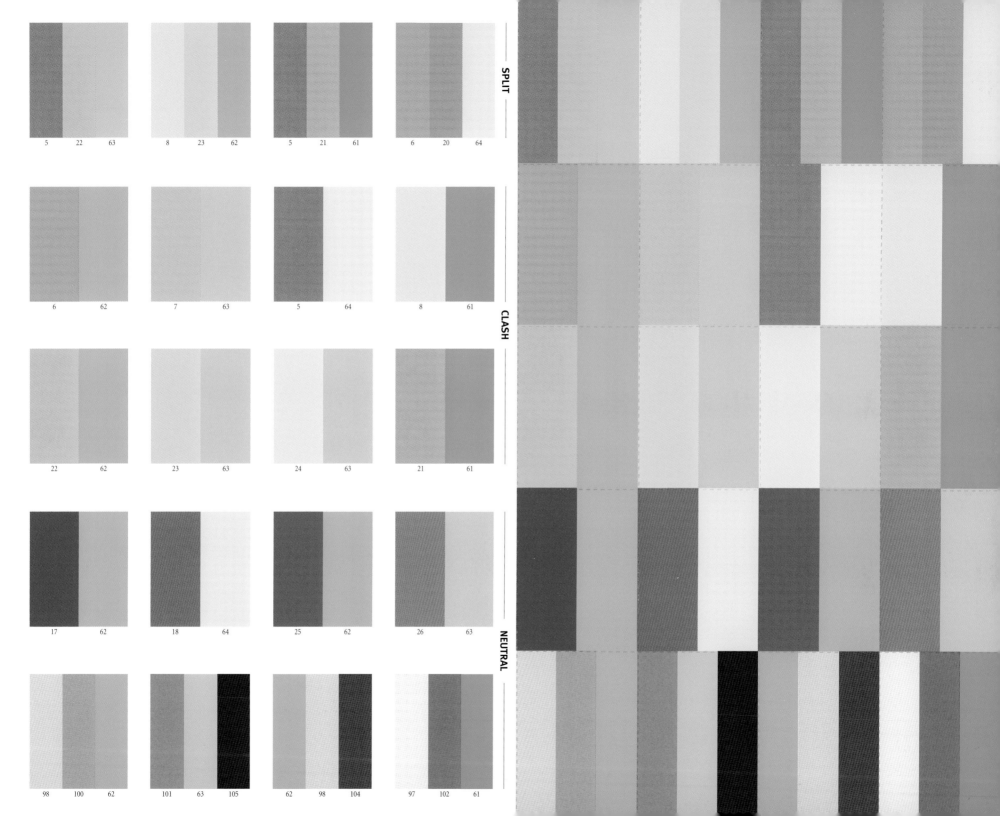

5 22 63

8 23 62

5 21 61

6 20 64

6 62

7 63

5 64

8 61

22 62

23 63

24 63

21 61

17 62

18 64

25 62

26 63

98 100 62

101 63 105

62 98 104

97 102 61

TROPICAL Split 64
TROPICAL Split 20
TROPICAL Split 6
TROPICAL Split 61
TROPICAL Split 21
TROPICAL Split 5
TROPICAL Split 62
TROPICAL Split 23
TROPICAL Split 8
TROPICAL Split 63
TROPICAL Split 22
TROPICAL Split 5

TROPICAL Clash 61
TROPICAL Clash 8
TROPICAL Clash 64
TROPICAL Clash 5
TROPICAL Clash 63
TROPICAL Clash 7
TROPICAL Clash 62
TROPICAL Clash 6

TROPICAL Clash 61
TROPICAL Clash 21
TROPICAL Clash 63
TROPICAL Clash 24
TROPICAL Clash 63
TROPICAL Clash 23
TROPICAL Clash 62
TROPICAL Clash 22

TROPICAL Neutral 63
TROPICAL Neutral 26
TROPICAL Neutral 62
TROPICAL Neutral 25
TROPICAL Neutral 64
TROPICAL Neutral 18
TROPICAL Neutral 62
TROPICAL Neutral 17

TROPICAL Neutral 61
TROPICAL Neutral 102
TROPICAL Neutral 97
TROPICAL Neutral 104
TROPICAL Neutral 98
TROPICAL Neutral 62
TROPICAL Neutral 105
TROPICAL Neutral 63
TROPICAL Neutral 101
TROPICAL Neutral 62
TROPICAL Neutral 100
TROPICAL Neutral 98

TROPICAL
Tips for Color Schemes

GENERAL COLOR

The lightness and transparency of tropical colors call out for translucent design materials: sheer see-through papers (perhaps printed in subtle half-tones) and loosely woven fabrics.

GRAPHIC DESIGN

Graphic designers will find tropical colors the natural choice for clients with travel and leisure businesses or for waterfront restaurants; and for massage therapists, aestheticians, and other "hands-on" clients.

INTERIOR DESIGN

Commercial interiors for casual, relaxed restaurants, sportswear boutiques, and hair salons or day spas are lightened by soothing tropical colors.

FINE ART

Fine artists may find the delicious clarity of tropical colors most inspiring for collages, woven wall hangings, and color field paintings.

Joann A. Ballinger
In the Light

Harley-Davidson

ICI Paints, maker of the Glidden brand

CLASSIC

Classic color schemes imply power. They generally include the depth and intensity of a royal blue hue. This beautiful color is sober, strong, and spiritual. It implies a search for inner truths. Blue is the darkest of colors; its dense pigmentation suggests depth of personality and reserves of integrity, authority, poise, and dignity. It is interesting to note how many national flags contain this color of blue, which is said to inspire devotion. The expression "true blue" illuminates the virtues of stability, faithfulness, and responsibility considered to be projected by this hue. Royal blue still contains a hint of green, making it more active and less heavy than a purer blue hue.

Classic color schemes project a sense of contemplative calm and tradition; they are therefore a good choice for decorating bedrooms, especially the master bedroom—the "seat of power." In the fine arts, royal blue is a color associated with shadow and twilight, frequently seen in the work of American illustrator Maxfield Parrish. This color scheme adds reserve and dignity to graphic design.

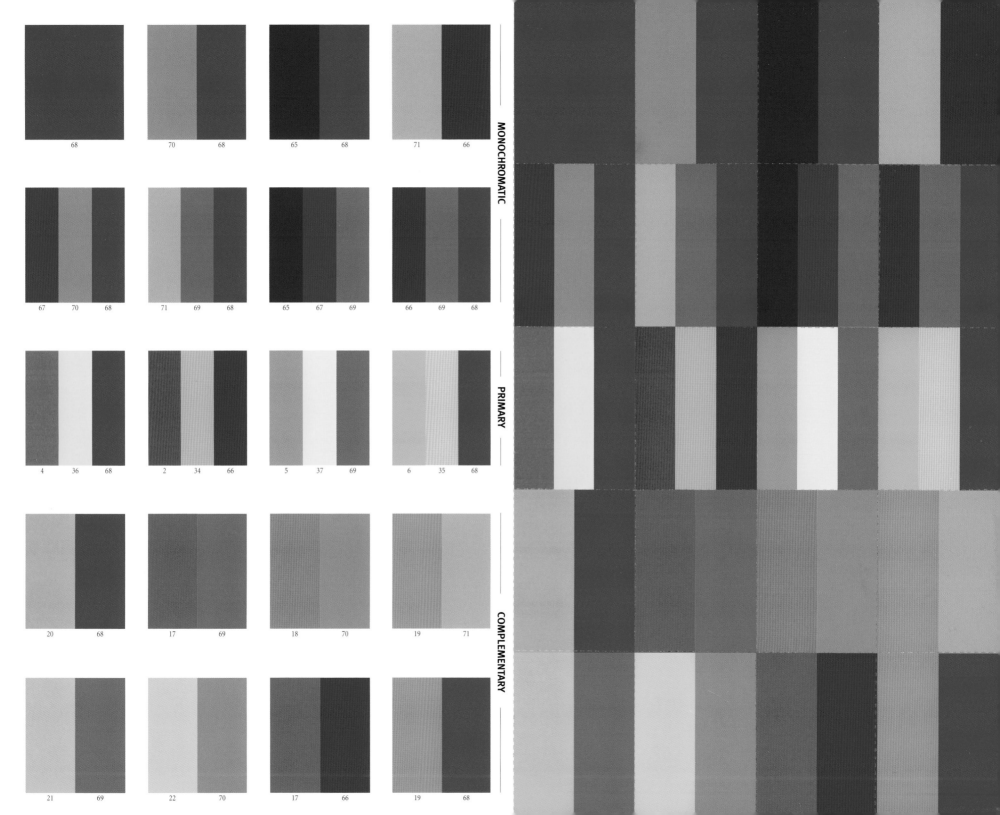

68

70 68

65 68

71 66

67 70 68

71 69 68

65 67 69

66 69 68

4 36 68

2 34 66

5 37 69

6 35 68

20 68

17 69

18 70

19 71

21 69

22 70

17 66

19 68

CLASSIC Monochromatic 66

CLASSIC Monochromatic 71

CLASSIC Monochromatic 68

CLASSIC Monochromatic 65

CLASSIC Monochromatic 68

CLASSIC Monochromatic 70

CLASSIC Monochromatic 68

CLASSIC Monochromatic 68

CLASSIC Monochromatic 69

CLASSIC Monochromatic 66

CLASSIC Monochromatic 69

CLASSIC Monochromatic 67

CLASSIC Monochromatic 65

CLASSIC Monochromatic 68

CLASSIC Monochromatic 69

CLASSIC Monochromatic 71

CLASSIC Monochromatic 68

CLASSIC Monochromatic 70

CLASSIC Monochromatic 67

CLASSIC Primary 68

CLASSIC Primary 35

CLASSIC Primary 6

CLASSIC Primary 69

CLASSIC Primary 37

CLASSIC Primary 5

CLASSIC Primary 66

CLASSIC Primary 34

CLASSIC Primary 2

CLASSIC Primary 68

CLASSIC Primary 36

CLASSIC Primary 4

CLASSIC Complementary 71

CLASSIC Complementary 19

CLASSIC Complementary 70

CLASSIC Complementary 18

CLASSIC Complementary 69

CLASSIC Complementary 17

CLASSIC Complementary 68

CLASSIC Complementary 20

CLASSIC Complementary 68

CLASSIC Complementary 19

CLASSIC Complementary 66

CLASSIC Complementary 17

CLASSIC Complementary 70

CLASSIC Complementary 22

CLASSIC Complementary 69

CLASSIC Complementary 21

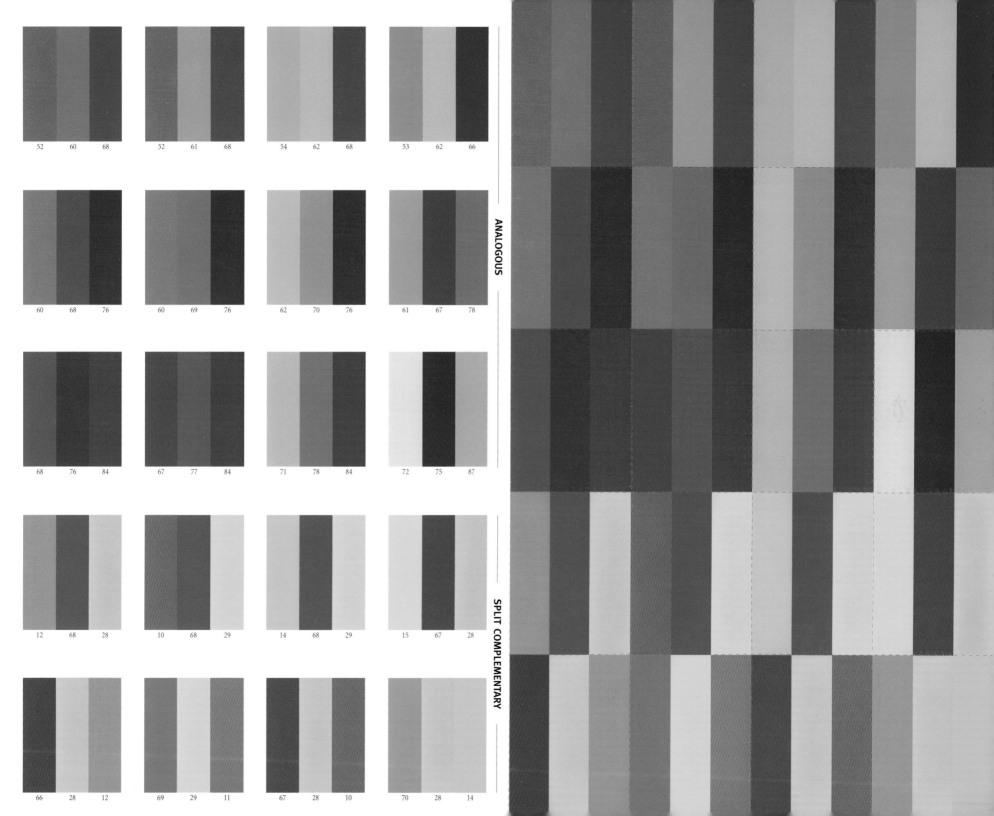

52 60 68
52 61 68
54 62 68
53 62 66

60 68 76
60 69 76
62 70 76
61 67 78

68 76 84
67 77 84
71 78 84
72 75 87

12 68 28
10 68 29
14 68 29
15 67 28

66 28 12
69 29 11
67 28 10
70 28 14

CLASSIC Analogous 66
CLASSIC Analogous 62
CLASSIC Analogous 53
CLASSIC Analogous 68
CLASSIC Analogous 62
CLASSIC Analogous 54
CLASSIC Analogous 68
CLASSIC Analogous 61
CLASSIC Analogous 52
CLASSIC Analogous 68
CLASSIC Analogous 60
CLASSIC Analogous 52

CLASSIC Analogous 78
CLASSIC Analogous 67
CLASSIC Analogous 61
CLASSIC Analogous 76
CLASSIC Analogous 70
CLASSIC Analogous 62
CLASSIC Analogous 76
CLASSIC Analogous 69
CLASSIC Analogous 60
CLASSIC Analogous 76
CLASSIC Analogous 68
CLASSIC Analogous 60

CLASSIC Analogous 87
CLASSIC Analogous 75
CLASSIC Analogous 72
CLASSIC Analogous 84
CLASSIC Analogous 78
CLASSIC Analogous 71
CLASSIC Analogous 84
CLASSIC Analogous 77
CLASSIC Analogous 67
CLASSIC Analogous 84
CLASSIC Analogous 76
CLASSIC Analogous 68

CLASSIC Split Complementary 28
CLASSIC Split Complementary 67
CLASSIC Split Complementary 15
CLASSIC Split Complementary 29
CLASSIC Split Complementary 68
CLASSIC Split Complementary 14
CLASSIC Split Complementary 29
CLASSIC Split Complementary 68
CLASSIC Split Complementary 10
CLASSIC Split Complementary 28
CLASSIC Split Complementary 68
CLASSIC Split Complementary 12

CLASSIC Split Complementary 14
CLASSIC Split Complementary 28
CLASSIC Split Complementary 70
CLASSIC Split Complementary 10
CLASSIC Split Complementary 28
CLASSIC Split Complementary 67
CLASSIC Split Complementary 11
CLASSIC Split Complementary 29
CLASSIC Split Complementary 69
CLASSIC Split Complementary 12
CLASSIC Split Complementary 28
CLASSIC Split Complementary 66

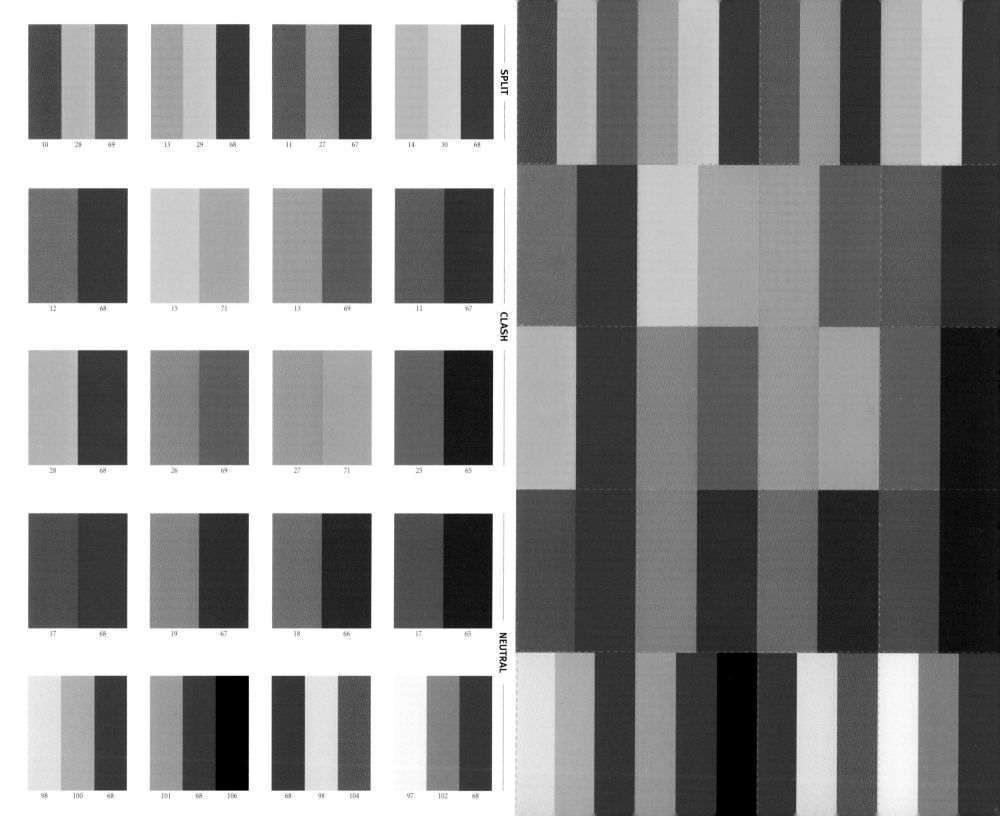

10 28 69

13 29 68

11 27 67

14 30 68

12 68

15 71

13 69

11 67

28 68

26 69

27 71

25 65

17 68

19 67

18 66

17 65

98 100 68

101 68 106

68 98 104

97 102 68

CLASSIC Split 68
CLASSIC Split 30
CLASSIC Split 14
CLASSIC Split 67
CLASSIC Split 27
CLASSIC Split 11
CLASSIC Split 68
CLASSIC Split 29
CLASSIC Split 13
CLASSIC Split 69
CLASSIC Split 28
CLASSIC Split 10

CLASSIC Clash 67
CLASSIC Clash 11
CLASSIC Clash 69
CLASSIC Clash 13
CLASSIC Clash 71
CLASSIC Clash 15
CLASSIC Clash 68
CLASSIC Clash 12

CLASSIC Clash 65
CLASSIC Clash 25
CLASSIC Clash 71
CLASSIC Clash 27
CLASSIC Clash 69
CLASSIC Clash 26
CLASSIC Clash 68
CLASSIC Clash 28

CLASSIC Neutral 65
CLASSIC Neutral 17
CLASSIC Neutral 66
CLASSIC Neutral 18
CLASSIC Neutral 67
CLASSIC Neutral 19
CLASSIC Neutral 68
CLASSIC Neutral 17

CLASSIC Neutral 68
CLASSIC Neutral 102
CLASSIC Neutral 97
CLASSIC Neutral 104
CLASSIC Neutral 98
CLASSIC Neutral 68
CLASSIC Neutral 106
CLASSIC Neutral 68
CLASSIC Neutral 101
CLASSIC Neutral 68
CLASSIC Neutral 100
CLASSIC Neutral 98

CLASSIC
Tips for Color Schemes

GENERAL COLOR

The primary color scheme is a true classic for decorating children's bedrooms, and for books, toys, or other designs geared toward young children.

GRAPHIC DESIGN

Posters, packaging, and advertising that should project a sense of trustworthiness, tradition, and stability can benefit from a classic color scheme.

INTERIOR DESIGN

The durable, livable nature of a classic color scheme makes it practical for residential interiors.

FINE ART

Fine artists and illustrators can create the illusion of deep shadows by using royal blue; its complementary and split complementary hues of orange, red-orange, and yellow-orange will create the sense of light.

ICI Paints, maker of the Glidden brand

Studio Najbrt, s.r.o.

Patty Herscher
Porcelaine

DEPENDABLE

Navy blue is a sort of "adopted neutral" the world over—a color that conveys reliability, responsibility, and durability. Uniforms and work clothes are often a distinctive shade of navy or indigo; this is true of the attire of children in private schools, policemen, officers in the navy, the garb of Japanese farmers, and the blue jeans of American cowboys. The proletarian nature of indigo is in fact best expressed by blue jeans,

which have become an anti-elitist classic throughout the world. Honesty and value are implied by navy blue, as in the "blue-plate specials" offered by diner-style restaurants. A calm strength of will is projected by a dependable color scheme. Even beauty becomes dependable when this color scheme is used; ancient Ming vases and Wedgewood china, both considered reliably and eternally beautiful, are decorated in indigo blue.

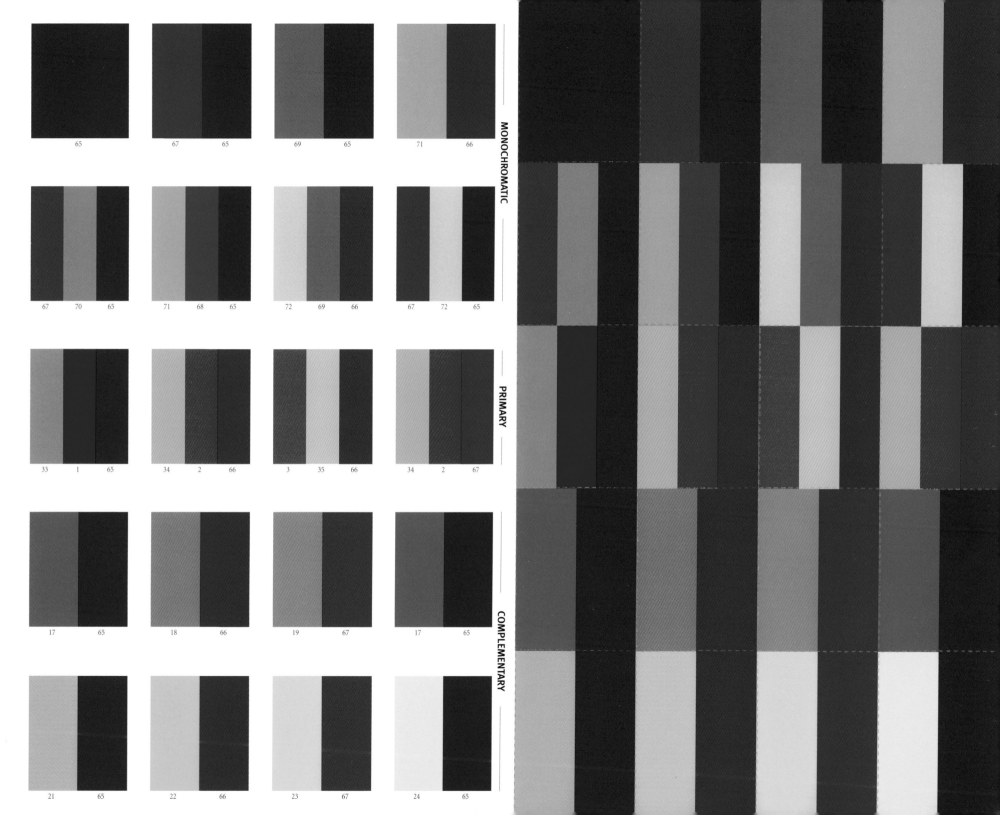

65

67 65

69 65

71 66

67 70 65

71 68 65

72 69 66

67 72 65

33 1 65

34 2 66

3 35 66

34 2 67

17 65

18 66

19 67

17 65

21 65

22 66

23 67

24 65

DEPENDABLE
Monochromatic
66

DEPENDABLE
Monochromatic
71

DEPENDABLE
Monochromatic
65

DEPENDABLE
Monochromatic
69

DEPENDABLE
Monochromatic
65

DEPENDABLE
Monochromatic
67

DEPENDABLE
Monochromatic
65

DEPENDABLE
Monochromatic
65

DEPENDABLE
Monochromatic
72

DEPENDABLE
Monochromatic
67

DEPENDABLE
Monochromatic
66

DEPENDABLE
Monochromatic
69

DEPENDABLE
Monochromatic
72

DEPENDABLE
Monochromatic
65

DEPENDABLE
Monochromatic
68

DEPENDABLE
Monochromatic
71

DEPENDABLE
Monochromatic
65

DEPENDABLE
Monochromatic
70

DEPENDABLE
Monochromatic
67

DEPENDABLE
Primary
67

DEPENDABLE
Primary
2

DEPENDABLE
Primary
34

DEPENDABLE
Primary
66

DEPENDABLE
Primary
35

DEPENDABLE
Primary
3

DEPENDABLE
Primary
66

DEPENDABLE
Primary
2

DEPENDABLE
Primary
34

DEPENDABLE
Primary
65

DEPENDABLE
Primary
1

DEPENDABLE
Primary
33

DEPENDABLE
Complementary
65

DEPENDABLE
Complementary
17

DEPENDABLE
Complementary
67

DEPENDABLE
Complementary
19

DEPENDABLE
Complementary
66

DEPENDABLE
Complementary
18

DEPENDABLE
Complementary
65

DEPENDABLE
Complementary
17

DEPENDABLE
Complementary
65

DEPENDABLE
Complementary
24

DEPENDABLE
Complementary
67

DEPENDABLE
Complementary
23

DEPENDABLE
Complementary
66

DEPENDABLE
Complementary
22

DEPENDABLE
Complementary
65

DEPENDABLE
Complementary
21

dependable color schemes

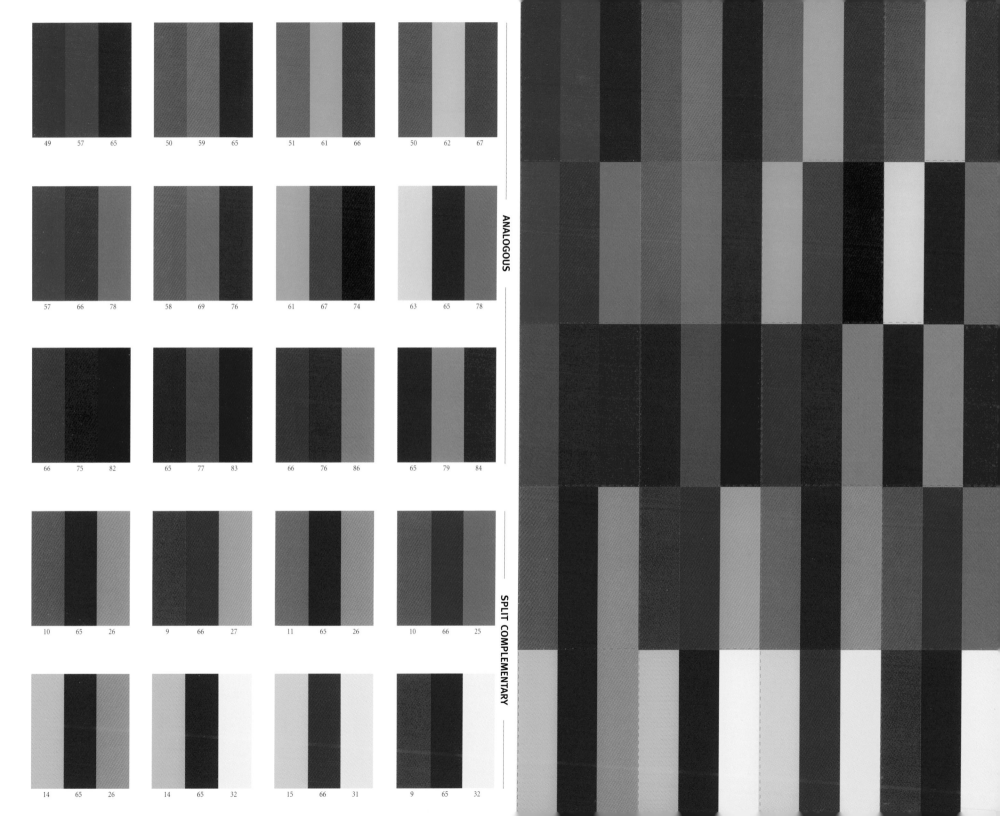

49 57 65　50 59 65　51 61 66　50 62 67

57 66 78　58 69 76　61 67 74　63 65 78

66 75 82　65 77 83　66 76 86　65 79 84

10 65 26　9 66 27　11 65 26　10 66 25

14 65 26　14 65 32　15 66 31　9 65 32

DEPENDABLE Analogous 67
DEPENDABLE Analogous 62
DEPENDABLE Analogous 50
DEPENDABLE Analogous 66
DEPENDABLE Analogous 61
DEPENDABLE Analogous 51
DEPENDABLE Analogous 65
DEPENDABLE Analogous 59
DEPENDABLE Analogous 50
DEPENDABLE Analogous 65
DEPENDABLE Analogous 57
DEPENDABLE Analogous 49

DEPENDABLE Analogous 78
DEPENDABLE Analogous 65
DEPENDABLE Analogous 63
DEPENDABLE Analogous 74
DEPENDABLE Analogous 67
DEPENDABLE Analogous 61
DEPENDABLE Analogous 76
DEPENDABLE Analogous 69
DEPENDABLE Analogous 58
DEPENDABLE Analogous 78
DEPENDABLE Analogous 66
DEPENDABLE Analogous 57

DEPENDABLE Analogous 84
DEPENDABLE Analogous 79
DEPENDABLE Analogous 65
DEPENDABLE Analogous 86
DEPENDABLE Analogous 76
DEPENDABLE Analogous 66
DEPENDABLE Analogous 83
DEPENDABLE Analogous 77
DEPENDABLE Analogous 65
DEPENDABLE Analogous 82
DEPENDABLE Analogous 75
DEPENDABLE Analogous 66

DEPENDABLE Split Complementary 25
DEPENDABLE Split Complementary 66
DEPENDABLE Split Complementary 10
DEPENDABLE Split Complementary 26
DEPENDABLE Split Complementary 65
DEPENDABLE Split Complementary 11
DEPENDABLE Split Complementary 27
DEPENDABLE Split Complementary 66
DEPENDABLE Split Complementary 9
DEPENDABLE Split Complementary 26
DEPENDABLE Split Complementary 65
DEPENDABLE Split Complementary 10

DEPENDABLE Split Complementary 32
DEPENDABLE Split Complementary 65
DEPENDABLE Split Complementary 9
DEPENDABLE Split Complementary 31
DEPENDABLE Split Complementary 66
DEPENDABLE Split Complementary 15
DEPENDABLE Split Complementary 32
DEPENDABLE Split Complementary 65
DEPENDABLE Split Complementary 14
DEPENDABLE Split Complementary 26
DEPENDABLE Split Complementary 65
DEPENDABLE Split Complementary 14

dependable color schemes

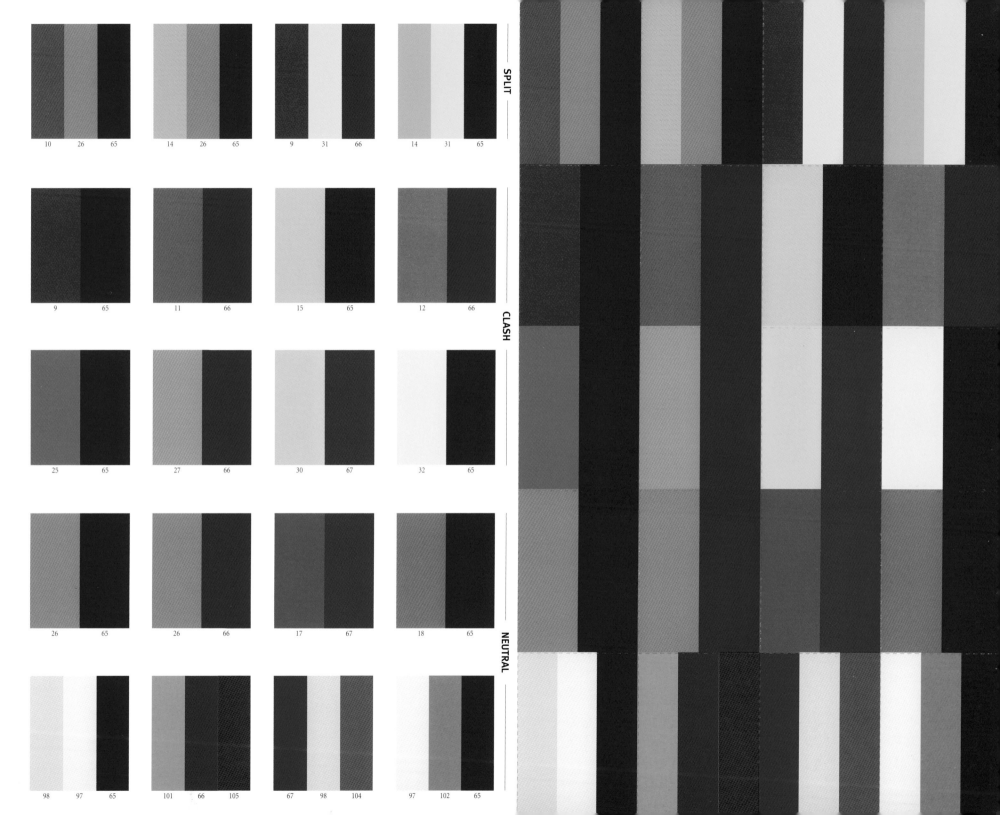

SPLIT

10	26	65
14	26	65
9	31	66
14	31	65

CLASH

9		65
11		66
15		65
12		66

25		65
27		66
30		67
32		65

NEUTRAL

26		65
26		66
17		67
18		65

98	97	65
101	66	105
67	98	104
97	102	65

DEPENDABLE Split 65

DEPENDABLE Split 31

DEPENDABLE Split 14

aDEPENDABLE Split 66

DEPENDABLE Split 31

DEPENDABLE Split 9

DEPENDABLE Split 65

DEPENDABLE Split 26

DEPENDABLE Split 14

DEPENDABLE Split 65

DEPENDABLE Split 26

DEPENDABLE Split 10

DEPENDABLE Clash 66

DEPENDABLE Clash 12

DEPENDABLE Clash 65

DEPENDABLE Clash 15

DEPENDABLE Clash 66

DEPENDABLE Clash 11

DEPENDABLE Clash 65

DEPENDABLE Clash 9

DEPENDABLE Clash 65

DEPENDABLE Clash 32

DEPENDABLE Clash 67

DEPENDABLE Clash 30

DEPENDABLE Clash 66

DEPENDABLE Clash 27

DEPENDABLE Clash 65

DEPENDABLE Clash 25

DEPENDABLE Neutral 65

DEPENDABLE Neutral 18

DEPENDABLE Neutral 67

DEPENDABLE Neutral 17

DEPENDABLE Neutral 66

DEPENDABLE Neutral 26

DEPENDABLE Neutral 65

DEPENDABLE Neutral 26

DEPENDABLE Neutral 65

DEPENDABLE Neutral 102

DEPENDABLE Neutral 97

DEPENDABLE Neutral 104

DEPENDABLE Neutral 98

DEPENDABLE Neutral 67

DEPENDABLE Neutral 105

DEPENDABLE Neutral 66

DEPENDABLE Neutral 101

DEPENDABLE Neutral 65

DEPENDABLE Neutral 97

DEPENDABLE Neutral 98

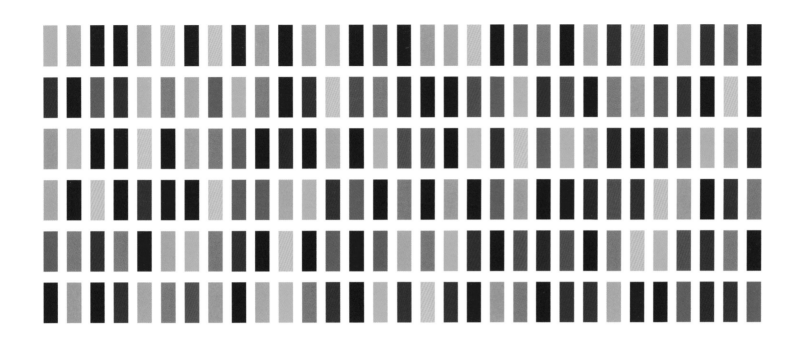

DEPENDABLE
Tips for Color Schemes

GENERAL COLOR

White accented with navy blue is a great color scheme; it has a fresh, approachable quality that makes it wonderful for daily-use items like dishes, tablecloths, towels, and sheets.

GRAPHIC DESIGN

In graphic design, a dependable color scheme will appeal to an older, more sober audience—good for annual reports, in advertising for the legal or medical professions, and so on.

INTERIOR DESIGN

Dependable interior color schemes should include a substantial proportion of lighter, brighter, or pastel colors to keep them looking rich, as opposed to oppressive.

FINE ART

A dependable color scheme is a useful starting place for artists who want to create images that exemplify the nautical. Blues absorb light; hints of complementary orange will enliven a predominantly blue canvas.

m Cube

Donna Levinstone
Season Suite 1

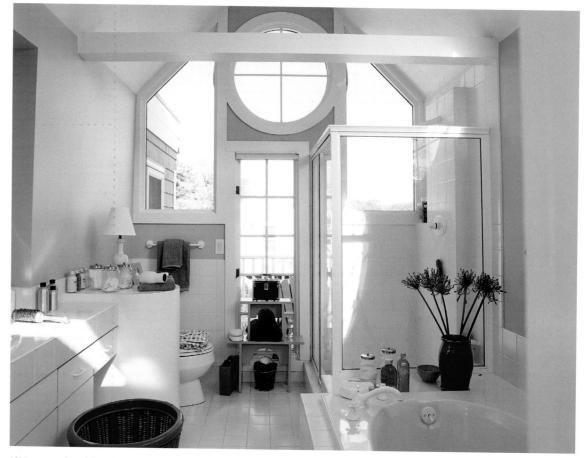

ICI Paints, maker of the Glidden brand

CALM

Pale blue is a cooling, soothing tint and the basis of the calm color scheme. Blue actually reduces blood pressure and pulse, and respiration rates; arthritis sufferers, when exposed to blue light, found that their pain abated. The purity of white and the honesty and steadfastness of blue combine to form a blue tint that is considered to be a meditative color, one that communicates deep spiritual understanding and a soft-spoken integrity. The gentle flow of water, the cyclical nature of tides, and the infinite blue of a country sky are implied when a calm color scheme is used. Painting a bedroom pale blue can enhance its restful qualities; it can also encourage a sense of patience and contentment in whoever sleeps there. The complementary and split complementary hues of orange, yellow-orange and red-orange, lightened into tints with white, add a more determined, earthy strength to pale blue.

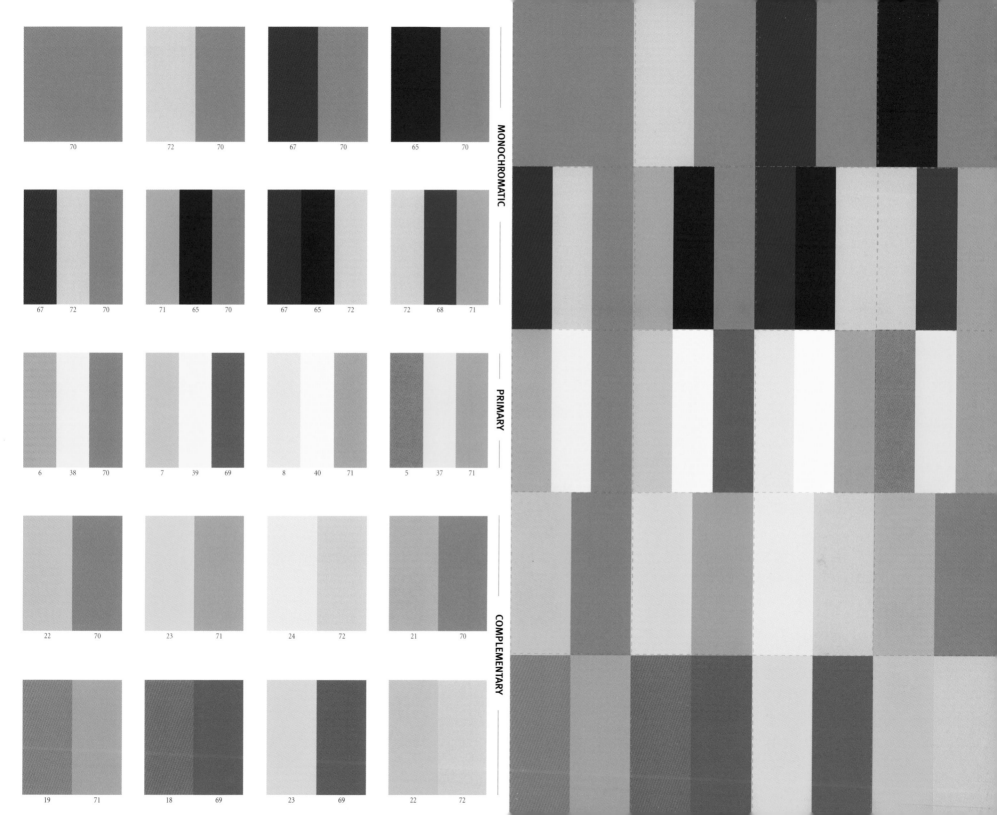

MONOCHROMATIC

70

72 70

67 70

65 70

67 72 70

71 65 70

67 65 72

72 68 71

PRIMARY

6 38 70

7 39 69

8 40 71

5 37 71

COMPLEMENTARY

22 70

23 71

24 72

21 70

19 71

18 69

23 69

22 72

CALM Complementary 72

CALM Complementary 22

CALM Complementary 69

CALM Complementary 23

CALM Complementary 69

CALM Complementary 18

CALM Complementary 71

CALM Complementary 19

CALM Complementary 70

CALM Complementary 21

CALM Complementary 72

CALM Complementary 24

CALM Complementary 71

CALM Complementary 23

CALM Complementary 70

CALM Complementary 22

CALM Primary 71

CALM Primary 37

CALM Primary 5

CALM Primary 71

CALM Primary 40

CALM Primary 8

CALM Primary 69

CALM Primary 39

CALM Primary 7

CALM Primary 70

CALM Primary 38

CALM Primary 6

CALM Monochromatic 71

CALM Monochromatic 68

CALM Monochromatic 72

CALM Monochromatic 72

CALM Monochromatic 65

CALM Monochromatic 67

CALM Monochromatic 70

CALM Monochromatic 65

CALM Monochromatic 71

CALM Monochromatic 70

CALM Monochromatic 72

CALM Monochromatic 67

CALM Monochromatic 70

CALM Monochromatic 65

CALM Monochromatic 70

CALM Monochromatic 67

CALM Monochromatic 70

CALM Monochromatic 72

CALM Monochromatic 70

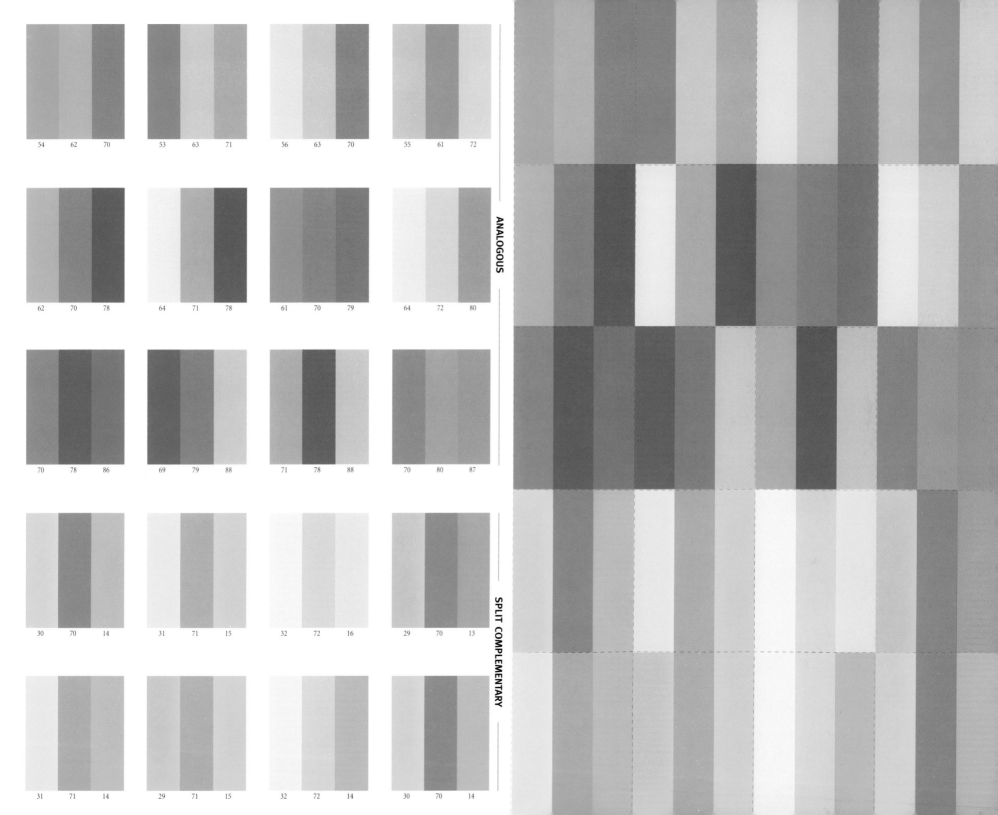

54	62	70
53	63	71
56	63	70
55	61	72

62	70	78
64	71	78
61	70	79
64	72	80

70	78	86
69	79	88
71	78	88
70	80	87

30	70	14
31	71	15
32	72	16
29	70	13

31	71	14
29	71	15
32	72	14
30	70	14

CALM Analogous 72
CALM Analogous 61
CALM Analogous 55
CALM Analogous 70
CALM Analogous 63
CALM Analogous 56
CALM Analogous 71
CALM Analogous 63
CALM Analogous 53
CALM Analogous 70
CALM Analogous 62
CALM Analogous 54

CALM Analogous 80
CALM Analogous 72
CALM Analogous 64
CALM Analogous 79
CALM Analogous 70
CALM Analogous 61
CALM Analogous 78
CALM Analogous 71
CALM Analogous 64
CALM Analogous 78
CALM Analogous 70
CALM Analogous 62

CALM Analogous 87
CALM Analogous 80
CALM Analogous 70
CALM Analogous 88
CALM Analogous 78
CALM Analogous 71
CALM Analogous 88
CALM Analogous 79
CALM Analogous 69
CALM Analogous 86
CALM Analogous 78
CALM Analogous 70

CALM Split Complementary 13
CALM Split Complementary 70
CALM Split Complementary 29
CALM Split Complementary 16
CALM Split Complementary 72
CALM Split Complementary 32
CALM Split Complementary 15
CALM Split Complementary 71
CALM Split Complementary 31
CALM Split Complementary 14
CALM Split Complementary 70
CALM Split Complementary 30

CALM Split Complementary 14
CALM Split Complementary 70
CALM Split Complementary 30
CALM Split Complementary 14
CALM Split Complementary 72
CALM Split Complementary 32
CALM Split Complementary 15
CALM Split Complementary 71
CALM Split Complementary 29
CALM Split Complementary 14
CALM Split Complementary 71
CALM Split Complementary 31

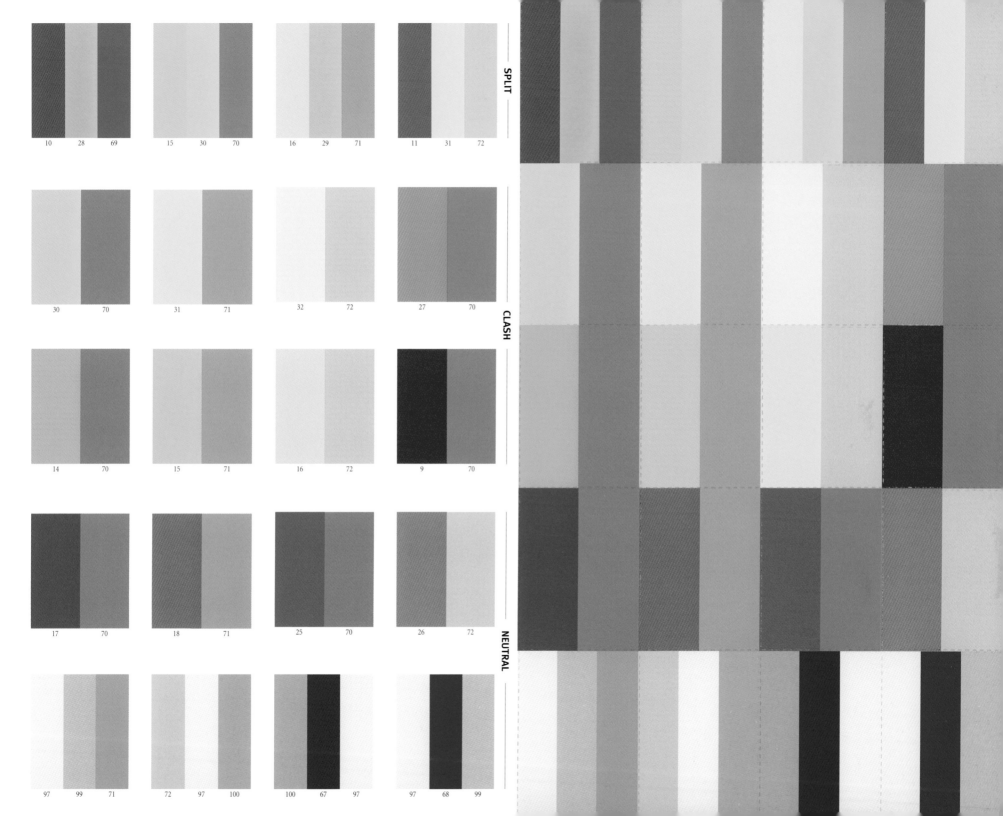

10 28 69

15 30 70

16 29 71

11 31 72

30 70

31 71

32 72

27 70

14 70

15 71

16 72

9 70

17 70

18 71

25 70

26 72

97 99 71

72 97 100

100 67 97

97 68 99

CALM Split 72
CALM Split 31
CALM Split 11
CALM Split 71
CALM Split 29
CALM Split 16
CALM Split 70
CALM Split 30
CALM Split 15
CALM Split 69
CALM Split 28
CALM Split 10

CALM Clash 70
CALM Clash 27
CALM Clash 72
CALM Clash 32
CALM Clash 71
CALM Clash 31
CALM Clash 70
CALM Clash 30

CALM Clash 70
CALM Clash 9
CALM Clash 72
CALM Clash 16
CALM Clash 71
CALM Clash 15
CALM Clash 70
CALM Clash 14

CALM Neutral 72
CALM Neutral 26
CALM Neutral 70
CALM Neutral 25
CALM Neutral 71
CALM Neutral 18
CALM Neutral 70
CALM Neutral 17

CALM Neutral 99
CALM Neutral 68
CALM Neutral 97
CALM Neutral 97
CALM Neutral 67
CALM Neutral 100
CALM Neutral 100
CALM Neutral 97
CALM Neutral 72
CALM Neutral 71
CALM Neutral 99
CALM Neutral 97

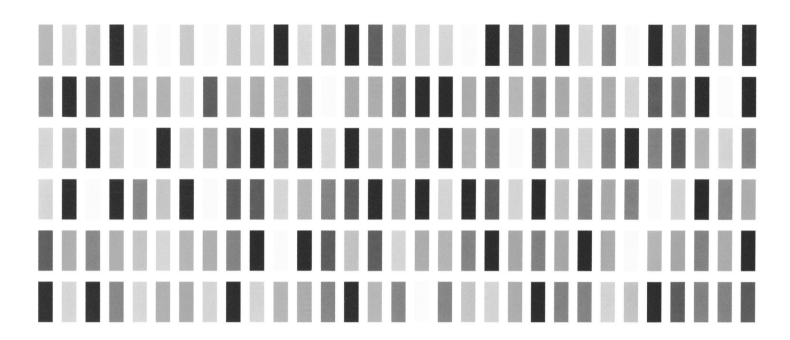

CALM
Tips for Color Schemes

GENERAL COLOR

Split complementaries are a sophisticated, fresh combination with many uses in interior or graphic design.

GRAPHIC DESIGN

The calm color scheme is appealing for advertising and packaging involving high-end, relaxed clothing and accessories.

INTERIOR DESIGN

Calm colors are very pleasing in a bathroom, where they reinforce the soothing, therapeutic effects of bathing.

FINE ART

Calm colors provide a fine palette for portraits. A tender background color of blue causes peachy skin tones to advance from the picture plane.

Zimmer + Rohde

DYNAMIC
KOREA

Interbrand Korea

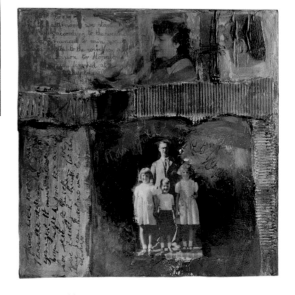

Artist: Ann Baldwin

REGAL

A deep blue-violet, known as "the royal purple," has been a color associated with ruling power for millennia. Authoritative, strong, and courageous, it is a striking hue that is impossible to ignore. It brings to mind the plush, embroidered cloaks of European nobility and the rustle of rich gold-embroidered silks and taffetas. Blue-violet is the darkest hue on the color wheel, and looks its most natural when combined with metallic gold, yellow-orange, or a fresh lemon yellow, all of which add light and sparkle.

Regal color schemes imply ancient and accustomed wealth, often with a slightly Eastern flavor, as if one's ancestors brought back precious carpets, textiles, and paintings from India or the Far East. Blue violet is the color of the finest sapphires, and there is a gemlike quality to regal colors that adds a precious, sensuous richness wherever they are used.

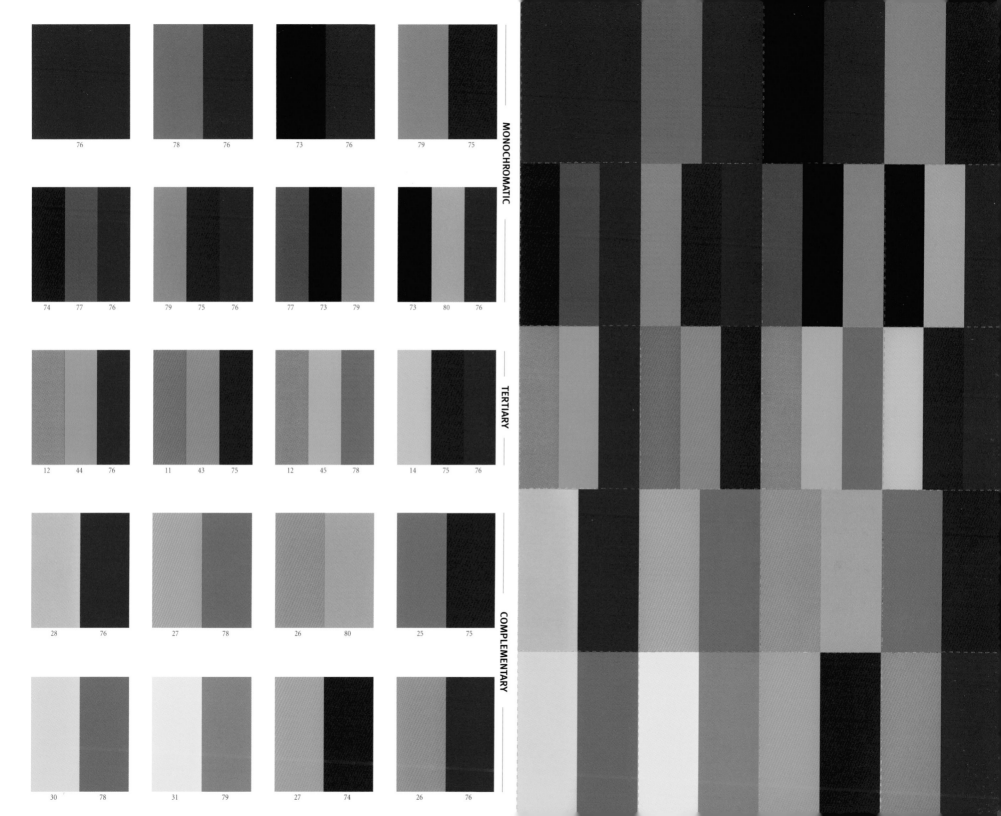

76

78 76

73 76

79 75

74 77 76

79 75 76

77 73 79

73 80 76

12 44 76

11 43 75

12 45 78

14 75 76

28 76

27 78

26 80

25 75

30 78

31 79

27 74

26 76

REGAL Complementary 76
REGAL Complementary 26
REGAL Complementary 74
REGAL Complementary 27
REGAL Complementary 79
REGAL Complementary 31
REGAL Complementary 78
REGAL Complementary 30

REGAL Complementary 75
REGAL Complementary 25
REGAL Complementary 80
REGAL Complementary 26
REGAL Complementary 78
REGAL Complementary 27
REGAL Complementary 76
REGAL Complementary 28

REGAL Tertiary 76
REGAL Tertiary 75
REGAL Tertiary 14
REGAL Tertiary 78
REGAL Tertiary 45
REGAL Tertiary 12
REGAL Tertiary 75
REGAL Tertiary 43
REGAL Tertiary 11
REGAL Tertiary 76
REGAL Tertiary 44
REGAL Tertiary 12

REGAL Monochromatic 76
REGAL Monochromatic 80
REGAL Monochromatic 73
REGAL Monochromatic 79
REGAL Monochromatic 73
REGAL Monochromatic 77
REGAL Monochromatic 76
REGAL Monochromatic 75
REGAL Monochromatic 79
REGAL Monochromatic 76
REGAL Monochromatic 77
REGAL Monochromatic 74

REGAL Monochromatic 75
REGAL Monochromatic 79
REGAL Monochromatic 76
REGAL Monochromatic 73
REGAL Monochromatic 76
REGAL Monochromatic 78
REGAL Monochromatic 76

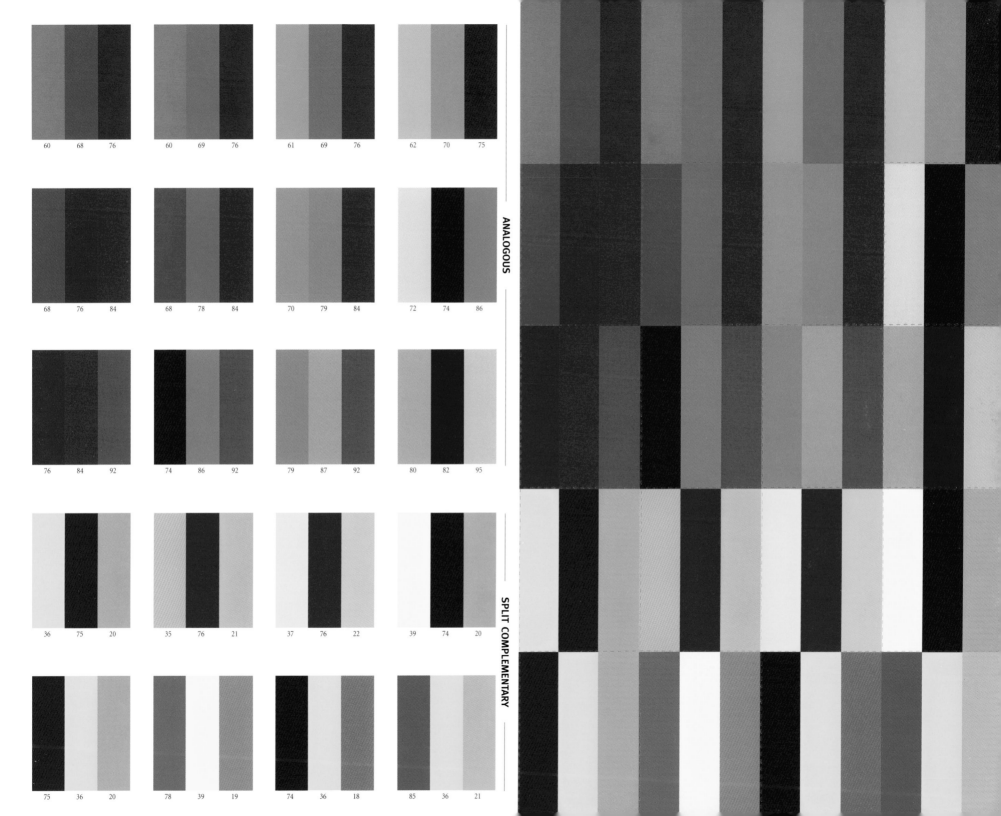

| 60 | 68 | 76 | | 60 | 69 | 76 | | 61 | 69 | 76 | | 62 | 70 | 75 |

| 68 | 76 | 84 | | 68 | 78 | 84 | | 70 | 79 | 84 | | 72 | 74 | 86 |

| 76 | 84 | 92 | | 74 | 86 | 92 | | 79 | 87 | 92 | | 80 | 82 | 95 |

| 36 | 75 | 20 | | 35 | 76 | 21 | | 37 | 76 | 22 | | 39 | 74 | 20 |

| 75 | 36 | 20 | | 78 | 39 | 19 | | 74 | 36 | 18 | | 85 | 36 | 21 |

REGAL Analogous 75
REGAL Analogous 70
REGAL Analogous 62
REGAL Analogous 76
REGAL Analogous 69
REGAL Analogous 61
REGAL Analogous 76
REGAL Analogous 69
REGAL Analogous 60
REGAL Analogous 76
REGAL Analogous 68
REGAL Analogous 60

REGAL Analogous 86
REGAL Analogous 74
REGAL Analogous 72
REGAL Analogous 84
REGAL Analogous 79
REGAL Analogous 70
REGAL Analogous 84
REGAL Analogous 78
REGAL Analogous 68
REGAL Analogous 84
REGAL Analogous 76
REGAL Analogous 68

REGAL Analogous 95
REGAL Analogous 82
REGAL Analogous 80
REGAL Analogous 92
REGAL Analogous 87
REGAL Analogous 79
REGAL Analogous 92
REGAL Analogous 86
REGAL Analogous 74
REGAL Analogous 92
REGAL Analogous 84
REGAL Analogous 76

REGAL Split Complementary 20
REGAL Split Complementary 74
REGAL Split Complementary 39
REGAL Split Complementary 22
REGAL Split Complementary 76
REGAL Split Complementary 37
REGAL Split Complementary 21
REGAL Split Complementary 76
REGAL Split Complementary 35
REGAL Split Complementary 20
REGAL Split Complementary 75
REGAL Split Complementary 36

REGAL Split Complementary 21
REGAL Split Complementary 36
REGAL Split Complementary 85
REGAL Split Complementary 18
REGAL Split Complementary 36
REGAL Split Complementary 74
REGAL Split Complementary 19
REGAL Split Complementary 39
REGAL Split Complementary 78
REGAL Split Complementary 20
REGAL Split Complementary 36
REGAL Split Complementary 75

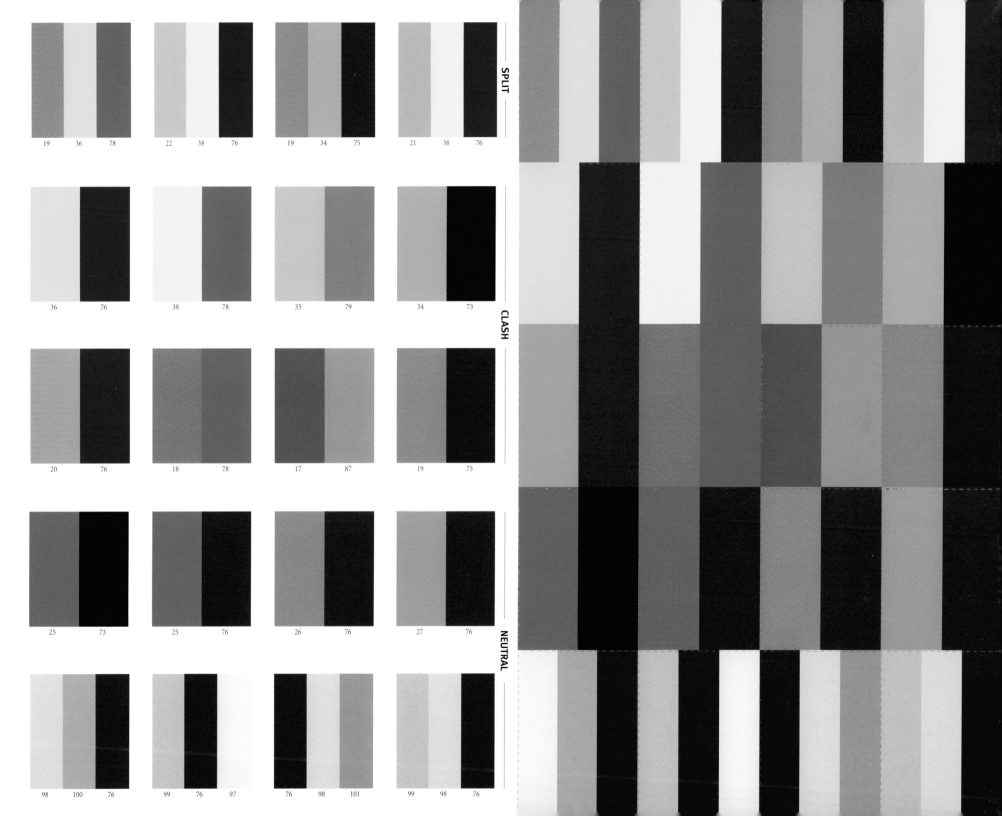

19 36 78

22 38 76

19 34 75

21 38 76

36 76

38 78

35 79

34 73

20 76

18 78

17 87

19 75

25 73

25 76

26 76

27 76

98 100 76

99 76 97

76 98 101

99 98 76

REGAL Split 76
REGAL Split 38
REGAL Split 21
REGAL Split 75
REGAL Split 34
REGAL Split 19
REGAL Split 76
REGAL Split 38
REGAL Split 22
REGAL Split 78
REGAL Split 36
REGAL Split 19

REGAL Clash 73
REGAL Clash 34
REGAL Clash 79
REGAL Clash 35
REGAL Clash 78
REGAL Clash 38
REGAL Clash 76
REGAL Clash 36

REGAL Clash 75
REGAL Clash 19
REGAL Clash 87
REGAL Clash 17
REGAL Clash 78
REGAL Clash 18
REGAL Clash 76
REGAL Clash 20

REGAL Neutral 76
REGAL Neutral 27
REGAL Neutral 76
REGAL Neutral 26
REGAL Neutral 76
REGAL Neutral 25
REGAL Neutral 73
REGAL Neutral 25

REGAL Neutral 76
REGAL Neutral 98
REGAL Neutral 99
REGAL Neutral 101
REGAL Neutral 98
REGAL Neutral 76
REGAL Neutral 97
REGAL Neutral 76
REGAL Neutral 99
REGAL Neutral 76
REGAL Neutral 100
REGAL Neutral 98

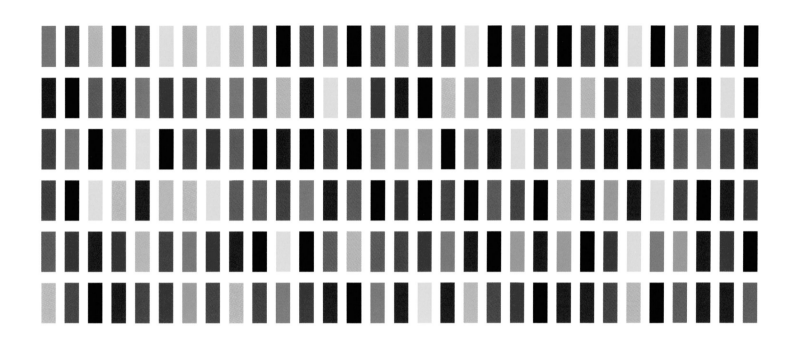

REGAL
Tips for Color Schemes

GENERAL COLOR

White, gold, and blue-violet are an elegant, authoritative color combination whether used in interiors, graphic design, or fine or applied arts.

GRAPHIC DESIGN

For graphic design, the richest papers—particularly those that include flecks of metal—support the saturation of a regal color scheme well.

INTERIOR DESIGN

Remember that painting a room blue-violet will diminish the contrast of its architectural details and make it seem darker—a blue-violet room should contain plenty of natural light.

FINE ART

For paintings that vibrate with deep emotional impact, the regal color scheme in split complementaries is unparalleled. It was a favorite of Van Gogh.

Johnathan Fox
Brand X Pictures

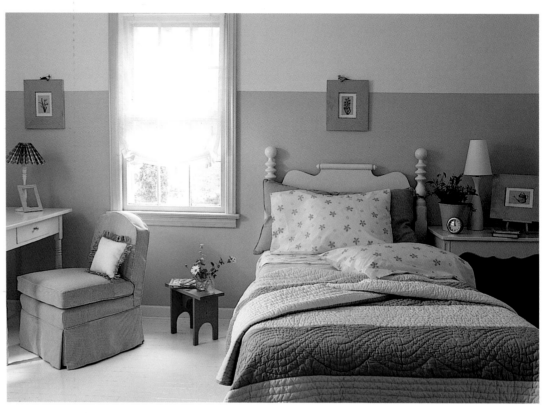

ICI Paints, maker of the Glidden brand

MAGICAL

Rare, unpredictable, and fascinating are the colors of the magical scheme. A powerful violet hue, which combines the passion of red with the spiritual openness of blue, is a central hue to the magical palette. In China, deep violet—known as purple—is considered the most fortunate of colors, conveying the power to attract fortune, rank, and nobility. In esoteric literature, violet or purple is identified with the Third Eye, seat of intuitive knowledge. There is an active, childlike openness to violet, and magical color schemes capitalize on this sense of fun; when paired with split complementaries like yellow-orange or yellow-green, this childlike quality becomes broader and more clownlike.

Yellow is the true complement to violet, adding freshness and a sense of balance. The two hues bring out the beauty in each other, like the violet and yellow of a lovely iris. The offbeat combinations of the magical color scheme add a sense of the fantastic to any art, design, or interior.

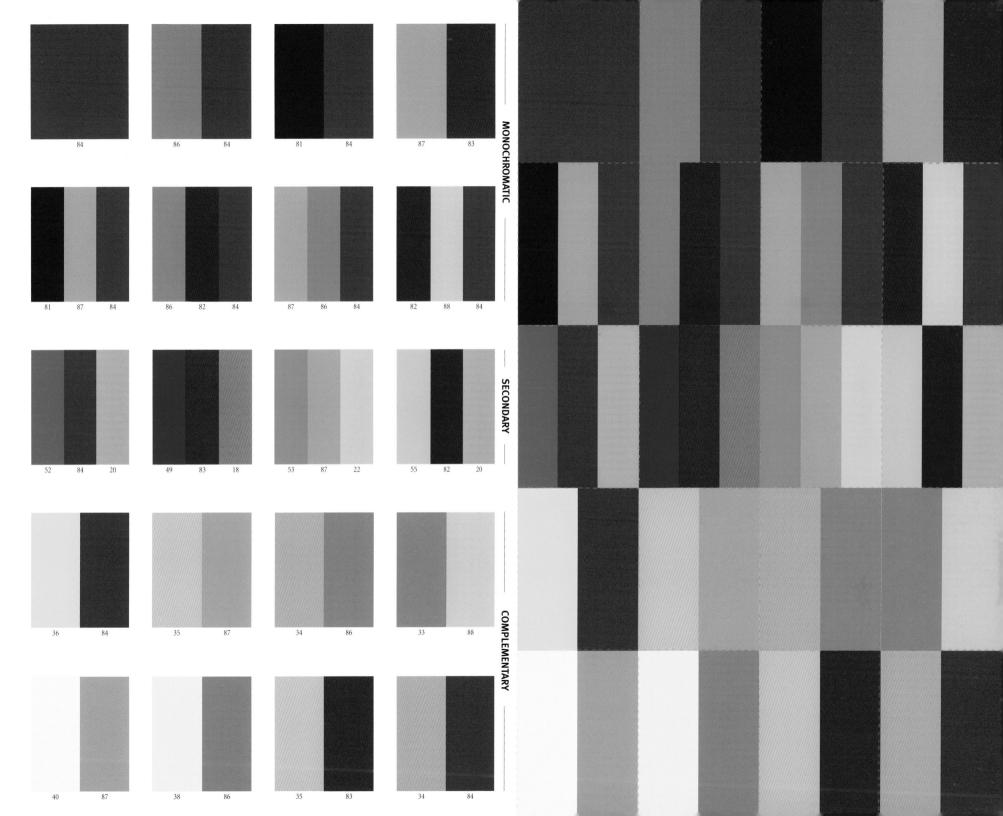

84

86 84

81 84

87 83

81 87 84

86 82 84

87 86 84

82 88 84

52 84 20

49 83 18

53 87 22

55 82 20

36 84

35 87

34 86

33 88

40 87

38 86

35 83

34 84

MAGICAL Complementary	MAGICAL Complementary	MAGICAL Secondary	MAGICAL Monochromatic	MAGICAL Monochromatic
84	88	20	84	83
34	33	82	88	87
83	86	55	82	84
35	34	22	84	81
86	87	87	86	84
38	35	53	87	86
87	84	18	84	84
40	56	83	82	
		49	86	
		20	84	
		84	87	
		52	81	

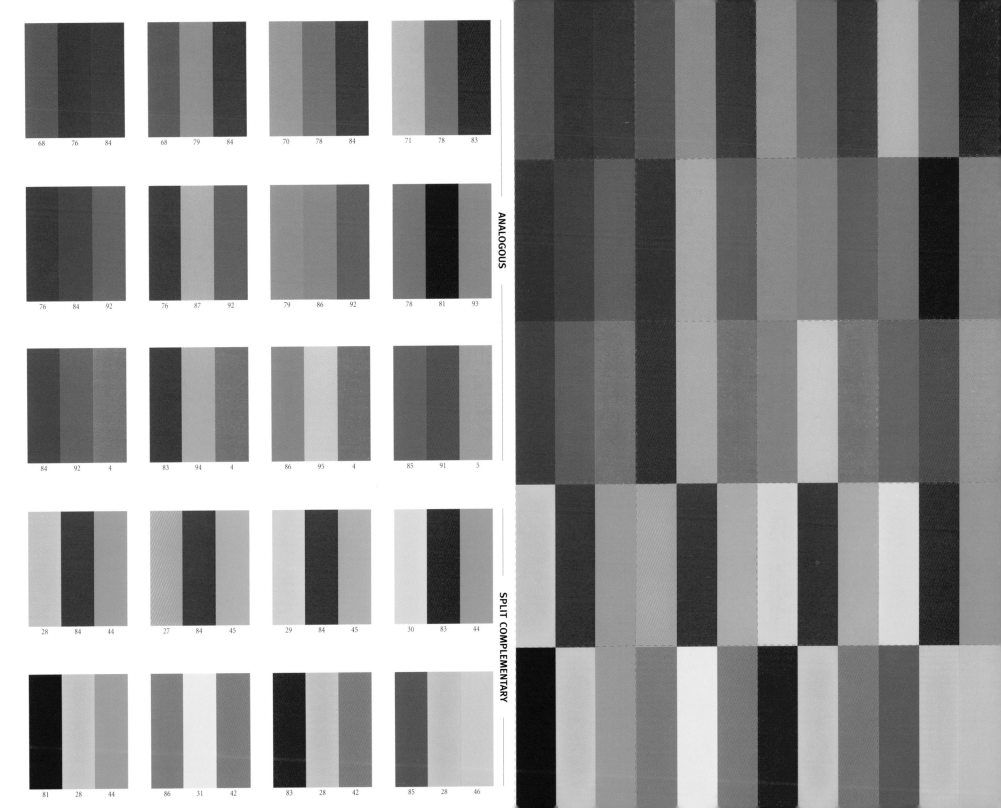

68 76 84
68 79 84
70 78 84
71 78 83

76 84 92
76 87 92
79 86 92
78 81 93

84 92 4
83 94 4
86 95 4
85 91 5

28 84 44
27 84 45
29 84 45
30 83 44

81 28 44
86 31 42
83 28 42
85 28 46

MAGICAL Split Complementary	MAGICAL Split Complementary	MAGICAL Analogous	MAGICAL Analogous	MAGICAL Analogous
46	44	5	93	83
28	83	91	81	78
85	30	85	78	71
42	45	4	92	84
28	84	95	86	78
83	29	86	79	70
42	45	4	92	84
31	84	94	87	79
86	27	83	76	68
44	44	4	92	84
28	84	92	84	76
81	28	84	76	68

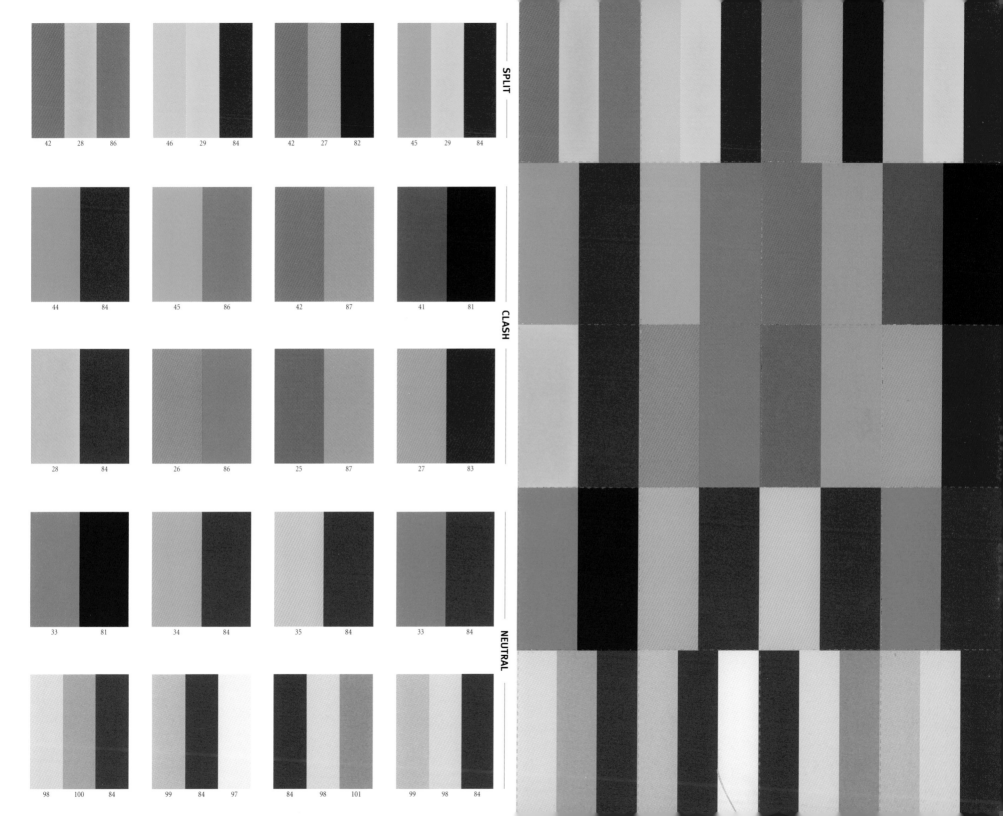

42 28 86

46 29 84

42 27 82

45 29 84

44 84

45 86

42 87

41 81

28 84

26 86

25 87

27 83

33 81

34 84

35 84

33 84

98 100 84

99 84 97

84 98 101

99 98 84

MAGICAL Split 84
MAGICAL Split 29
MAGICAL Split 45
MAGICAL Split 82
MAGICAL Split 27
MAGICAL Split 42
MAGICAL Split 84
MAGICAL Split 29
MAGICAL Split 46
MAGICAL Split 86
MAGICAL Split 28
MAGICAL Split 42

MAGICAL Clash 81
MAGICAL Clash 41
MAGICAL Clash 87
MAGICAL Clash 42
MAGICAL Clash 86
MAGICAL Clash 45
MAGICAL Clash 84
MAGICAL Clash 44

MAGICAL Clash 83
MAGICAL Clash 27
MAGICAL Clash 87
MAGICAL Clash 25
MAGICAL Clash 86
MAGICAL Clash 26
MAGICAL Clash 84
MAGICAL Clash 28

MAGICAL Neutral 84
MAGICAL Neutral 33
MAGICAL Neutral 84
MAGICAL Neutral 35
MAGICAL Neutral 84
MAGICAL Neutral 34
MAGICAL Neutral 81
MAGICAL Neutral 33

MAGICAL Neutral 84
MAGICAL Neutral 98
MAGICAL Neutral 99
MAGICAL Neutral 101
MAGICAL Neutral 98
MAGICAL Neutral 84
MAGICAL Neutral 97
MAGICAL Neutral 84
MAGICAL Neutral 99
MAGICAL Neutral 84
MAGICAL Neutral 100
MAGICAL Neutral 98

MAGICAL
Tips for Color Schemes

GENERAL COLOR

Whimsy is instantly conveyed with a magical color scheme.

▪ GRAPHIC DESIGN

Magical colors, particularly in their more unusual analogous combinations, are well suited for design advertising festive events—Mardi Gras, fiestas, and so on.

▪ INTERIOR DESIGN

A sophisticated spin on magical colors can be achieved by using textiles that combine hues against walls with the palest touch of violet.

▪ FINE ART

Ethereal, mystical visuals are easily created with the use of paint, ink, pencil, or software and fantasy colors.

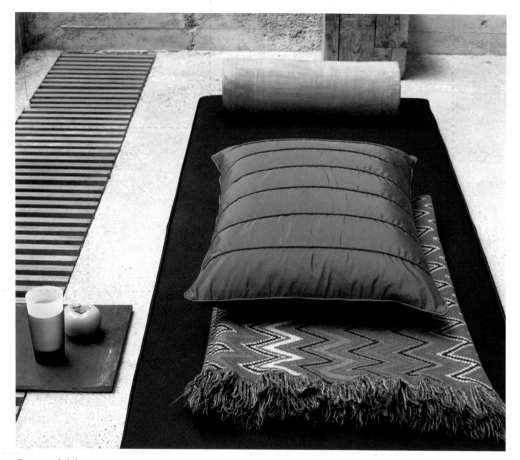

Zimmer + Rohde

Artist: Pam Sussman

Danielle Foushée Design

ENERGETIC

No color is as energetic as red-violet, which combines the penetrating nature of red with the inspiration of violet. Also called magenta or fuchsia, this outgoing hue seems to vibrate, especially when in contact with its complementary hue of yellow-green. The energetic color scheme is daring, bold, and enthusiastic, suggesting youthful high spirits and activity. It is avant-garde and exciting, the antithesis of tradition.

The energetic color scheme can be great for creating momentary excitement, but may be rather difficult to live with over the long term. It is therefore wonderful for graphic design, especially for invitations, reminder mailings, and self-promotion pieces, all of which have a short "shelf life" but should project maximum energy; interiors may require the balance of neutral gray tones. In the fine arts, energetic colors recall the Fauves, and create activity and movement in a painting, illustration, or collage.

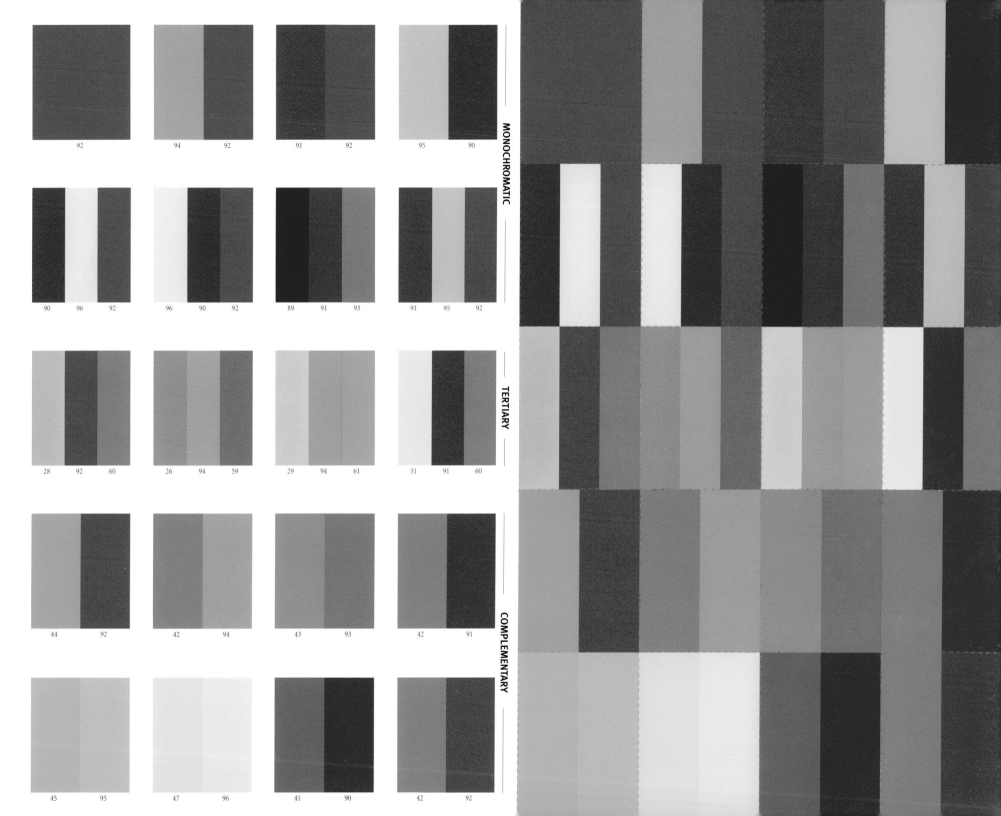

MONOCHROMATIC

92

94 92

91 92

95 90

90 96 92

96 90 92

89 91 93

91 95 92

TERTIARY

28 92 60

26 94 59

29 94 61

31 91 60

COMPLEMENTARY

44 92

42 94

43 93

42 91

45 95

47 96

41 90

42 92

ENERGETIC
Monochromatic
90

ENERGETIC
Monochromatic
95

ENERGETIC
Monochromatic
92

ENERGETIC
Monochromatic
91

ENERGETIC
Monochromatic
92

ENERGETIC
Monochromatic
94

ENERGETIC
Monochromatic
92

ENERGETIC
Monochromatic
92

ENERGETIC
Monochromatic
95

ENERGETIC
Monochromatic
91

ENERGETIC
Monochromatic
93

ENERGETIC
Monochromatic
91

ENERGETIC
Monochromatic
89

ENERGETIC
Monochromatic
92

ENERGETIC
Monochromatic
90

ENERGETIC
Monochromatic
96

ENERGETIC
Monochromatic
92

ENERGETIC
Monochromatic
96

ENERGETIC
Monochromatic
90

ENERGETIC
Tertiary
60

ENERGETIC
Tertiary
91

ENERGETIC
Tertiary
31

ENERGETIC
Tertiary
61

ENERGETIC
Tertiary
94

ENERGETIC
Tertiary
29

ENERGETIC
Tertiary
59

ENERGETIC
Tertiary
94

ENERGETIC
Tertiary
26

ENERGETIC
Tertiary
60

ENERGETIC
Tertiary
92

ENERGETIC
Tertiary
28

ENERGETIC
Complementary
91

ENERGETIC
Complementary
42

ENERGETIC
Complementary
93

ENERGETIC
Complementary
43

ENERGETIC
Complementary
94

ENERGETIC
Complementary
42

ENERGETIC
Complementary
92

ENERGETIC
Complementary
44

ENERGETIC
Complementary
92

ENERGETIC
Complementary
42

ENERGETIC
Complementary
90

ENERGETIC
Complementary
41

ENERGETIC
Complementary
96

ENERGETIC
Complementary
47

ENERGETIC
Complementary
95

ENERGETIC
Complementary
45

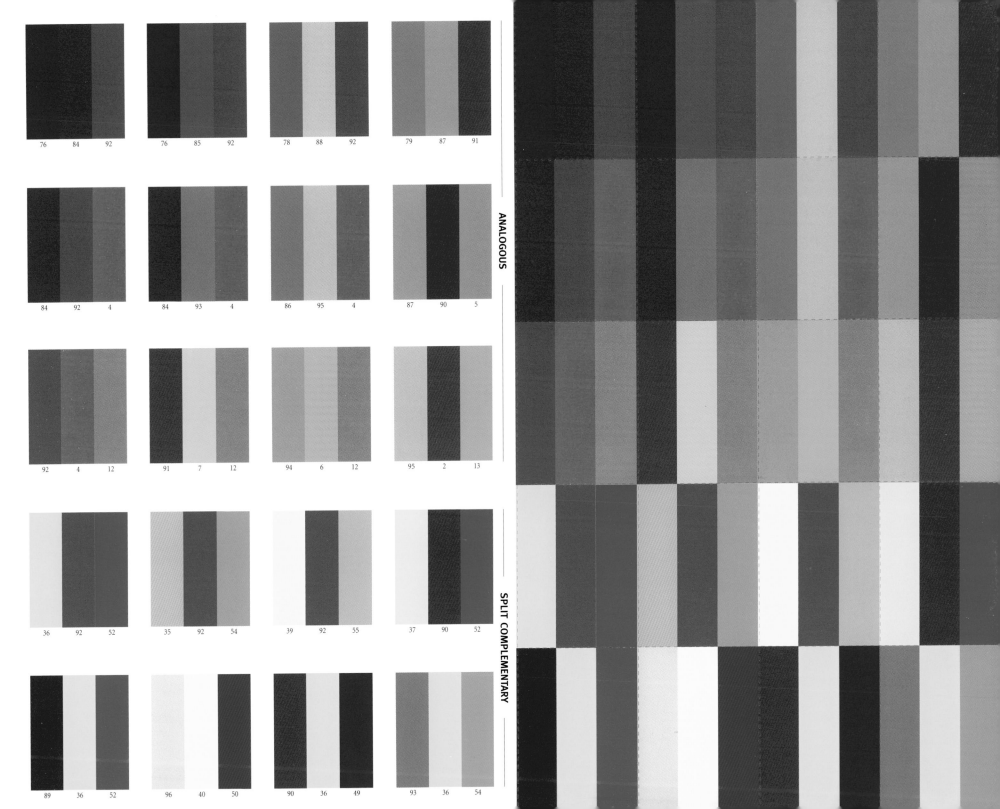

76 84 92

76 85 92

78 88 92

79 87 91

84 92 4

84 93 4

86 95 4

87 90 5

92 4 12

91 7 12

94 6 12

95 2 13

36 92 52

35 92 54

39 92 55

37 90 52

89 36 52

96 40 50

90 36 49

93 36 54

ENERGETIC Analogous	ENERGETIC Analogous	ENERGETIC Analogous	ENERGETIC Split Complementary	ENERGETIC Split Complementary
91	5	13	52	54
87	90	2	90	36
79	87	95	37	93
92	4	12	55	49
88	95	6	92	36
78	86	94	39	90
92	4	12	54	50
85	93	7	92	40
76	84	91	35	96
92	4	12	52	52
84	92	4	92	36
76	84	92	36	89

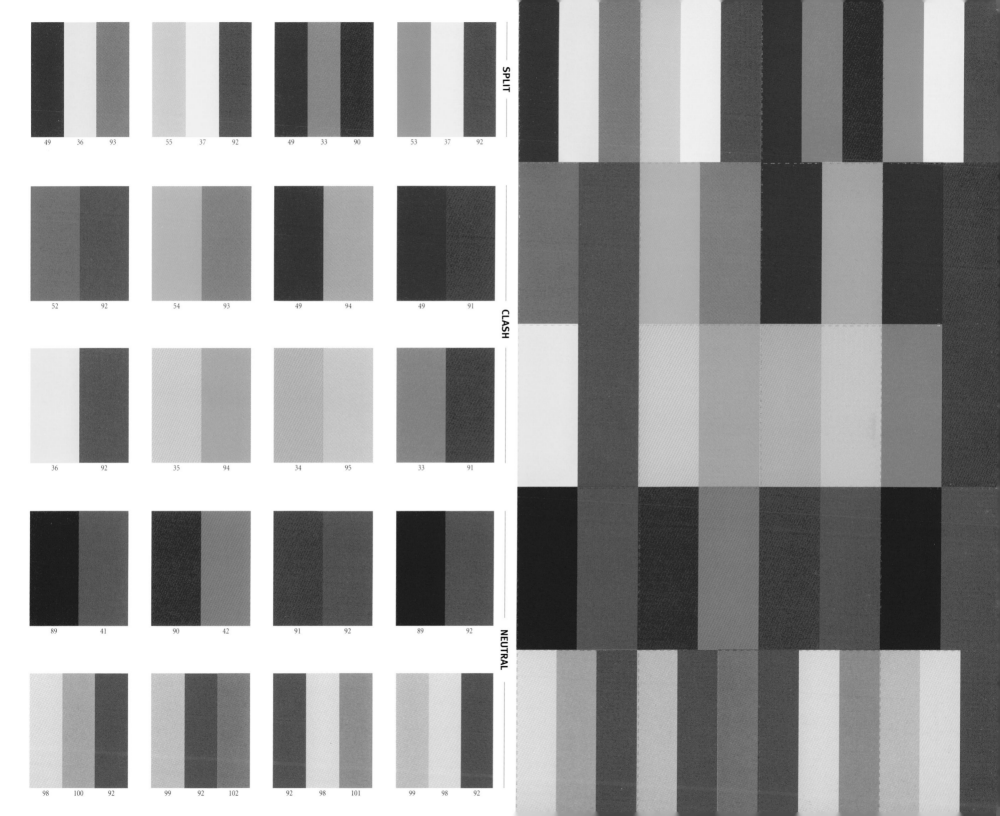

SPLIT

| 49 | 36 | 93 | | 55 | 37 | 92 | | 49 | 33 | 90 | | 53 | 37 | 92 |

CLASH

| 52 | 92 | | 54 | 93 | | 49 | 94 | | 49 | 91 |

| 36 | 92 | | 35 | 94 | | 34 | 95 | | 33 | 91 |

NEUTRAL

| 89 | 41 | | 90 | 42 | | 91 | 92 | | 89 | 92 |

| 98 | 100 | 92 | | 99 | 92 | 102 | | 92 | 98 | 101 | | 99 | 98 | 92 |

ENERGETIC Split 92
ENERGETIC Split 37
ENERGETIC Split 53
ENERGETIC Split 90
ENERGETIC Split 33
ENERGETIC Split 49
ENERGETIC Split 92
ENERGETIC Split 37
ENERGETIC Split 55
ENERGETIC Split 93
ENERGETIC Split 36
ENERGETIC Split 49

ENERGETIC Clash 91
ENERGETIC Clash 49
ENERGETIC Clash 94
ENERGETIC Clash 49
ENERGETIC Clash 93
ENERGETIC Clash 54
ENERGETIC Clash 92
ENERGETIC Clash 52

ENERGETIC Clash 91
ENERGETIC Clash 33
ENERGETIC Clash 95
ENERGETIC Clash 34
ENERGETIC Clash 94
ENERGETIC Clash 35
ENERGETIC Clash 92
ENERGETIC Clash 36

ENERGETIC Neutral 92
ENERGETIC Neutral 89
ENERGETIC Neutral 92
ENERGETIC Neutral 91
ENERGETIC Neutral 42
ENERGETIC Neutral 90
ENERGETIC Neutral 41
ENERGETIC Neutral 89

ENERGETIC Neutral 92
ENERGETIC Neutral 98
ENERGETIC Neutral 99
ENERGETIC Neutral 101
ENERGETIC Neutral 98
ENERGETIC Neutral 92
ENERGETIC Neutral 102
ENERGETIC Neutral 92
ENERGETIC Neutral 99
ENERGETIC Neutral 92
ENERGETIC Neutral 100
ENERGETIC Neutral 98

ENERGETIC
Tips for Color Schemes

GENERAL COLOR

A humorous, youthful, sporty message is conveyed whenever an energetic color scheme is used.

GRAPHIC DESIGN

Graphic designers will find energetic colors useful for packaging targeted at young, impulsive audiences; hair care packaging, for example, often features energetic hues against a black background.

INTERIOR DESIGN

In interior design, energetic colors must be used cleverly to be livable. Pale yellow or green walls stand up to fuchsia, while tonal gray and black helps to ground hues.

FINE ART

Energetic colors imply speed and activity; fine artists can add a moving quality to paintings with a few gestural dashes of magenta and chartreuse oil stick.

ICI Paints, maker of the Glidden brand

Howary Design Associates

Pamela G. Allnutt
The Coming of Winter

SUBDUED

Subdued colors are those that are muted with the addition of neutral gray and/or white. Subtlety is their keynote; they are low in contrast, and the emotional impact of their original hues is dampened. These are the colors beloved of Impressionist painters of the nineteeth century, including Berthe Morisot and Mary Cassatt, for they seem to hint delicately at shape, light, and movement. Mauve is the color most often seen in a subdued color scheme; a grayed tonal aspect of passionate magenta, it is a soft and retiring color,

which conveys a bit of wistful longing. Perhaps that is why Victorian widows wore black for one year after their spouse's death and, subsequently, adopted mauve. When combined with its complementary green and yellow tones, mauve takes on a more lively aspect.

There is a faintly retro feeling to mauve, whether it is used in art or design. It calls up the Art Deco period of the 1920s and '30s, as well as the more recent Post Modern design of the 1980s.

complete color harmony workbook

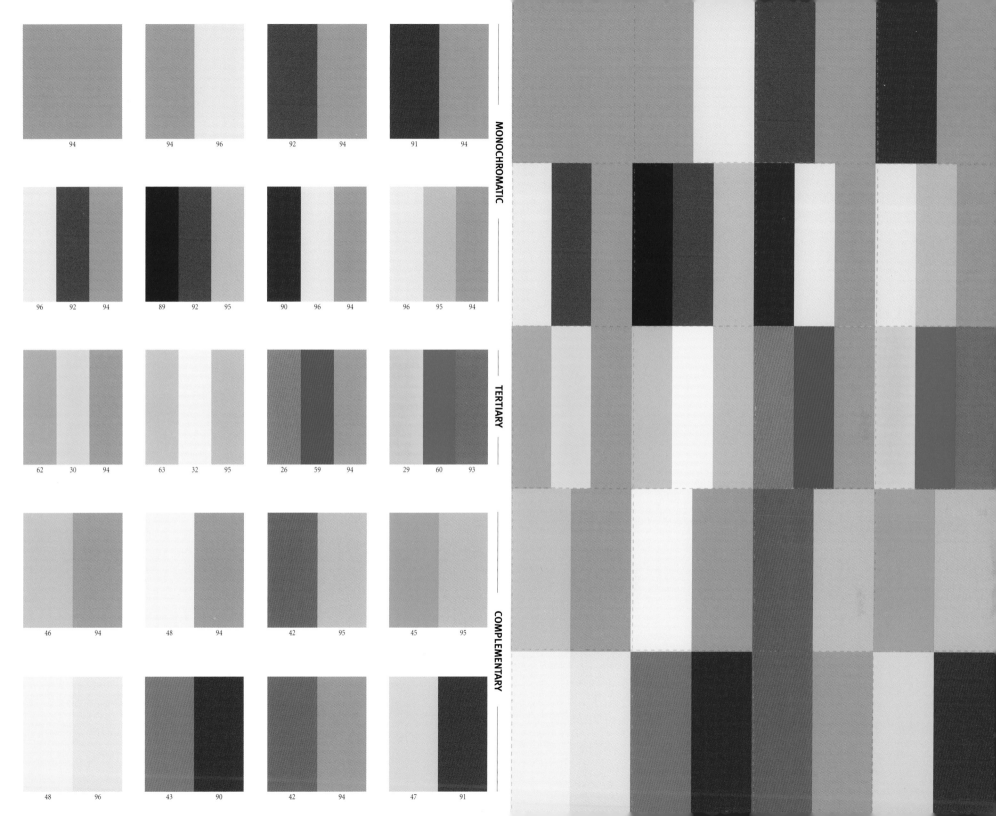

94

94 96

92 94

91 94

96 92 94

89 92 95

90 96 94

96 95 94

62 30 94

63 32 95

26 59 94

29 60 93

46 94

48 94

42 95

45 95

48 96

43 90

42 94

47 91

SUBDUED Monochromatic 94
SUBDUED Monochromatic 91
SUBDUED Monochromatic 94
SUBDUED Monochromatic 92
SUBDUED Monochromatic 96
SUBDUED Monochromatic 94
SUBDUED Monochromatic 94

SUBDUED Monochromatic 94
SUBDUED Monochromatic 95
SUBDUED Monochromatic 96
SUBDUED Monochromatic 94
SUBDUED Monochromatic 96
SUBDUED Monochromatic 90
SUBDUED Monochromatic 95
SUBDUED Monochromatic 92
SUBDUED Monochromatic 89
SUBDUED Monochromatic 94
SUBDUED Monochromatic 92
SUBDUED Monochromatic 96

SUBDUED Tertiary 93
SUBDUED Tertiary 60
SUBDUED Tertiary 29
SUBDUED Tertiary 94
SUBDUED Tertiary 59
SUBDUED Tertiary 26
SUBDUED Tertiary 95
SUBDUED Tertiary 32
SUBDUED Tertiary 63
SUBDUED Tertiary 94
SUBDUED Tertiary 30
SUBDUED Tertiary 62

SUBDUED Complementary 95
SUBDUED Complementary 45
SUBDUED Complementary 95
SUBDUED Complementary 42
SUBDUED Complementary 94
SUBDUED Complementary 48
SUBDUED Complementary 94
SUBDUED Complementary 46

SUBDUED Complementary 91
SUBDUED Complementary 47
SUBDUED Complementary 94
SUBDUED Complementary 42
SUBDUED Complementary 90
SUBDUED Complementary 43
SUBDUED Complementary 96
SUBDUED Complementary 48

subdued color schemes

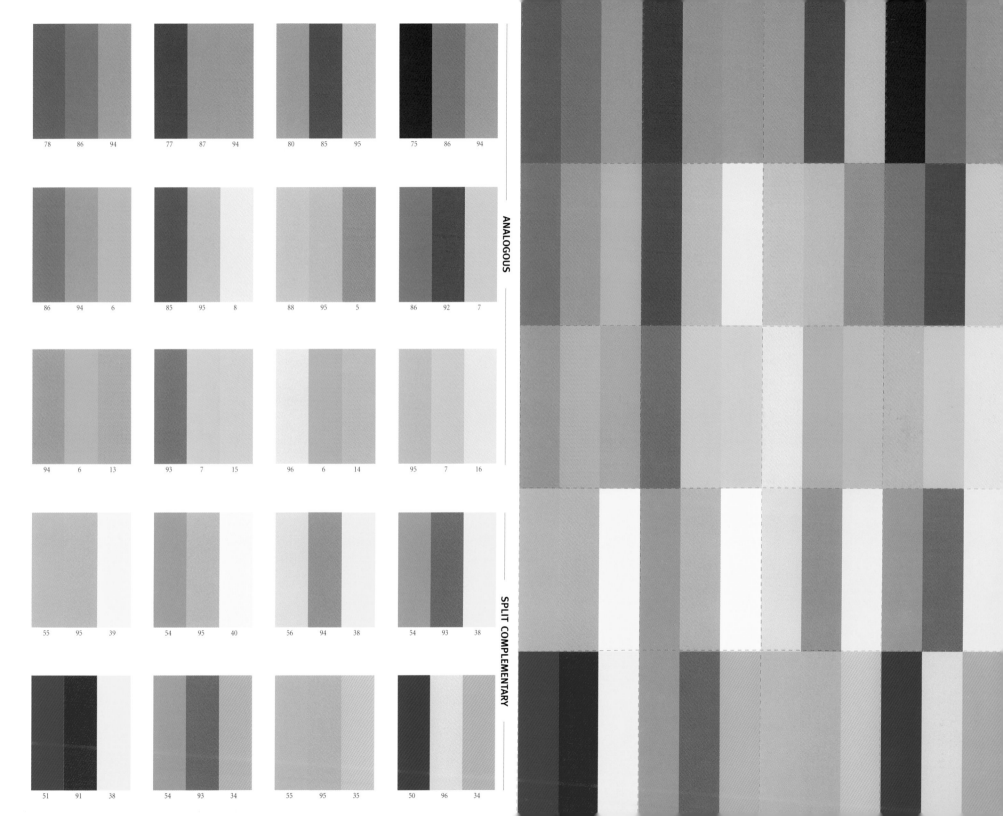

78 86 94

77 87 94

80 85 95

75 86 94

86 94 6

85 95 8

88 95 5

86 92 7

94 6 13

93 7 15

96 6 14

95 7 16

55 95 39

54 95 40

56 94 38

54 93 38

51 91 38

54 93 34

55 95 35

50 96 34

SUBDUED Analogous 94
SUBDUED Analogous 86
SUBDUED Analogous 75
SUBDUED Analogous 95
SUBDUED Analogous 85
SUBDUED Analogous 80
SUBDUED Analogous 94
SUBDUED Analogous 87
SUBDUED Analogous 77
SUBDUED Analogous 94
SUBDUED Analogous 86
SUBDUED Analogous 78

SUBDUED Analogous 7
SUBDUED Analogous 92
SUBDUED Analogous 86
SUBDUED Analogous 5
SUBDUED Analogous 95
SUBDUED Analogous 88
SUBDUED Analogous 8
SUBDUED Analogous 95
SUBDUED Analogous 85
SUBDUED Analogous 6
SUBDUED Analogous 94
SUBDUED Analogous 86

SUBDUED Analogous 16
SUBDUED Analogous 7
SUBDUED Analogous 95
SUBDUED Analogous 14
SUBDUED Analogous 6
SUBDUED Analogous 96
SUBDUED Analogous 15
SUBDUED Analogous 7
SUBDUED Analogous 93
SUBDUED Analogous 13
SUBDUED Analogous 6
SUBDUED Analogous 94

SUBDUED Split Complementary 38
SUBDUED Split Complementary 93
SUBDUED Split Complementary 54
SUBDUED Split Complementary 38
SUBDUED Split Complementary 94
SUBDUED Split Complementary 56
SUBDUED Split Complementary 40
SUBDUED Split Complementary 95
SUBDUED Split Complementary 54
SUBDUED Split Complementary 39
SUBDUED Split Complementary 95
SUBDUED Split Complementary 55

SUBDUED Split Complementary 34
SUBDUED Split Complementary 96
SUBDUED Split Complementary 50
SUBDUED Split Complementary 35
SUBDUED Split Complementary 95
SUBDUED Split Complementary 55
SUBDUED Split Complementary 34
SUBDUED Split Complementary 93
SUBDUED Split Complementary 54
SUBDUED Split Complementary 38
SUBDUED Split Complementary 91
SUBDUED Split Complementary 51

subdued color schemes

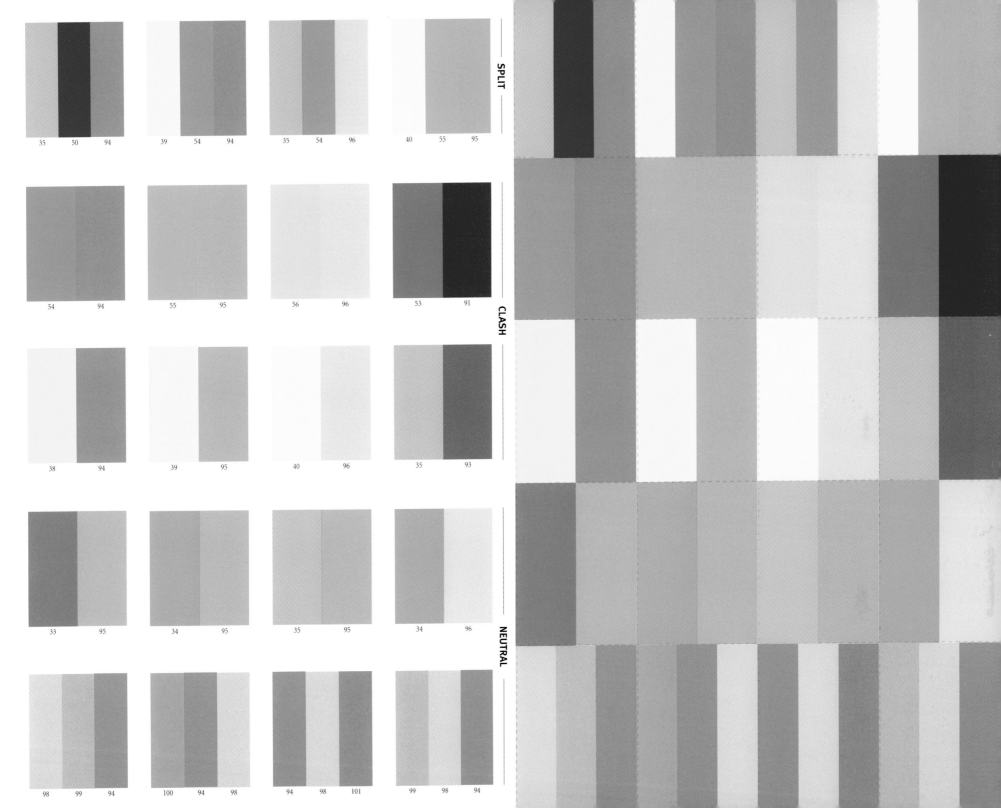

SPLIT

| 35 | 50 | 94 | | 39 | 54 | 94 | | 35 | 54 | 96 | | 40 | 55 | 95 |

CLASH

| 54 | 94 | | 55 | 95 | | 56 | 96 | | 53 | 91 |

| 38 | 94 | | 39 | 95 | | 40 | 96 | | 35 | 93 |

NEUTRAL

| 33 | 95 | | 34 | 95 | | 35 | 95 | | 34 | 96 |

| 98 | 99 | 94 | | 100 | 94 | 98 | | 94 | 98 | 101 | | 99 | 98 | 94 |

SUBDUED Split 95 · SUBDUED Split 55 · SUBDUED Split 40 · SUBDUED Split 96 · SUBDUED Split 54 · SUBDUED Split 35 · SUBDUED Split 94 · SUBDUED Split 54 · SUBDUED Split 39 · SUBDUED Split 94 · SUBDUED Split 50 · SUBDUED Split 35

SUBDUED Clash 91 · SUBDUED Clash 53 · SUBDUED Clash 96 · SUBDUED Clash 56 · SUBDUED Clash 95 · SUBDUED Clash 55 · SUBDUED Clash 94 · SUBDUED Clash 54

SUBDUED Clash 93 · SUBDUED Clash 35 · SUBDUED Clash 96 · SUBDUED Clash 40 · SUBDUED Clash 95 · SUBDUED Clash 39 · SUBDUED Clash 94 · SUBDUED Clash 38

SUBDUED Neutral 96 · SUBDUED Neutral 34 · SUBDUED Neutral 95 · SUBDUED Neutral 35 · SUBDUED Neutral 95 · SUBDUED Neutral 34 · SUBDUED Neutral 95 · SUBDUED Neutral 33

SUBDUED Neutral 94 · SUBDUED Neutral 98 · SUBDUED Neutral 99 · SUBDUED Neutral 101 · SUBDUED Neutral 98 · SUBDUED Neutral 94 · SUBDUED Neutral 98 · SUBDUED Neutral 94 · SUBDUED Neutral 100 · SUBDUED Neutral 94 · SUBDUED Neutral 99 · SUBDUED Neutral 98

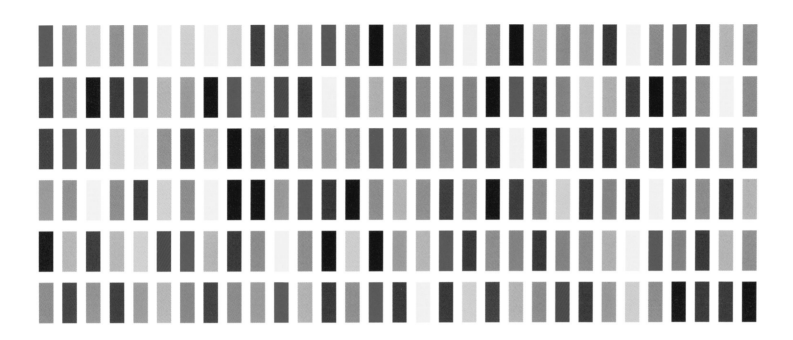

SUBDUED
Tips for Color Schemes

GENERAL COLOR

Subdued colors are rather withdrawn. Whenever they are used, remember that complementary and split complementary combinations keep mauve from becoming too passive.

GRAPHIC DESIGN

Subdued colors are rather feminine; a good choice for a woman's personal stationery or business card.

INTERIOR DESIGN

The grayness of subdued colors, particularly mauve, can be unflattering to many skin tones; if using mauve in interior design, be sure the lighting has a compensatory warmth.

FINE ART

Fine artists will find that using subdued colors adds a quality of longing to paintings or drawings.

Grafikz Design

Donald L. Berry
Commuters

ICI Paints, maker of the Glidden brand

PROFESSIONAL

The classic professional attire? It is, of course, the gray flannel suit—and gray is therefore central to the professional color scheme. Gray is a serious, sober, no-nonsense neutral that communicates that the wearer is willing to give up an ego-driven sense of self to be part of a greater "team." It is anonymous, silent, and receptive . . . all qualities that make it an ideal ground on which to lay other, brilliant colors. There is an industrial aspect to the professional color scheme, making it a popular interior color scheme for office buildings. This is a

color scheme that suggests an analytical, emotionally cool atmosphere; it is distinctively of the twentieth century, and is in fact instantly identifiable as the color scheme used in posters and graphics since the early 1900s (for example, in early Soviet art and graphics). An achromatic palette allows any color present to take on additional vibrancy. In the fine arts, the professional color scheme has often been used for abstract paintings; in representational work, it often indicates a wet, foggy, or stormy environment.

PROFESSIONAL 99 · PROFESSIONAL 100 · PROFESSIONAL 97 · PROFESSIONAL 98 · PROFESSIONAL 99 · PROFESSIONAL 101 · PROFESSIONAL 101 · PROFESSIONAL 100 · PROFESSIONAL 98 · PROFESSIONAL 98

PROFESSIONAL 102 · PROFESSIONAL 99 · PROFESSIONAL 103 · PROFESSIONAL 105 · PROFESSIONAL 100 · PROFESSIONAL 104 · PROFESSIONAL 102 · PROFESSIONAL 104 · PROFESSIONAL 99 · PROFESSIONAL 102

PROFESSIONAL 103 · PROFESSIONAL 101 · PROFESSIONAL 105 · PROFESSIONAL 105 · PROFESSIONAL 98 · PROFESSIONAL 101 · PROFESSIONAL 106 · PROFESSIONAL 97 · PROFESSIONAL 99 · PROFESSIONAL 106

PROFESSIONAL 8 · PROFESSIONAL 101 · PROFESSIONAL 5 · PROFESSIONAL 104 · PROFESSIONAL 4 · PROFESSIONAL 97 · PROFESSIONAL 98 · PROFESSIONAL 100 · PROFESSIONAL 3 · PROFESSIONAL 98 · PROFESSIONAL 2 · PROFESSIONAL 97

PROFESSIONAL 99 · PROFESSIONAL 97 · PROFESSIONAL 10 · PROFESSIONAL 99 · PROFESSIONAL 14 · PROFESSIONAL 97 · PROFESSIONAL 98 · PROFESSIONAL 11 · PROFESSIONAL 100 · PROFESSIONAL 97 · PROFESSIONAL 100 · PROFESSIONAL 12

PROFESSIONAL 22
PROFESSIONAL 102
PROFESSIONAL 99
PROFESSIONAL 101
PROFESSIONAL 23
PROFESSIONAL 98
PROFESSIONAL 102
PROFESSIONAL 20
PROFESSIONAL 99
PROFESSIONAL 98
PROFESSIONAL 24
PROFESSIONAL 97

PROFESSIONAL 99
PROFESSIONAL 27
PROFESSIONAL 98
PROFESSIONAL 28
PROFESSIONAL 100
PROFESSIONAL 97
PROFESSIONAL 102
PROFESSIONAL 31
PROFESSIONAL 100
PROFESSIONAL 97
PROFESSIONAL 29
PROFESSIONAL 98

PROFESSIONAL 102
PROFESSIONAL 38
PROFESSIONAL 101
PROFESSIONAL 97
PROFESSIONAL 35
PROFESSIONAL 105
PROFESSIONAL 39
PROFESSIONAL 100
PROFESSIONAL 104
PROFESSIONAL 97
PROFESSIONAL 36
PROFESSIONAL 98

PROFESSIONAL 98
PROFESSIONAL 42
PROFESSIONAL 97
PROFESSIONAL 43
PROFESSIONAL 98
PROFESSIONAL 101
PROFESSIONAL 104
PROFESSIONAL 47
PROFESSIONAL 100
PROFESSIONAL 99
PROFESSIONAL 44
PROFESSIONAL 97

PROFESSIONAL 101
PROFESSIONAL 55
PROFESSIONAL 102
PROFESSIONAL 99
PROFESSIONAL 52
PROFESSIONAL 97
PROFESSIONAL 48
PROFESSIONAL 98
PROFESSIONAL 101
PROFESSIONAL 99
PROFESSIONAL 49
PROFESSIONAL 97

PROFESSIONAL 104 · PROFESSIONAL 62 · PROFESSIONAL 97 · PROFESSIONAL 101 · PROFESSIONAL 59 · PROFESSIONAL 99 · PROFESSIONAL 102 · PROFESSIONAL 63 · PROFESSIONAL 100 · PROFESSIONAL 97 · PROFESSIONAL 60 · PROFESSIONAL 98

PROFESSIONAL 101 · PROFESSIONAL 71 · PROFESSIONAL 97 · PROFESSIONAL 66 · PROFESSIONAL 98 · PROFESSIONAL 102 · PROFESSIONAL 103 · PROFESSIONAL 70 · PROFESSIONAL 98 · PROFESSIONAL 68 · PROFESSIONAL 100 · PROFESSIONAL 98

PROFESSIONAL 78 · PROFESSIONAL 101 · PROFESSIONAL 97 · PROFESSIONAL 103 · PROFESSIONAL 79 · PROFESSIONAL 102 · PROFESSIONAL 74 · PROFESSIONAL 97 · PROFESSIONAL 100 · PROFESSIONAL 101 · PROFESSIONAL 76 · PROFESSIONAL 99

PROFESSIONAL 82 · PROFESSIONAL 100 · PROFESSIONAL 97 · PROFESSIONAL 98 · PROFESSIONAL 88 · PROFESSIONAL 101 · PROFESSIONAL 84 · PROFESSIONAL 99 · PROFESSIONAL 97 · PROFESSIONAL 100 · PROFESSIONAL 87 · PROFESSIONAL 99

PROFESSIONAL 97 · PROFESSIONAL 90 · PROFESSIONAL 102 · PROFESSIONAL 100 · PROFESSIONAL 92 · PROFESSIONAL 97 · PROFESSIONAL 102 · PROFESSIONAL 95 · PROFESSIONAL 98 · PROFESSIONAL 92 · PROFESSIONAL 97 · PROFESSIONAL 100

PROFESSIONAL
Tips for Color Schemes

GENERAL COLOR

Because of their inherent neutrality, professional colors can be used to showcase brilliantly colored items. Try using them on walls, backgrounds, and backdrops.

GRAPHIC DESIGN

What is the one compelling reason to use the professional color scheme in graphic design? It is inexpensive, as it usually involves black and white with a single color.

INTERIOR DESIGN

While the professional color scheme is excellent for environments that should be "clean" and unemotional—a design studio, a living room— it may be too cold and hard-edged for a bedroom or bathroom.

FINE ART

Professional colors imply the industrial, mechanical, and modern. These colors recall the heroic look of Russian Constructivist paintings and the Machine Age.

Artist: Jane Maxwell

Hakobo (Jacob Stepien)

ICI Paints, maker of the Glidden brand

GRAPHIC

The color combination of black and white is classic and dramatic at the same time—think piano keys and tuxedoes. In decorating, black-and-white tiles add a touch of elegance to a hallway, while in fashion, nothing is more cosmopolitan than basic black with pearls.

When combined with a single bright, such as red or hot pink, black and white is graphic, a bit shocking, and decidedly memorable.

Black can be mysterious, even seductive, like black cats and film noir. Because it is so powerful, even a fine line of black boldly separates colors in graphic design.

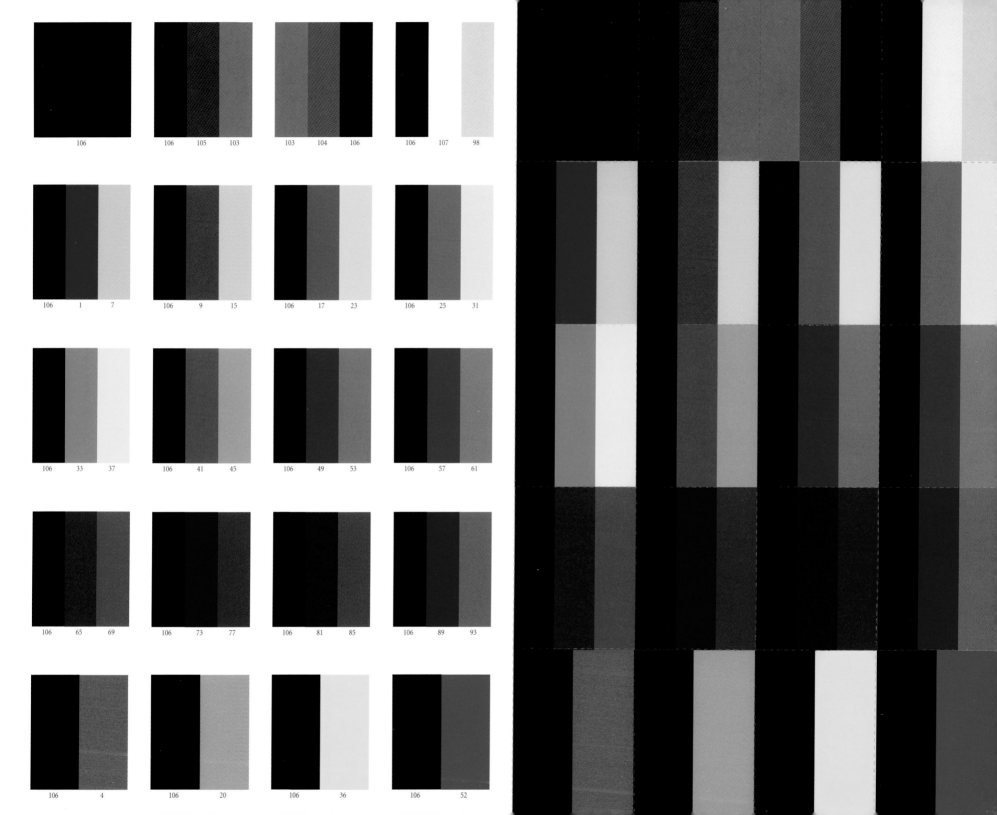

GRAPHIC Monocromatic 98
GRAPHIC Monocromatic 107
GRAPHIC Monocromatic 106
GRAPHIC Monocromatic 106
GRAPHIC Monocromatic 104
GRAPHIC Monocromatic 103
GRAPHIC Monocromatic 103
GRAPHIC Monocromatic 105
GRAPHIC Monocromatic 106
GRAPHIC Monocromatic 106

GRAPHIC Monocromatic 31
GRAPHIC Monocromatic 25
GRAPHIC Monocromatic 106
GRAPHIC Monocromatic 23
GRAPHIC Monocromatic 17
GRAPHIC Monocromatic 106
GRAPHIC Monocromatic 15
GRAPHIC Monocromatic 9
GRAPHIC Monocromatic 106
GRAPHIC Monocromatic 7
GRAPHIC Monocromatic 1
GRAPHIC Monocromatic 106

GRAPHIC Tertiary 61
GRAPHIC Tertiary 57
GRAPHIC Tertiary 106
GRAPHIC Tertiary 53
GRAPHIC Tertiary 49
GRAPHIC Tertiary 106
GRAPHIC Tertiary 45
GRAPHIC Tertiary 41
GRAPHIC Tertiary 106
GRAPHIC Tertiary 37
GRAPHIC Tertiary 33
GRAPHIC Tertiary 106

GRAPHIC 93
GRAPHIC Complementary 89
GRAPHIC Complementary 106
GRAPHIC Complementary 85
GRAPHIC Complementary 81
GRAPHIC Complementary 106
GRAPHIC Complementary 77
GRAPHIC Complementary 73
GRAPHIC Complementary 106
GRAPHIC Complementary 69
GRAPHIC Complementary 65
GRAPHIC Complementary 106

GRAPHIC Complementary 52
GRAPHIC Complementary 106
GRAPHIC Complementary 36
GRAPHIC Complementary 106
GRAPHIC Complementary 20
GRAPHIC Complementary 106
GRAPHIC Complementary 4
GRAPHIC Complementary 106

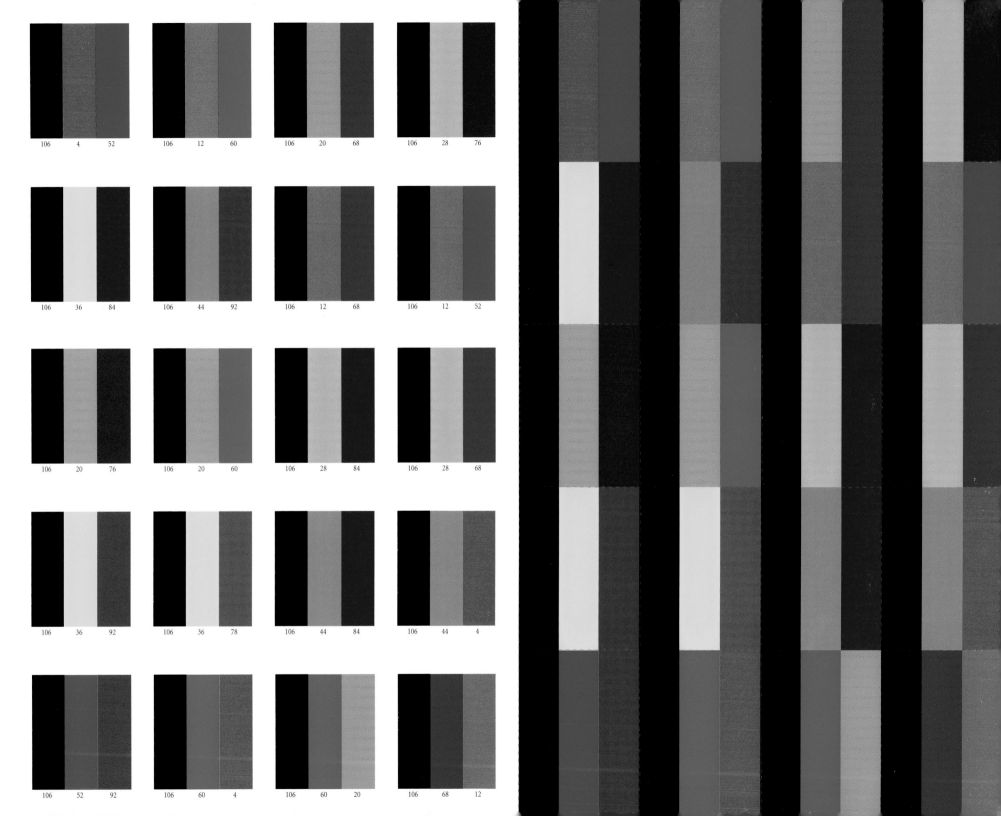

106 4 52

106 12 60

106 20 68

106 28 76

106 36 84

106 44 92

106 12 68

106 12 52

106 20 76

106 20 60

106 28 84

106 28 68

106 36 92

106 36 78

106 44 84

106 44 4

106 52 92

106 60 4

106 60 20

106 68 12

GRAPHIC Analogous 76 | GRAPHIC Analogous 28 | GRAPHIC Analogous 106 | GRAPHIC Analogous 68 | GRAPHIC Analogous 20 | GRAPHIC Analogous 106 | GRAPHIC Analogous 60 | GRAPHIC Analogous 12 | GRAPHIC Analogous 106 | GRAPHIC Analogous 52 | GRAPHIC Analogous 4 | GRAPHIC Analogous 106

GRAPHIC Analogous 52 | GRAPHIC Analogous 12 | GRAPHIC Analogous 106 | GRAPHIC Analogous 68 | GRAPHIC Analogous 12 | GRAPHIC Analogous 106 | GRAPHIC Analogous 92 | GRAPHIC Analogous 44 | GRAPHIC Analogous 106 | GRAPHIC Analogous 84 | GRAPHIC Analogous 36 | GRAPHIC Analogous 106

GRAPHIC Analogous 68 | GRAPHIC Analogous 28 | GRAPHIC Analogous 106 | GRAPHIC Analogous 84 | GRAPHIC Analogous 28 | GRAPHIC Analogous 106 | GRAPHIC Analogous 60 | GRAPHIC Analogous 20 | GRAPHIC Analogous 106 | GRAPHIC Analogous 76 | GRAPHIC Analogous 20 | GRAPHIC Analogous 106

GRAPHIC Split Complementary 4 | GRAPHIC Split Complementary 44 | GRAPHIC Split Complementary 106 | GRAPHIC Split Complementary 84 | GRAPHIC Split Complementary 44 | GRAPHIC Split Complementary 106 | GRAPHIC Split Complementary 76 | GRAPHIC Split Complementary 36 | GRAPHIC Split Complementary 106 | GRAPHIC Split Complementary 92 | GRAPHIC Split Complementary 36 | GRAPHIC Split Complementary 106

GRAPHIC Split Complementary 12 | GRAPHIC Split Complementary 68 | GRAPHIC Split Complementary 106 | GRAPHIC Split Complementary 20 | GRAPHIC Split Complementary 60 | GRAPHIC Split Complementary 106 | GRAPHIC Split Complementary 4 | GRAPHIC Split Complementary 60 | GRAPHIC Split Complementary 106 | GRAPHIC Split Complementary 92 | GRAPHIC Split Complementary 52 | GRAPHIC Split Complementary 106

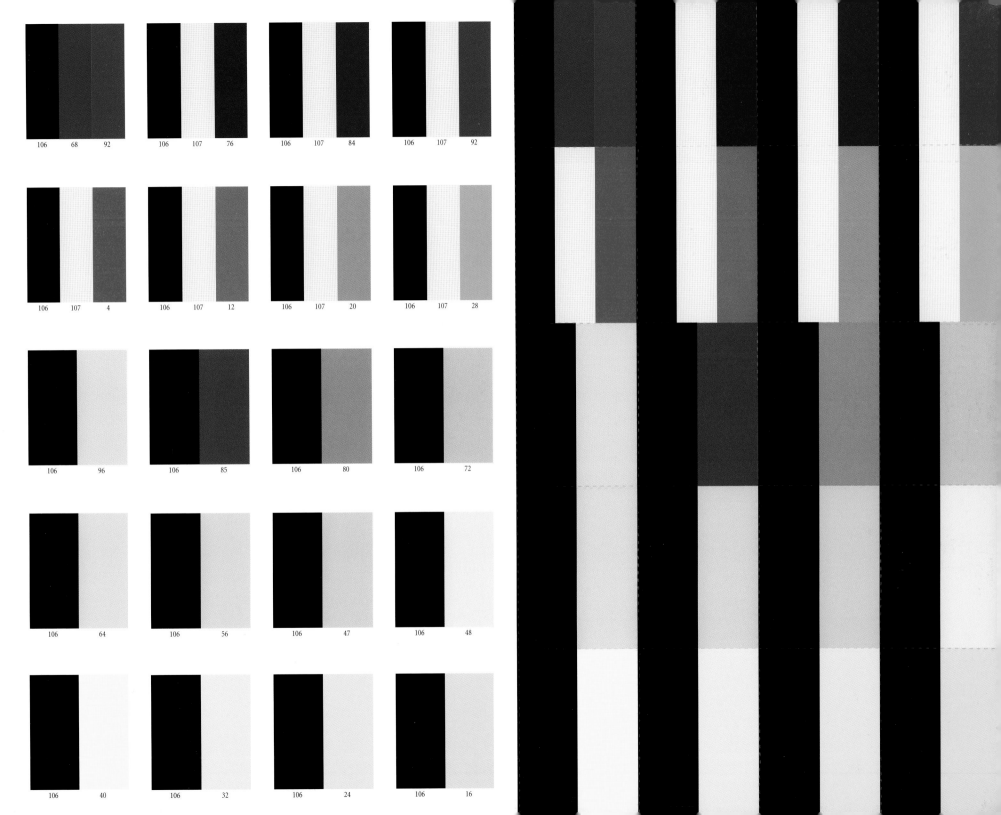

106 68 92

106 107 76

106 107 84

106 107 92

106 107 4

106 107 12

106 107 20

106 107 28

106 96

106 85

106 80

106 72

106 64

106 56

106 47

106 48

106 40

106 32

106 24

106 16

GRAPHIC Split 92 · GRAPHIC Split 107 · GRAPHIC Split 106 · GRAPHIC Split 84 · GRAPHIC Split 107 · GRAPHIC Split 106 · GRAPHIC Split 76 · GRAPHIC Split 107 · GRAPHIC Split 106 · GRAPHIC Split 92 · GRAPHIC Split 68 · GRAPHIC Split 106

GRAPHIC Split 28 · GRAPHIC Split 107 · GRAPHIC Split 106 · GRAPHIC Split 20 · GRAPHIC Split 107 · GRAPHIC Split 106 · GRAPHIC Split 12 · GRAPHIC Split 107 · GRAPHIC Split 106 · GRAPHIC Split 4 · GRAPHIC Split 107 · GRAPHIC Split 106

GRAPHIC Clash 72 · GRAPHIC Clash 106 · GRAPHIC Clash 80 · GRAPHIC Clash 106 · GRAPHIC Clash 88 · GRAPHIC Clash 106 · GRAPHIC Clash 96 · GRAPHIC Clash 106

GRAPHIC Neutral 48 · GRAPHIC Neutral 106 · GRAPHIC Neutral 47 · GRAPHIC Neutral 106 · GRAPHIC Neutral 56 · GRAPHIC Neutral 106 · GRAPHIC Neutral 64 · GRAPHIC Neutral 106

GRAPHIC Neutral 16 · GRAPHIC Neutral 106 · GRAPHIC Neutral 24 · GRAPHIC Neutral 106 · GRAPHIC Neutral 32 · GRAPHIC Neutral 106 · GRAPHIC Neutral 40 · GRAPHIC Neutral 106

GRAPHIC
Tips for Color Schemes

GENERAL COLOR

The graphic palette is bold, dramatic, and powerful. Black accents paired with bright, saturated hues will surely build drama and energy.

GRAPHIC DESIGN

Graphic design is perfectly suited to this color palette for both visual and economic reasons. Sophisticated and edgy, it makes a powerful statement. It communicates boldly and creates a lasting impression with perspective and depth.

INTERIOR DESIGN

Reliably stylish, black and white is elegant and inviting. Basic in design, it allows other colors to play off the palette. Deep reds, purples, and shades of blue stand out in sharp contrast. Alternatively, the focus of a room done in this color scheme might rather be a grand piano, a chinoiserie cabinet, or marble floor tile. The graphic palette is timeless in design.

FINE ART

Black is the absence of color, and white is the stimulus that makes it speak to us. From the beginning of time, artists have been drawn to the simplicity of this color combination. Photography, sculpture, paintings, and line drawings evolve from the graphic palette, while contrasting colors accentuate the permanence and drama of the message.

creative color combinations

Maine Cottage Furniture

Fresh

Artist: Jocelyn Curry

PURE

White is not merely the absence of color, but also a hue that designates purity, innocence, and class. It is hopeful, suggesting goodness and truth. Remember, the good guys always wore white hats, and a little white lie isn't so bad after all.

Cool whites echo an icy cleanliness, especially when combined with pale blues and spa greens, while warmer tones of white suggest tranquility and refinement. Though boring when used alone, white takes on a quiet, moneyed appeal in tonal combinations with the softest beiges and gives the eye a place to rest when combined with energizing brights.

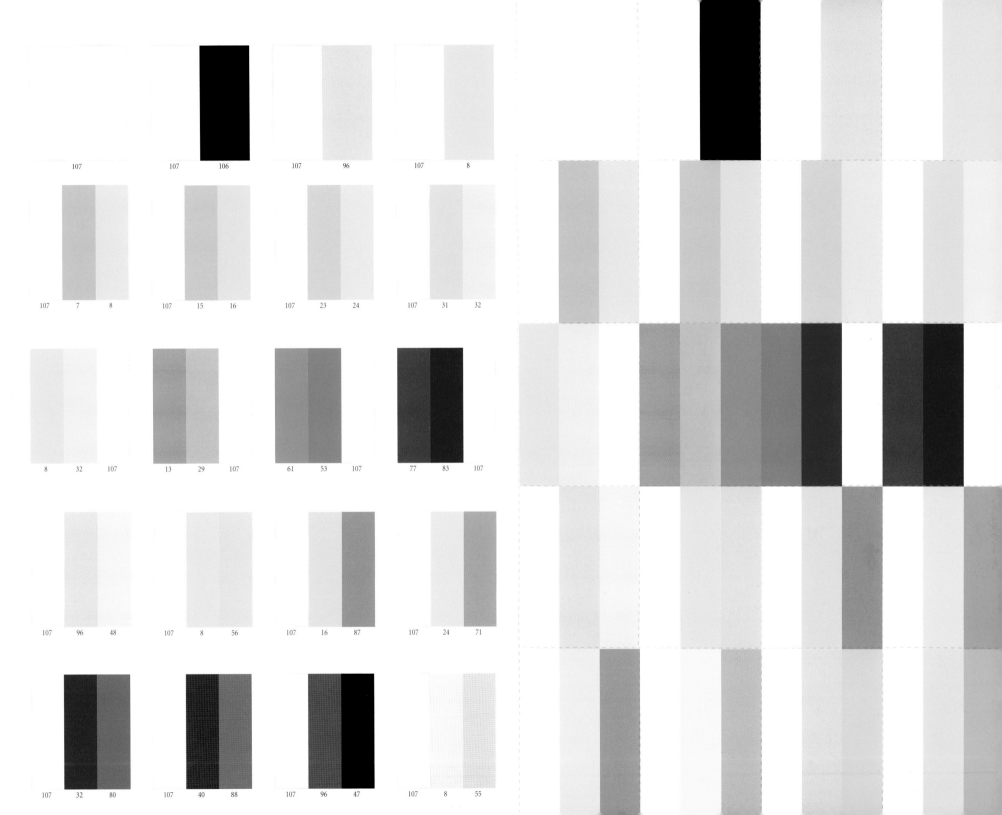

107

107 106

107 96

107 8

107 7 8

107 15 16

107 23 24

107 31 32

8 32 107

13 29 107

61 53 107

77 83 107

107 96 48

107 8 56

107 16 87

107 24 71

107 32 80

107 40 88

107 96 47

107 8 55

PURE Monocromatic 8
PURE Monocromatic 107
PURE Monocromatic 96
PURE Monocromatic 107
PURE Monocromatic 106
PURE Monocromatic 107
PURE Monocromatic 107

PURE Monocromatic 32
PURE Monocromatic 31
PURE Monocromatic 107
PURE Monocromatic 24
PURE Monocromatic 23
PURE Monocromatic 107
PURE Monocromatic 16
PURE Monocromatic 15
PURE Monocromatic 107
PURE Monocromatic 8
PURE Monocromatic 7
PURE Monocromatic 107

PURE Tertiary 107
PURE Tertiary 85
PURE Tertiary 77
PURE Tertiary 107
PURE Tertiary 53
PURE Tertiary 61
PURE Tertiary 107
PURE Tertiary 29
PURE Tertiary 13
PURE Tertiary 107
PURE Tertiary 32
PURE Tertiary 8

PURE 72
PURE Complementary 24
PURE Complementary 107
PURE Complementary 67
PURE Complementary 16
PURE Complementary 107
PURE Complementary 56
PURE Complementary 8
PURE Complementary 107
PURE Complementary 48
PURE Complementary 96
PURE Complementary 107

PURE 55
PURE Complementary 8
PURE Complementary 106
PURE Complementary 47
PURE Complementary 96
PURE Complementary 107
PURE Complementary 88
PURE Complementary 40
PURE Complementary 107
PURE Complementary 80
PURE Complementary 32
PURE Complementary 107

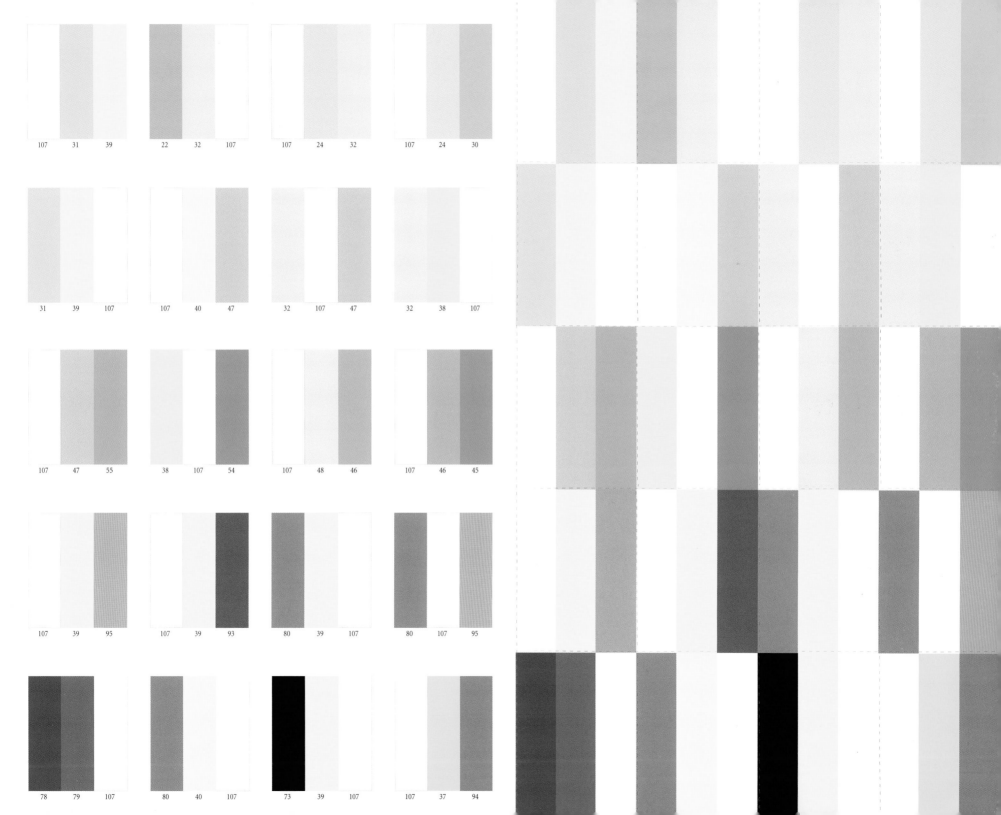

107 31 39 22 32 107 107 24 32 107 24 30

31 39 107 107 40 47 32 107 47 32 38 107

107 47 55 38 107 54 107 48 46 107 46 45

107 39 95 107 39 93 80 39 107 80 107 95

78 79 107 80 40 107 73 39 107 107 37 94

PURE
Split Complementary
94

PURE
Split Complementary
37

PURE
Split Complementary
107

PURE
Split Complementary
107

PURE
Split Complementary
39

PURE
Split Complementary
75

PURE
Split Complementary
107

PURE
Split Complementary
40

PURE
Split Complementary
80

PURE
Split Complementary
107

PURE
Split Complementary
39

PURE
Split Complementary
78

PURE
Split Complementary
95

PURE
Split Complementary
107

PURE
Split Complementary
80

PURE
Split Complementary
107

PURE
Split Complementary
39

PURE
Split Complementary
80

PURE
Split Complementary
93

PURE
Split Complementary
39

PURE
Split Complementary
107

PURE
Split Complementary
95

PURE
Split Complementary
39

PURE
Split Complementary
107

PURE
Analogous
45

PURE
Analogous
46

PURE
Analogous
PURE

PURE
Analogous
46

PURE
Analogous
48

PURE
Analogous
107

PURE
Analogous
54

PURE
Analogous
107

PURE
Analogous
38

PURE
Analogous
55

PURE
Analogous
47

PURE
Analogous
107

PURE
Analogous
107

PURE
Analogous
38

PURE
Analogous
32

PURE
Analogous
47

PURE
Analogous
107

PURE
Analogous
32

PURE
Analogous
47

PURE
Analogous
40

PURE
Analogous
107

PURE
Analogous
107

PURE
Analogous
39

PURE
Analogous
31

PURE
Analogous
30

PURE
Analogous
24

PURE
Analogous
PURE

PURE
Analogous
32

PURE
Analogous
24

PURE
Analogous
107

PURE
Analogous
107

PURE
Analogous
107

PURE
Analogous
32

PURE
Analogous
22

PURE
Analogous
39

PURE
Analogous
31

PURE
Analogous
107

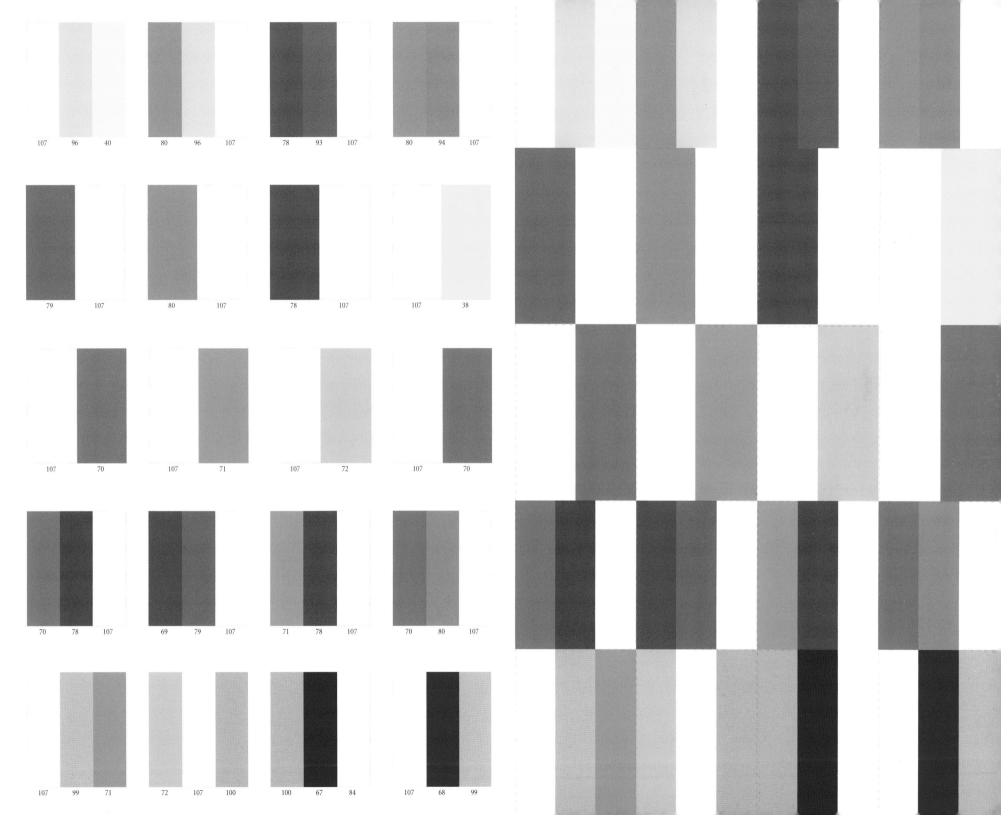

PURE Neutral 99
PURE Neutral 68
PURE Neutral 107
PURE Neutral 107
PURE Neutral 67
PURE Neutral 100
PURE Neutral 100
PURE Neutral 107
PURE Neutral 72
PURE Neutral 71
PURE Neutral 99
PURE Neutral 107

PURE Neutral 107
PURE Neutral 80
PURE Neutral 70
PURE Neutral 107
PURE Neutral 78
PURE Neutral 71
PURE Neutral 107
PURE Neutral 79
PURE Neutral 69
PURE Neutral 107
PURE Neutral 78
PURE Neutral 70

PURE Clash 70
PURE Clash 107
PURE Clash 72
PURE Clash 107
PURE Clash 71
PURE Clash 107
PURE Clash 70
PURE Clash 107

PURE Split 38
PURE Split 107
PURE Split 107
PURE Split 78
PURE Split 107
PURE Split 80
PURE Split 107
PURE Split 79

PURE Split 107
PURE Split 94
PURE Split 80
PURE Split 107
PURE Split 93
PURE Split 78
PURE Split 107
PURE Split 96
PURE Split 90
PURE Split 40
PURE Split 96
PURE Split 107

PURE
Tips for Color Schemes

GENERAL COLOR

The pure palette is clean and refined. Pale pastels and myriad tones of white combine to generate feelings of peace and tranquility.

GRAPHIC DESIGN

Graphic artists use pure colors effectively to illustrate sensibility. This color scheme encourages feelings of trust and goodness, which reassure the observer.

INTERIOR DESIGN

Cool and clean, the pure palette creates a restful sanctuary. White on white contrasts effectively with any accessory colors one might dream of using. Basic beige or creamy vanilla mixed with the softest of pastels are sophisticated and easy on the eyes.

FINE ART

Pure are the colors of Monet's *The Beach at Sainte-Adrese*. It is the palette of many French impressionist painters. Refined and restful, it is the palest blue sky, the serenity of a snow scene, the soft pink of a rose petal. The purity of alabaster and marble speak to the sculptor as he refines his work.

PROCESS COLOR CONVERSION CHART

Color No.	Cyan C	Magenta M	Yellow Y	Black K
1	0	100	100	45
2	0	100	100	25
3	0	100	100	15
4	0	100	100	0
5	0	85	70	0
6	0	65	50	0
7	0	45	30	0
8	0	20	10	0
9	0	90	80	45
10	0	90	80	25
11	0	90	80	15
12	0	90	80	0
13	0	70	65	0
14	0	55	50	0
15	0	40	35	0
16	0	20	20	0
17	0	60	100	45
18	0	60	100	25

Color No.	Cyan C	Magenta M	Yellow Y	Black K
19	0	60	100	15
20	0	60	100	0
21	0	50	80	0
22	0	40	60	0
23	0	25	40	0
24	0	15	20	0
25	0	40	100	45
26	0	40	100	25
27	0	40	100	15
28	0	40	100	0
29	0	30	80	0
30	0	25	60	0
31	0	15	40	0
32	0	10	20	0
33	0	0	100	45
34	0	0	100	25
35	0	0	100	15
36	0	0	100	0

Color No.	Cyan C	Magenta M	Yellow Y	Black K
37	0	0	80	0
38	0	0	60	0
39	0	0	40	0
40	0	0	25	0
41	60	0	100	45
42	60	0	100	25
43	60	0	100	15
44	60	0	100	0
45	50	0	80	0
46	35	0	60	0
47	25	0	40	0
48	12	0	20	0
49	100	0	90	45
50	100	0	90	25
51	100	0	90	15
52	100	0	90	0
53	80	0	75	0
54	60	0	55	0

	Color No.	Cyan C	Magenta M	Yellow Y	Black K
	55	45	0	35	0
	56	25	0	20	0
	57	100	0	40	45
	58	100	0	40	25
	59	100	0	40	15
	60	100	0	40	0
	61	80	0	30	0
	62	60	0	25	0
	63	45	0	20	0
	64	25	0	10	0
	65	100	60	0	45
	66	100	60	0	25
	67	100	60	0	15
	68	100	60	0	0
	69	85	50	0	0
	70	65	40	0	0
	71	50	25	0	0
	72	30	15	0	0

	Color No.	Cyan C	Magenta M	Yellow Y	Black K
	73	100	90	0	45
	74	100	90	0	25
	75	100	90	0	15
	76	100	90	0	0
	77	85	80	0	0
	78	75	65	0	0
	79	60	55	0	0
	80	45	40	0	0
	81	80	100	0	45
	82	80	100	0	25
	83	80	100	0	15
	84	80	100	0	0
	85	65	85	0	0
	86	55	65	0	0
	87	40	50	0	0
	88	25	30	0	0
	89	40	100	0	45
	90	40	100	0	25

	Color No.	Cyan C	Magenta M	Yellow Y	Black K
	91	40	100	0	15
	92	40	100	0	0
	93	35	80	0	0
	94	25	60	0	0
	95	20	40	0	0
	96	10	20	0	0
	97	0	0	0	10
	98	0	0	0	20
	99	0	0	0	30
	100	0	0	0	35
	101	0	0	0	45
	102	0	0	0	55
	103	0	0	0	65
	104	0	0	0	75
	105	0	0	0	85
	106	0	0	0	100